Mastering the FUJIFILM X-Pro1

Rico Pfirstinger

# Mastering the
## FUJIFILM X-Pro1

rockynook

**Rico Pfirstinger**
rico@ricopress.de

**Editor:** Gerhard Rossbach
**Translation:** David Schlesinger
**Copyeditor:** Hillary Danz
**Layout and Type:** Rico Pfirstinger
**Cover Design:** Anna Diechtierow
**Printer:** Tallinna Raamatutrükikoja OÜ
Printed in Estonia

**ISBN:** 978-1-937538-14-9

1st Edition 2012
© 2012 by Rico Pfirstinger

**Rocky Nook Inc.**
802 East Cota St., 3rd Floor
Santa Barbara, CA 93103
www.rockynook.com

Copyright © 2012 by dpunkt.verlag GmbH, Heidelberg, Germany
Title of the German original: Das Fuji X-Pro1 Handbuch
ISBN 978-3-86490-004-4

Library of Congress Cataloging-in-Publication Data

Pfirstinger, Rico.
  Mastering the Fujifilm X-Pro 1 / by Rico Pfirstinger. -- 1st edition.
    pages cm
  ISBN 978-1-937538-14-9 (softcover : alk. paper)
  1.  Fujifilm digital cameras--Handbooks, manuals, etc. 2.  Photography--Digital
techniques--Handbooks, manuals, etc.  I. Title.
  TR263.F85P47 2012
  006.6'86--dc23
                        2012034126

Distributed by O'Reilly Media
1005 Gravenstein Highway North
Sebastopol, CA 95472

# FOREWORD

Do you really need a second handbook for a camera like the FUJIFILM X-Pro1? Doesn't the owner's manual cover everything? The answer is: no, it doesn't.

That's not to say that the owner's manual is bad; it documents all of the camera's functions briefly—including features that I (and probably a majority of other photographers) won't ever use. What's missing are background information and practical tips based on experience. What's the best way to activate a function? Which setting should you use in different circumstances? Why is the camera exhibiting a certain behavior? And most important, which functions don't work the way you would expect them to and how you should handle them?

This book in no way makes the X-Pro1 owner's manual superfluous, and you should read the manual, because this book picks up where the manual leaves off. It condenses the knowledge and experience I gained in 15 months of groundwork, during which I collected a

wealth of information from Internet forums and countless other sources. While I was researching, I also shot thousands of images with the cameras of the FUJIFILM X-series—in particular the X100 and, since February 2012, the X-Pro1.

This handbook includes personal experiences, tips, and background information—not only from me, but from other photographers as well. Some basic photographic knowledge is assumed. The X-Pro1 is probably not your first camera, and you hopefully are already familiar with concepts like *aperture* and *shutter speed*.

If you still need to learn the basics, there are many excellent books (including some from this publisher) for building the knowledge and skills to fill this gap.

I hope you enjoy reading this book and shooting with your X-Pro1!

*Rico Pfirstinger, September 2012*

# 1 AN OVERVIEW OF THE X-PRO1 SYSTEM ................................................. 2

Interchangeable Lenses / Flash Units / Accessories

## 1.1 THE CAMERA ................................................................. 4

Overview of the Controls / Color Codes for the LED Indicator Lamp /
Camera Menus / Highlighted vs. Selected / The Quick Menu (Q Button) /
Updating Firmware / Restoring the Frame Counter /
SD Memory Cards / Long Start-Up Times? / Batteries and Chargers /
Diopter / The X-Trans Sensor / Cleaning the Sensor

## 1.2 THE LENSES ................................................................. 34

FUJINON XF18mmF2 R / FUJINON XF35mmF1.4 R / FUJINON XF60mmF2.4 R Macro

## 1.3 SYSTEM FLASH UNITS AND PRACTICAL ACCESSORIES ................ 43

Remote Flash / Additional Handgrip

# 2 SHOOTING WITH THE X-PRO1 ................................................. 48

## 2.1 HERE WE GO! ................................................................. 48

RAW or JPEG? / Setting the Image Size and Format

## 2.2 HYBRID VIEWFINDER AND MONITOR ................................... 61

The Optical Viewfinder (OVF) / The Electronic Viewfinder (EVF) / The LCD Monitor /
LCD/EVF Brightness / Image Playback

## 2.3 EXPOSURE AND METERING ................................................. 78

Exposure Control / Metering / Exposure Compensation /
Exposing Correctly with the Live Histogram and Exposure Compensation /
Automatic Exposure Bracketing / HDR Exposures

## 2.4 FOCUSING WITH THE X-PRO1 ............................................. 109

Functionality / Ten Practical Autofocus Tips /
Single Autofocus (AF-S) / Continuous Autofocus (AF-C) /
The AE-L/AF-L button / Focusing in the Dark / Manual Focus (MF) /
Distance and Depth of Field Indicators / Closeups (Macro Mode) /
Focusing on Fast-Moving Objects

## 2.5 ISO, DETAIL, AND IMAGE NOISE ......................................... 138

ISO Setting and Image Quality / Practical ISO Tips /
Automatic ISO / ISO Bracketing

2.6 EXTENDING THE DYNAMIC RANGE ........................................158

Questions and Answers about the DR Function /
Tips for Handling the DR Function / DR Bracketing

2.7 WHITE BALANCE AND JPEG SETTINGS ...........................................174

Setting the White Balance / Film Simulation / Color /
Contrast / Sharpness / Noise Reduction / Custom Shooting Profiles /
Internal vs. External RAW Conversion / Color Space /
Working with the Internal RAW Converter

2.8 CONTINUOUS SHOOTING, PANORAMAS, MOVIES,
DOUBLE EXPOSURES, AND THE SELF-TIMER .................................222

Continuous Shooting (Burst Mode) / Panorama Images / Movies /
Double Exposures / Self-Timer

2.9 FLASH PHOTOGRAPHY WITH THE X-PRO1 ....................................238

Automatic Flash / Forced Flash / Slow Synchro /
Synchronization to the Second Shutter Curtain /
Suppressed Flash / Red-Eye Correction / Fastest Flash Sync Speed /
Flash Exposure Correction / Controlling the Ambient Light /
Tips for Exposing with Flash

2.10 USING THIRD-PARTY LENSES .............................................251

Connecting and Recognizing Third-Party Lenses /
Focusing with Third-Party Lenses / Exposing Correctly with Third-Party Lenses /
Special Features of the FUJIFILM M Adapter

2.11 SOURCES AND LINKS ........................................................258

2.12 FIRMWARE VERSION 2.00 ..................................................261

INDEX ......................................................................263

# | AN OVERVIEW OF THE X-PRO1 SYSTEM

The FUJIFILM X-Pro1 system comprises the camera itself as well as a host of additional components available from Fuji and several third-party vendors.

## INTERCHANGEABLE LENSES

In addition to a variety of Fuji X-Mount autofocus lenses, you can also attach current and older lenses from manufacturers such as Canon, Nikon, Contax, and Leica with the help of adapters. A FUJIFILM adapter will enable you to use the Leica M-system, and those from other manufacturers like Kipon or Novoflex expand your options for lens mounts even further.

## FLASH UNITS

The X-Pro1 unfortunately doesn't come equipped with a built-in flash, but you can choose from three different system flash units designed for the X-Pro1 (and other Fuji camera models) that feature automatic TTL flash exposure capabilities. Or you can avail yourself of flash equipment from other manufacturers while shooting in manual mode.

## ACCESSORIES

Do you wear glasses? If so, a diopter ring could make a big difference for you. With its help, you'll be able to get the most from the X-Pro1's unique hybrid viewfinder without needing your glasses.

Do you plan on traveling with your X-Pro1? Then you'll need replacement batteries and a handy power adapter. And how about an additional handgrip that allows you to get a better hold of your camera while shooting?

There's more: Which memory cards should you use? Which filters should you affix to your lenses? How do you update the firmware for your camera and X-Mount lenses? And how do you keep troublesome dust and dirt particles from compromising your camera's X-Trans sensor?

As you can see, there are many questions to answer.

Image 1: The **FUJIFILM X-Pro1** with the XF35mmF1.4 R standard focal length lens as well as the XF18mmF2 R wide-angle and XF60mmF2.4 R tele-macro lenses.

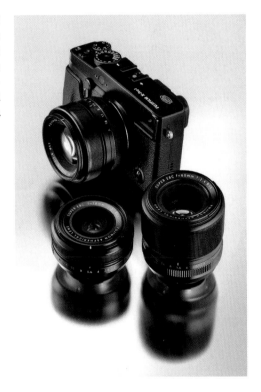

# 1.1 THE CAMERA

Before we get started with the actual operation of the X-Pro1, we should take a quick look at the camera's buttons, dials, menus, and connections—not because I think that you haven't done this already, but to be sure that we're speaking the same language and using the same terminology.

## OVERVIEW OF THE CONTROLS

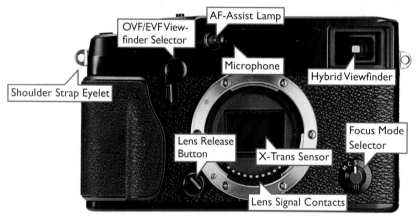

Image 2: **X-Pro1 Front View:** hybrid viewfinder, shoulder strap eyelet, focus mode selector, lens release button, lens signal contacts, X-Trans sensor, OVF/EVF viewfinder selector, AF-assist lamp, microphone (left/right).

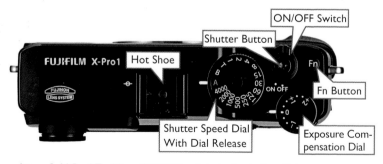

Image 3: **X-Pro1 Top View:** ON/OFF switch, shutter button, Fn button, exposure compensation dial, shutter-speed dial with dial release, hot shoe.

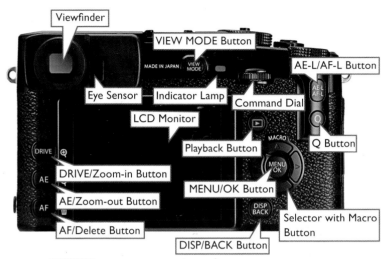

Viewfinder

VIEW MODE Button

AE-L/AF-L Button

Eye Sensor — Indicator Lamp

Command Dial

LCD Monitor

Playback Button

Q Button

DRIVE/Zoom-in Button

MENU/OK Button

AE/Zoom-out Button

AF/Delete Button

Selector with Macro Button

DISP/BACK Button

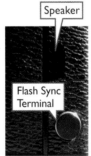

Speaker

Flash Sync Terminal

Image 4: **X-Pro1 Back and Left Side View:** viewfinder with diopter ring, eye sensor, LCD monitor, VIEW MODE button, indicator lamp, command dial, AE-L/AF-L button, Quick Menu (Q) button, playback button, selector with macro button, MENU/OK button, DISP/BACK button, AF/delete button, AE/playback zoom-out button, DRIVE/playback zoom-in button, flash sync terminal, speaker.

The selector enables you to navigate through the camera's menus and to control various features such as the selection of the autofocus frame. You can confirm your selections either by pressing the MENU/OK button or by pressing the shutter button halfway down.

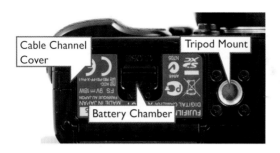

Image 5: **X-Pro I Bottom View:** tripod mount, battery and memory card chamber, cable channel cover.

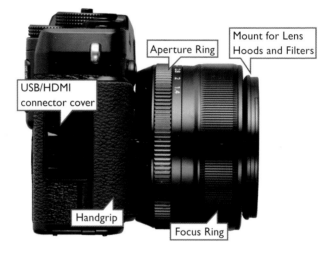

Image 6: **X-Pro I Right Side View** (with 35mm f/1.4 lens): USB/HDMI connector cover, handgrip, aperture ring, focus ring, mount for lens hood and filters.

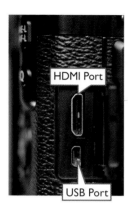

Image 7: X-Pro I Right Side View:
open connector cover revealing HDMI
and USB ports.

HDMI Port

USB Port

## COLOR CODES FOR THE LED INDICATOR LAMP

The indicator lamp next to the VIEW MODE button conveys the following information:

 The autofocus has identified a target and has it in focus.

 Warning—the image might be blurry, out of focus, or poorly exposed. You can, however, still snap the exposure.

 The camera is saving images, but you can continue to shoot.

 The camera is saving images, and you are not able to take additional shots.

 There is a lens or memory error.

## CAMERA MENUS

By pressing the MENU/OK button you can view the camera's menus on the monitor or in the viewfinder. The X-Pro1 has three types of menus:

- SHOOTING MENU
  The shooting menu—characterized by the color red—consists of five pages and contains functions that directly affect how you will capture images. These include ISO settings, dynamic range, various image settings (white balance, color, focus, contrast, etc.), AF mode, button assignments, and several photographic assistance features (grid lines, AF-assist lamp, AF-field correction frames, etc.).

- SETUP MENU
  The blue setup menu has three screens and is where you will define the general configurations for your camera. From this menu, for example, you can select your preferred language, set the date and time, adjust various settings, clean the sensor, and format your memory card.

- PLAYBACK MENU
  The green playback menu is the shortest of the three at only two pages. Its purpose is to allow you to manage your saved exposures. Since most photographers prefer to take care of this on a computer, this menu may be of limited use to you.

Press the MENU/OK button to access the X-Pro1's menus. All three menus will never be displayed at the same time. The shooting menu and the setup menu are accessible while in shooting mode. In playback mode (after you've pressed the playback button on the camera's back), you will be able to access both the playback and the setup menus. To switch back to shooting mode while in playback, simply press the shutter-release button halfway.

The selector keys allow you to navigate through the various menu options by moving up, down, left, and right. In addition, the numbered tabs along the left side of the menu make it easy to jump quickly from one page of the menu to another.

By pressing the MENU/OK button and holding it down for a few seconds, you can lock the four selector keys. To unlock the keys, simply press and hold the MENU/OK button again. Unfortunately this trick doesn't lock other buttons that users sometimes inadvertently press, such as the AE-L/AF-L and Q buttons. This oversight may be remedied in a future firmware update.

## HIGHLIGHTED VS. SELECTED

When I refer to a *highlighted* menu option in this book, I am describing the process of navigating to a particular entry, but not actually selecting it or activating the particular setting or feature. A menu option that has already been *selected* is indicated with a bar next to the active feature.

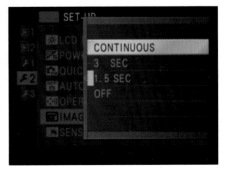

Image 8: Highlighted vs. Selected: In this illustration, the menu option CONTINUOUS is highlighted. The setting that is actually selected and active, however, is 1.5 SEC. You can use the MENU/OK button or the left selector key to activate a highlighted entry.

## THE QUICK MENU (Q BUTTON)

The X-Pro1 has yet a fourth menu—the so-called Quick Menu. This menu is FUJIFILM's response to complaints issued by users of the X100, who said that accessing important functions in the camera's nested menus was in some cases inconvenient.

Image 9: While in shooting mode, you can open the **Quick Menu** by pressing the Q button. This menu allows you direct access to 16 of the most commonly used camera features: select custom settings, ISO definition, dynamic range, white balance, noise reduction, image size, image quality, film simulation, highlight tone, shadow tone, color, sharpness, self-timer, AF mode, flash mode, and viewfinder/LCD brightness.

Use the selector keys to navigate to any of the 16 functions and then use the command dial to change the settings for the function of your choice. You can apply any changes you make in the Quick Menu using one of three buttons: you can press the Q button once again, you can press the MENU/OK button, or you can depress the shutter-release button halfway.

The X-Pro1 allows you to create up to seven *custom shooting profiles*, which you can bring up in no time with the help of the Quick Menu. To create a new shooting profile or change the settings of an existing one, hold down the Q button for a few seconds. This will bring you directly to the menu option EDIT/SAVE CUSTOM SETTING in the shooting menu, where you can either save your current camera settings as one of the seven profiles (SAVE CURRENT SETTINGS) or manually set and save values for ISO, dynamic range, film simulation, white

balance, color, sharpness, highlights, shadows, and noise reduction for each profile.

While in the Quick Menu, you can use the command dial to shuffle rapidly through the seven shooting profiles. As you do this, you will be able to see a live image on the camera's display depicting the settings of each profile. In other words, you not only see which of the seven profiles is currently active, you also see all of the settings that are associated with that profile. You can also just use the predefined profiles as a starting point and then use the Quick Menu to make further adjustments to the settings. Any changes you make to the profile's baseline settings will be indicated with a red dot.

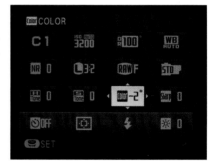

Image 10: **Shooting Profiles in the Quick Menu:** In this illustration the first shooting profile is selected (C1), but the values for the dynamic range (DR100) and color (−2) have been manually adjusted. The camera indicates these changes with a red dot. These changes won't be saved with the shooting profile; they are only active until you overwrite them or select another shooting profile. To make permanent changes to a shooting profile, hold down the Q button for a few seconds or select EDIT/SAVE CUSTOM SETTING from the shooting menu.

Have no fear; I will go over the various settings and features that I glossed over in the previous paragraph in greater detail in the coming chapters. I'll discuss ISO settings in section 2.5, dynamic range functions in section 2.6, and white balance and various JPEG settings in section 2.7.

Here I only wanted to emphasize that you can access the 16 most-used functions with the Q button and the Quick Menu instead of finding them in the traditional menus. All 16 features—and many more—can also be found on the conventional shooting and setup menus.

## UPDATING FIRMWARE

The X-Pro1 is a novel camera in many ways, but it also features a few peculiarities (typical Fuji!). Accordingly, users have many recommendations and wishes, and they would like to see the firmware (aka the control software) of the camera and lenses further improved, the range of functions expanded, and the kinks debugged.

Since FUJIFILM has heard a number of these requests, there should gradually be a series of firmware updates for the X-Pro1 and its lenses that you will be able to install on your own. You can determine the status of the firmware in your camera (and whichever lens you have attached at the time) by holding down the DISP/BACK button while turning the camera on.

By following photography news sources or consulting appropriate Internet forums, you can find out if there is a newer firmware version than what is currently installed on your camera. A small selection of these appear at the end of this book, and you can download the actual firmware updates directly from FUJIFILM at the following website address:

🌐 www.fujifilm.com/support/digital_cameras/software/#firmware

When downloading new firmware updates to your computer, make sure you don't have older firmware updates either for the X-Pro1 or for other Fuji cameras in your destination folder when saving. File naming conflicts may cause your computer to save the file under a different name, which your camera won't recognize and won't be able to install. Currently, firmware files for cameras are called FPUPDATE.DAT and updates for lenses are called XFUPDATE.DAT. Additionally, if you happen to own multiple X-Mount lenses, which may well be the case, and you would like to update all of them, you must take care not to mix anything up.

When installing firmware updates for your camera or lens, all of the camera functions and user settings will revert to the default setup. In other words, after every update, you will need to reconfigure your camera to the settings of your choice. This is cumbersome—not to mention annoying— and I hope this won't always be necessary in the future. Until then, however, it's a good idea to write down your custom settings before performing a firmware update.

**Follow these steps when updating your firmware:**

- Locate the latest firmware for your camera or your specific lens on the FUJIFILM website and download it to your personal computer. Unzip the file if necessary and then double-check that your computer hasn't given the downloaded file a name other than FPUPDATE.DAT or XFUPDATE.DAT. If the file name was changed to something else, you could rename it back (and delete or move the old firmware file). Or do whatever you need to do to ensure the file has the name the camera wants (like downloading it again elsewhere).

- Make sure that you have a fully charged battery in your camera.

- Connect an SD memory card to your computer. The card must have been formatted in your camera (SETUP MENU > FORMAT). If your computer has one, you can use an integrated card reader; otherwise you will need an external card reader.

- Copy the FPUPDATE.DAT file (if you're updating your camera) or the XFUPDATE.DAT file (if you're updating a specific lens) to the top level of the SD card.

- Disconnect the SD card from your computer (using your operating system to unmount it). Make sure your camera is turned off, and insert the card into the appropriate port on your camera.

- If you are updating a specific lens, make sure this lens (and no other one) is affixed to the camera. Even though every firmware update file for lenses has the same file name (XFUPDATE.DAT), you must be careful to download and install the firmware update file that is specifically designed for the lens you are using (e.g., 35mm f/1.4).

- Turn your camera on while holding down the DISP/ BACK button.

- Follow the directions on the LCD monitor and do not interrupt the update process. Do not turn the camera off before you receive confirmation that the process has completed!

> **IMPORTANT**
>
> The updating process can take several minutes, so it is important that your battery be fully charged. You wouldn't want your camera to shut down during the update because if it did, you might need to have a professional service your camera. This is also a potential outcome if you were to mistakenly update a lens (e.g., 50mm f/1.4) with a firmware update designed for a different lens (e.g., 18mm f/2.0).

Lenses and camera bodies must be updated together (at least that's the case now). If you attach an updated lens to a camera body that has not yet been updated, the camera will detect this after you turn it on by indicating that a firmware update for the camera is needed.

Conversely, the camera will also indicate that a lens firmware update is needed if you attach a lens that hasn't been updated to a camera body with a newer firmware version.

> **HINT**
>
> The basis for this book is firmware version 1.11 for the camera, version 1.01 for the 35mm f/1.4 and 18mm f/2.0 lenses, and version 1.02 for the 60mm f/2.4 lens.

## RESTORING THE FRAME COUNTER

Updating your camera's firmware could cause its internal frame counter to reset to zero. If you would like to restore it to its previous position, follow these steps:

- Insert your SD card into your computer and rename a picture that is saved on the card with your desired image number. For example, name the file DSCF2725.JPG instead of DSCF0001.JPG.

- Return the SD card to your camera and take a new exposure. This image will automatically be saved with the subsequent number in its filename—DSCF2726.JPG in the example. Bingo!

Image 11: **What's in a name?**
Well, whatever you want! Simply by renaming an image file on your memory card using your computer, you can trick the X-Pro I into resuming its internal frame counter where you want it to start.

This little trick obviously works for any situation in which you want to avoid unwanted or conflicting image numbers—for example, if you shoot with multiple cameras or you are using a camera that you normally don't use.

In these cases, reset the image counter by going to SETUP MENU 1 > FRAME NO. > RENEW and then format the memory card by going to SETUP MENU 3 > FORMAT. Next, take a picture and change its filename

(DSCF0001) on your computer to the number you prefer by using the steps described above. Then take a new exposure with this memory card.

While in the heat of the moment, don't forget to set the frame counter back to a continuous progression by selecting SETUP MENU 1 > FRAME NO. > CONTINU-OUS; otherwise the frame counter will start numbering images again from scratch after you format your card the next time.

## SD MEMORY CARDS

The X-Pro1 is compatible with SD, SDHC, and SDXD memory cards. You can safely ignore that FUJIFILM only guarantees the functional capabilities of SanDisk and (of course) FUJIFILM brand memory cards—the camera also works fine with the products of other manufacturers.

Fuji's recommendation that you should use memory cards in speed class four or higher is also something short of realistic. The X-Pro1 writes RAW files in excess of 26 MB and JPEGs in excess of 3–5 MB, or in other words around 30 MB per RAW+JPEG exposure. When shooting continuously and producing six exposures per second that adds up to 180 MB of data that can occur within the span of a second!

The camera's buffer memory can fill up remarkably quickly—and it should be emptied (read: the data should be written to the memory card) just as quickly, so you can take additional exposures. I recommend at least a speed class 10 memory card; if you use anything less, you're saving money in the wrong place.

As a matter of fact, many of my colleagues and I go a step further. We only use the fastest SD cards available on the market today. Why? Because the cameras in the X series can actually put this extra speed to use—our own and other tests have shown this repeatedly. This advantage comes into play especially with the X-Pro1's

automatic exposure bracketing function, during which the camera is completely blocked (unnecessarily, in my opinion) until all three bracketed shots are saved.

What it all comes down to is the *write speed* of the memory card. Watch out for deceptive marketing that advertises exceptionally fast speeds but really only describes the read speed of the cards.

As of July 2012, the fastest available SD cards read and write data with a nominal speed of 95 MB/s. I personally have had good experiences with models from Panasonic and SanDisk. Since these exceptionally fast cards aren't cheap, I generally use smaller capacity versions with 8 or 16 GB for my X-series cameras and make a habit of transferring my exposures to my computer regularly. When shooting with the maximum RAW+JPEG quality settings on your X-Pro1, a 16 GB card is good for 500 exposures.

In addition to one or two of these superfast memory cards, I usually also carry a few more affordable class 10 cards that have a larger capacity (32 or 64 GB), which I use for data backup (things can even happen to laptops) or in situations in which I have a greater need for capacity than I do for speed.

Image 12: **The Need for Speed:**
SD memory cards such as the SanDisk Extreme Pro with a nominal read and write speed of 95 MB/s are part of the basic equipment for many X-Pro1 users, according to an American camera forum.

## LONG START-UP TIMES?

Again and again photographers who shoot with FUJI-FILM's X-series complain about the start-up times of their cameras. Usually these complaints mention a wait time of at least 10 seconds between turning the camera on and the moment when the camera is ready to use. The culprit for these delays is actually always an SD memory card that has been used in other devices (a PC, iPad, or something else) to transfer pictures. This problem arises from the widespread bad habit among computer users of failing to unmount the memory card from the device using the computer's operating system and instead simply popping the card out. The X-Pro1 owner's manual points out that users should actually format their SD memory cards anew after each use in another device (SETUP MENU 3 > FORMAT).

This is surely good advice (although many Fuji camera owners obviously don't follow it), but it is not especially feasible in practice—for example, if you don't want to delete the images from the memory card but do want to transfer them to another device in the meantime. I recommend the following practices to avoid problems with the start-up time of your camera:

- Leave your SD card in your X-Pro1 and transfer your images to another device with the USB cable that comes with the camera. No additional files that could affect the camera start-up time are written to the memory card when you use this method.

- Use the read-only lock on your SD memory card before inserting it into other devices. This will also prevent unwanted files from being written to the card. You will need to remember, of course, to turn the lock off before using the card in your camera again. If you

happen to forget to do this, your X-Pro1 will remind you with a warning the next time you turn it on.

## BATTERIES AND CHARGERS

The X-Pro1 uses a rechargeable lithiumion battery, model NP-W126, which you can purchase independently at camera retailers—but at a stiff price. Many photographers opt instead for (largely) identical and markedly less expensive alternatives from third-party manufacturers. You can find compatible models for about $12, but these bargain batteries don't always match the endurance of the original battery.

A fully charged battery is good for about 300 exposures. Consider this a ballpark estimate, though, because

Image 13: A **FUJIFILM original battery**, model NP-W126, with a rated capacity of 1260 mAh. Compatible and less-expensive models are available from other manufacturers in on- and offline markets. Not all models feature the practical gray arrow, however, that indicates the correct orientation for inserting the battery (but you can solve the problem with a marker easily enough). Take care to match up the gray arrow with the gray battery latch and make sure to test whether the battery is in correctly by turning your camera on each time you replace it.

the actual charge-life of a battery depends on your personal settings and your habits as a photographer. If you shoot with the optical viewfinder (and switch off the LCD display on the back of the camera), for example, the range of exposures per battery charge jumps up to 1000.

---

**TIP**

Don't become a slave to your camera battery—it's better to get yourself a few spare batteries. This will allow you to concentrate on your photography instead of worrying about how many exposures you can squeeze out of the remaining charge in your battery.

---

The X-Pro1 also features an energy conservation mode, which can be activated and deactivated by navigating to SETUP MENU 2 > POWER SAVE MODE. Do yourself and your images a favor, however, and use this mode only in the most dire of emergencies. This mode not only reduces the power consumption of your camera; it also limits the camera's capabilities. The autofocus works slower in power save mode, and the live histogram won't be available to you in the optical viewfinder. You're better off taking a second, third, or even a fourth battery with you instead of limiting your camera's ability to perform.

On the other hand, it does make sense to use the camera's quick start mode, which you can toggle on and off at SETUP MENU 2 > QUICK START MODE. The automatic turn-off feature is also advisable. With this option activated, the camera will automatically power down after a period of not being used. You can determine the length of time before the camera shuts off at SETUP MENU 2 > AUTO POWER OFF.

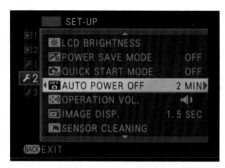

Image 14:
The power save mode, quick start mode, and auto power off features can all be found in **SETUP MENU 2**.

I personally set the auto power off feature to two minutes. My camera powers down after two minutes of not being used and accordingly saves energy from being wasted. You can bring your sleeping X-Pro1 back to life by pressing the shutter-release button halfway down. Alternatively, you can press the ON/OFF button to turn your camera off and then (after a quick moment) turn it back on.

The NP-W126 and its compatible brethren are not intelligent batteries, which is why you should take the camera's battery indicator with a grain of salt. As long as all three bars fill up the battery symbol, you don't have anything to worry about. When there are only two bars, the battery is already below half of its total charge, and when there's only one bar (the symbol will turn red at this point) it's time to swap out the battery as soon as possible. The battery charger that comes with the camera, model BC-W126, includes a conventional cable connection. When you are travelling, this means that in

**TIP**

While saving energy is in, it only makes sense to do so with the X-Pro1 when it doesn't come at the expense of performance. For this reason, avoid using the camera's power save mode and opt instead to use the quick start mode and the automatic off feature.

addition to the included power cable, you can also use other cables that fit into local power outlets. One useful travel option is the Apple World Travel Adapter Kit. While this kit is actually designed for users with iPods, iPhones, iPads, and laptops from Apple, you can also attach the small adapter to the Fuji power supply unit and then plug your charger into a foreign power outlet.

Image 15: The **original power charger**, model BC-W126, features a standard power cable connection, which allows you to use the plug from the Apple World Travel Adapter Kit, among many others—a feature that's especially convenient for foreign travel.

As is the case with batteries, it's wise to purchase a second charger. In addition to the original charger, there are various third-party offerings for this unit.

The BC-W126 includes a status lamp that glows green as long as the battery is charging. When the light goes out, it means that the battery is fully charged. A blinking status indicator is a bad sign—it indicates a battery failure. When this occurs, unplug the charger from the wall and remove the battery. Insert another battery and check to see if the light continues to blink after you plug the charger in. If it does, your charger may be the source of the problem.

## DIOPTER

Retro cameras like the X-Pro1 are in some ways intended for an older crowd, which is why countless retailers and prospective buyers find it all the more incomprehensible that the camera's viewfinder doesn't feature an integrated multilevel optical adjustment for photographers who wear glasses (unlike the X100, X10, and S-S1). Anyone who wears glasses to read or drive will need to either wear his or her glasses while photographing or purchase a diopter correction lens with 19mm threads.

The first surprise: FUJIFILM didn't offer its own diopter lens as part of its accessories for the X-Pro1 for several months, instead pointing users toward Cosina as a third-party manufacturer.

The second surprise: aside from this tip, the owner's manual doesn't have anything else to offer on this important subject. In the English language FAQs on FUJIFILM's global website you can at least find that the X-Pro1's viewfinder features an internal setting of −1D. But what exactly does this information mean in practice?

The factory-provided diopter on the viewfinder is neutral—it is a simple piece of glass with no corrective optical effects. You could in principal remove the glass entirely, but that would allow dirt and dust to accumulate in your viewfinder more easily.

Image 16: The **diopter lens** that comes with your camera is an optically neutral piece of glass. Its rubber mount should protect eyeglasses from getting scratched if photographers press them up against it. Some X-Pro I users have lost the factory-installed, neutral diopter lens after just a few days. To make sure this doesn't happen to you, check that the ring is screwed in tightly to the viewfinder on your camera so that it won't come undone by, for example, rubbing against your clothing when your camera is hanging around your neck.

Since camera viewfinders are designed for photographers with standard eyesight, we can assume that the neutral diopter lens (i.e., 0D) that comes with the X-Pro1 represents the normal case for people with normal vision.

Experience shows that on this basis farsighted people who wear glasses to read should use a diopter lens with the same correction value as they use for help reading. For example, if you use a pair of reading glasses with a correction of +1D, you would be best off attaching a +1D diopter lens to your viewfinder.

You can attach FUJIFILM's own corrective lenses to your X-Pro1, along with other offerings from Cosina and Carl Zeiss, as well as various Nikon diopter lenses for its film F System. The threads are standard; the only thing you'll need to do is make sure the lens has a 19mm thread diameter.

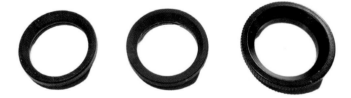

Image 17: **A Comparison of 19mm Diopter Lenses:** Left, a neutral diopter provided by the factory; middle, a +2D diopter lens from Carl Zeiss (also with a protective rubber ring); and right, a somewhat larger +1D diopter lens from Nikon without a rubber ring.

Diopter lenses from Fuji, Cosina, and Zeiss all have rubber rings around them, which is practical if you want or have to wear a pair of glasses while you use the lenses. Various Nikon diopter lenses are constructed entirely of metal. The upside of this, however, is that they feature a slightly larger inlet view, which many photographers will find beneficial.

People who wear gradient lenses or have complicated vision correction requirements should visit an optometrist with their cameras to discuss and try out different corrective lenses. You can purchase diopter lenses from FUJIFILM, Cosina, Carl Zeiss, and Nikon at most specialized retailers.

## IMPORTANT

The X-Pro1's optical and digital viewfinder displays are located at different virtual levels of distance. This makes it important for you to use a corrective lens that allows you to see the images provided by both the digital and the optical viewfinder sharply. The standardization of corrective values for Nikon diopter lenses is slightly different from other manufacturers. With Nikon's lenses you need to purchase a lens that has an advertised corrective value of 1D less than you actually need. For instance, if you need an effective correction of +1D, then you should purchase a neutral Nikon diopter lens. To achieve a correction of +2D, get a Nikon diopter with a marketed value of +1D. This complication only applies to lenses manufactured by Nikon. With lenses from FUJIFILM, Cosina, and Zeiss, the marketed and effective corrective values are the same.

### THE X-TRANS-SENSOR

The X-Pro1's sensor is anything but ordinary. Though on paper it may not sound like anything earthshaking, behind its somewhat middling specs—an APS-C format and 16-megapixel resolution—lies a special quality that FUJIFILM developed in order to bring the X-Pro1's image quality on par with the performance of larger full-format sensors.

Image 18: **The Heart of Any X-Pro1 — The X-Trans-Sensor:** Since dirt and dust particles can settle on the sensor with time, it should be cleaned occasionally.

The innovation lies in the structure of the color filter over the sensor pixels. While conventional sensors employ a simple self-repeating 2x2-color matrix in the so-called Bayer array, the X-Pro1 features a complex pattern of 6x6 color pixels. The advantage of this seemingly random pixel array is the way in which it suppresses moiré effects, which have the potential to noticeably disturb the appearance of an image.

Image 19: *Top,* **Bayer sensor;** *bottom,* **X-Trans sensor.** While traditional Bayer sensors require a low-pass filter to suppress undesirable moiré effects, the X-Pro1's complex color array means no such filter is needed. This benefits the camera's resolution and amounts to an excellent image quality for the sensor's size.

Camera manufacturers usually attempt to ward off moiré effects by installing a low-pass filter in front of the Bayer sensor. The disadvantage of this method is that the filter causes a noticeable loss of resolution. Fuji's

alternative approach, the X-Trans sensor, combines both approaches: by doing away with the need for the low-pass filter, it achieves a remarkably high resolution, while the unusual pixel array effectively suppresses the appearance of moiré effects so that such problems occur only in rare instances.

One disadvantage of the unconventional sensor array is that external RAW converters aren't capable of interpreting its data without additional decoding. This requires both extra resources and money. As of now, the X-Pro1's RAW format files are supported by relatively few RAW converter programs.

## CLEANING THE SENSOR

The settling of dust and dirt particles on the sensor is a fundamental problem for all digital cameras with interchangeable lenses. These particles can mar images by showing up as distracting spots in the light areas of an image (e.g., sky, clouds, walls).

To minimize the effect of this problem, the X-Pro1 offers an integrated cleaning mechanism that runs when you turn your camera on or off. Navigate to SETUP MENU 2 > SENSOR CLEANING to control this setting. You can choose to run the cleaning manually, by selecting OK, or you can choose to have the cleaning process run when you turn your camera on and/or off.

I have my camera set to clean the sensor both when I switch it on and when I turn it off—it's best to shake the sensor up a bit as often as possible. And this is actually all this function does: with the help of high-frequency vibrations, the dust particles loosen from the sensor preventing them from becoming permanently attached. Don't put too much stock in the sensor cleaning function. If any dirt particles have settled on the sensor, they're likely to remain stubbornly attached even after running the cleaning mechanism.

Accordingly, the most important strategy for maintaining a clean sensor is the active and passive avoidance of dust:

- Don't leave your camera unnecessarily open without protective housing covers.

- As much as possible, avoid changing your lenses in dusty or dirty environments.

- When changing your lens, hold your camera pointed downward, not upward.

- When attaching a lens, make sure that the rear lens opening and the optics are clean and free of dust to prevent transferring dust to the sensor inadvertently.

- Don't touch the sensor!

Despite diligent preventative measures, it's an unavoidable fact that the sensor of your X-Pro1 will collect dirt or dust over time if you use it regularly. Don't deceive yourself—the question is not *if*, but *when*!

You can run the following test to check whether dust has already settled on your sensor. Take an exposure of a blue or white sky, a bright wall, or a white piece of paper with a fully dimmed lens (the highest f-stop possible). It's best to use the camera's automatic exposure bracketing feature (DRIVE button > AE BKT) and to manually set the lens to be out of focus—for the sky, set the focus for a short-range shot, and for a piece of paper, set the focus to infinity. If you then transfer your images to your computer and maximize the contrast, any flecks on your sensor should be readily visible.

Image 20: **Taking a Look at Flecks on the Sensor:** This is how the sensor of my preproduction X-Pro I looked after three weeks of use in Asia. This exposure of a piece of white paper reveals (with the help of stark contrast settings on my PC) over a dozen flecks on the image sensor. Something no amount of shaking and vibrating will remedy.

Using a cleaning bellows is one safe method to remove dust particles from the lens and sensor. Photographers are particularly fond of the Rocket-air Blower from the manufacturer Giottos. This product features an air valve, which prevents dust from entering its bellows—the last thing you want to do is blow additional dust into the camera's chamber. The goal is to loosen and remove the existing blemishes with a clean stream of air. For the best results with this tool, blow from below into the sensor chamber of your open camera.

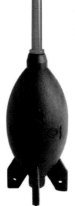

Image 21: The **Super Rocket-air Blower** from Giottos may look comical, but it effectively removes dust from cameras and lenses.

Don't use compressed air from a gas duster! These products contain propellants, whose particles can end up sticking to the image sensor, causing exactly the opposite effect of your intended result. Additionally, the stream of compressed air can harm the sensor by turning these particles into tiny and harmful projectiles.

If you've read through the owner's manual for your X-Pro1, you'll know there's an official decision on this matter. FUJIFILM advises that you should not use a brush (or any other item) to clean the sensor, and threatens that any resulting damages from doing so will void the warranty.

What about when the flecks on the sensor simply won't go away? My colleague Michael J. Hussmann, who's a legend when it comes to photo technology, recommends a "fruit snack on a stick." This is the nickname for Pentax's Sensor Cleaning Kit—and you'll see why people call it that at first sight.

Image 22: Pentax's **Sensor Cleaning Kit** includes a specially coated cleaning head that collects dust from the sensor. After every time you dab dust off of the sensor, you'll need to clean the head with a special piece of sticky paper that comes in the kit. To clean the entire area of the X-Pro1's sensor, you'll need to blot off the cleaning head approximately six times.

I can't introduce you to all of the methods and means of cleaning a sensor in this book, but I did ask Torben Hondong, the service manager for FUJIFILM in Germany, how he handles dust removal from the X-Pro1's sensors.

FUJIFILM depends (as do countless other camera manufacturers) on the products from the U.S. company Photographic Solutions. The basis of every damp cleaning is the so-called Sensor Swabs that are soaked in a cleaning solution called Eclipse and then wiped like a windshield wiper across the sensor—one side of the swab from left to right, and the other side from right to left. It's important that the swabs (which aren't cheap, to say the least) are used only one time and that each side of each swab is wiped across the sensor only once. Otherwise the dirt and dust collected on the first pass can scratch the sensor on the way back.

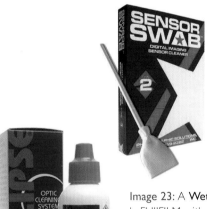

Image 23: A **Wet Cleaning of the Sensor** à la FUJIFILM with products from Photographic Solutions: Sensor Swabs (for the X-Pro I you'll need size 2) are moistened in Eclipse cleaning solution and wiped over the sensor one time.

Specialist Torben Hondong doesn't rely on just this standard solution (available for anyone to purchase in camera stores). More commonly, he replaces the original cloth on the swaps with special "Cleaning Wiper" cloths from Japan, which he finds work better because they smear less. In particularly difficult cases, he treats the affected area of the sensor with a drop of Zeiss Optical Cleaning Mixture. Hondong cautions, however, that this relatively aggressive solution is not recommended for home use.

That being said, it is usually possible to take care of the normal dirt and dust buildup on the X-Pro1's sensor by yourself with products for DSLR cameras that are readily available in retail stores. The Canadian company Visible Dust offers a similar, and in fact more sophisticated, line of products, such as swabs and cleaning solutions, at prices that aren't any higher than those of Photographic Solutions.

As a last resort for particularly stubborn sensor dirt that won't come out, you can always send your camera in to be serviced.

## 1.2 THE LENSES

The optical standard equipment for the X-Pro1 consists of three high-aperture fixed focal length lenses with X-Mount connections and autofocus (AF): the 18mm f/2.0, the 35mm f/1.4, and the 60mm f/2.4. In the traditional 35mm format, this is tantamount to focal lengths of 27mm (wide-angle), 53mm (standard focal length), and 91mm (modest tele-macro).

This is by no means all, because by the middle of 2013 four additional fixed focal length lenses (14mm f/2.8, 23mm f/1.4, 27mm f/2.8 pancake, and 56mm f/1.4) and three image-stabilized zoom lenses (10–24mm f/4, 18–55mm f/2.8–4, 55–200mm f/3.5–4.8) are supposed to be available to flesh out the range of options.

The camera's slim flange-back distance makes it possible to connect countless lenses from third parties. Manufacturers such as Kipon and Novoflex offer adapters that enable you to use lenses from dozens of other systems with the X-Pro1. Additionally, FUJIFILM offers its own adapter for the Leica M-system lenses, which allows for adjustments to correct distortions, vignetting, and color shifts (see section 2.10).

Information between the camera and the X-Mount lenses travels over electronic contacts. Even manual focusing (MF) is ultimately electronic. This "focus by wire" method is often criticized since it operates with a small delay and does not provide the photographer with immediate feedback—unlike true mechanical MF lenses. However, Fuji didn't actually design the AF lenses to have pure manual focusing capabilities. The intention was—and is—much more to use the autofocus even in MF mode (by using the AF-L button) and to use the lens's focus ring for fine adjustments (with the help of the magnified electronic viewfinder). This concept has already led to many misunderstandings with the X100.

Fuji offers the three X-Mount lenses that make up the basic equipment for the X-Pro1 with fitting lens hoods, which you'd be wise to employ. Protective filters with a 52mm thread diameter fit on the 18mm and 35mm lenses. The 60mm lens, however, features threads with only a 39mm diameter.

As is the case with the camera body itself, all three lenses are truly lightweight in relation to their size and construction, making them a real joy to bring along.

### FUJINON XF18mmF2 R

The 18mm f/2.0 wide-angle lens for the X-Pro1 is often considered a tool for reporting, partly because its upper aperture limit is quite large for its focal length, allowing photographers to capture people and moments even in adverse circumstances with relative ease.

Due to a diminished sharpness around the edges and a need for electronic distortion corrections by the camera or by your RAW converter program, this lens is sometimes considered less ideal for architecture and landscape photography.

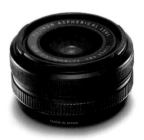

Image 24:
The **Fujinon XF18mmF2 R** wide-angle lens weighs in at just 100 grams despite an aperture of f/2.0.

This opinion must be qualified, though. The image on page 37 shows a landscape shot with the 18mm f/2.0 lens on March 21, 2012 in Bali. The RAW file was developed using a beta version of the free RAW converter RPP 64 with the V50 film simulation preset and was polished off with Apple Aperture 3.2.

No automatic or manual lens corrections were undertaken during the RAW conversion or during the finishing.

### FUJINON XF35mmF1.4 R

The 35mm lens is the standard for the X-Pro1. If you would like to buy only one lens (initially) for your camera, this would be it in nearly every case—and for good reason, because with an aperture of f/1.4, this lens excels in low-light situations and offers excellent performance if you want to isolate a subject.

Even at full aperture this lens produces extraordinarily sharp and high-resolution images, and the value it brings for its price is exceptional. Owing to its 35mm equivalent focal length of 53mm, this lens functions as a great all-around lens but is sometimes considered not ideal for portrait photography.

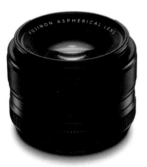

Image 26: In terms of resolution and sharpness, the **Fujinon XF35mmF1.4 R** competes with more expensive lenses. And despite offering a large aperture, its 187 grams makes it a true lightweight.

Image 25: Volcano in Bali: ▶
Exposure parameters: X-Pro1 preproduction camera, XF18mmF2 R preproduction lens, ISO 200, f/8.0, 1/400 second, automatic white balance.

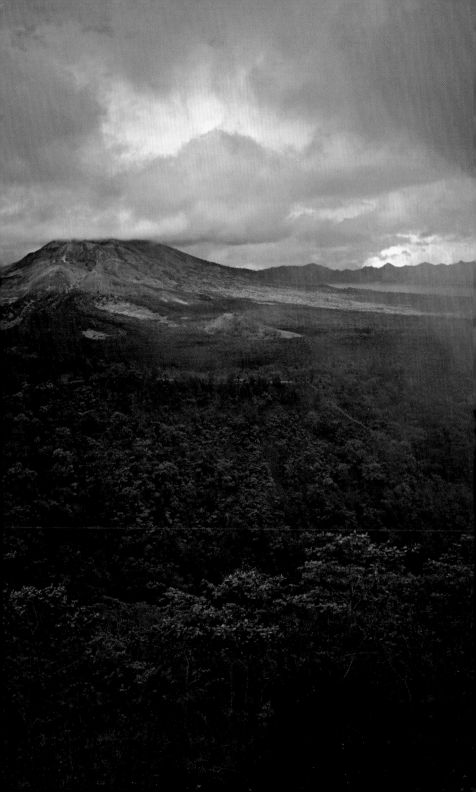

I also have some reservations about this criticism. The following image shows a portrait snapped on February 16, 2012 at the Warsaw Railway Museum with the preproduction 35mm lens. The RAW file was developed with Silkypix 4, and the image was finished with Apple Aperture 3.2.

The lighting in this exposure is a mixture of natural daylight (from the window on the right) and artificial light (from a studio floodlight in the back and on the left). The camera's auto DR setting settled on the extended dynamic range of DR400%. In other words, it "underexposed" the RAW file by two f-stops (see section 2.6).

### FUJINON XF60mmF2.4 R MACRO

This modest telephoto lens, with its 35mm equivalent focal length of 90mm, is actually better suited for portraiture, but Fuji sells it as a macro lens for closeup photography. With a minimum distance of nearly 11 inches between subject and lens, however, one can't really speak of this as a bona fide macro lens.

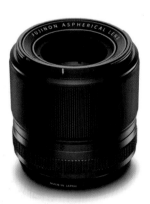

Image 28: The **Fujinon XF60mmF2.4 R Macro** is the largest of the three basic lenses for the X-Pro I, but it still only weighs just over 200 grams. Since its inner tube extends and retracts when focusing, the lens has only a 39mm diameter filter connection. It comes complete with a sizeable lens hood.

Image 27: **Lady in Warsaw:** ▶
Exposure parameters: X-Pro I preproduction camera, XF35mmF1.4 R preproduction lens, ISO 800, f/1.8, 1/1000 second, automatic white balance.

Nevertheless, the 60mm lens is ideal for closeups. Even at its full aperture, it produces sharp and high-resolution images. It is often criticized for its slow autofocus (AF), which can be a hindrance for someone working quickly.

As you may suspect, I also don't agree entirely with this judgment. I've successfully photographed nimble surfers on man-made waves as well as lively butterflies that alight on a blossom for no more than a second or two with this lens. In every instance, the lens acts quickly and precisely. You can learn more about using the AF in section 2.4.

The following photograph shows a closeup from March 26, 2012 taken on the island of Sentosa in Singapore with a 90mm-equivalent focal length. The RAW file was developed with Silkypix 4 and finished with Aperture 3.2. This was a freehand snapshot using autofocus (with the smallest autofocus frame) on the head of a butterfly that landed for a moment on my companion's hand. The auto DR again opted to shoot at an extended dynamic range of DR400% (see section 2.6 for more on dynamic range).

**TIP**

To use filters with a 52mm diameter on the XF60mmF2.4 R Macro (which has a 39mm connection), you can purchase a relatively inexpensive 39-to-52mm step-up ring. To be able to attach this ring to the lens, you'll need to attach a spacer ring with a diameter of 39mm between the lens and the step-up ring. An easy solution for this is to find any old inexpensive 39mm filter from which you can remove the actual filter and just use the ring.

Image 29: ▶
**Trusting Butterfly:**
Exposure parameters: X-Pro I preproduction camera, XF60mmF2.4 R Macro preproduction lens, ISO 800, f/4.5, 1/125 second, automatic white balance.

You should avail yourself of the lens hoods that come with the three lenses as much as possible. They not only shield your optics from unwanted stray light; they also protect them from damage.

Image 30: The included **lens hoods** belong on your lenses and not in a drawer.

If that's not enough for you, you can also attach neutral protective filters to your lenses to protect them from damage. Fuji offers such filters for the different X-Mount lens sizes. Keep in mind, however, that every additional lens through which the camera captures an image has the potential to have a negative effect on the image's quality. For this reason, you should only use a protective filter when you actually need it.

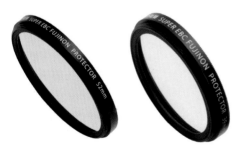

Image 31: FUJIFILM **protective filters** with 52mm and 39mm thread diameters. The 39mm small filter also lends itself well to function as a spacer ring for a 39-to-52mm step-up ring.

The X-Pro1 doesn't need other filters, such as the skylight or UV filters that were familiar from the days of film photography.

# 1.3 SYSTEM FLASH UNITS AND PRACTICAL ACCESSORIES

In contrast to the other current cameras available from FUJIFILM, the X-Pro1 does not include an integrated flash. In principle, you can attach and use any flash unit available on the market to the hot shoe or to an external flash connector (including studio flash units and remote triggers), but the automatic flash exposure metering and flash control features only work with TTL flash units from FUJIFILM (TTL means that light is metered "through the lens").

As of this writing, Fuji offers three units: the EF-42, EF-20, and EF-X20. The models EF-42 and EF-20 have been around longer and were not specifically designed for use with the X-Pro1 or other cameras in the X series. In fact, these two flash units weren't developed by FUJI-FILM—they are essentially versions of the models PZ-42X and RD2000 from the Japanese company Sunpak that were manufactured for Fuji.

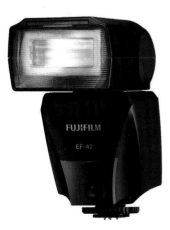

Image 32: The **EF-42** is the most powerful and versatile flash in Fuji's offerings, but its ungainly dimensions and conventional shape don't fit the X-Pro1 particularly well.

The EF-42 design isn't ideal for the X-Pro1; it is better suited for bridge cameras such as the X-S1 because of its size. Aside from its powerful performance (its output ranges from a guide number of 24 to 42 depending on focal length), its construction, which enables you to tilt and swivel the lamp, is a real advantage.

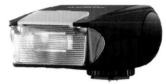

Image 33: The relatively affordable **EF-20** is a well-liked and valued compromise of performance, size, and design. It is probably Fuji's most popular automatic flash.

The EF-20 is considerably more handy than its bigger brother and its design fits much better with the X-Pro1. The flash lamp can be adjusted up and down but not from side to side. With a guide number of 20, this flash unit is well equipped to handle most everyday situations.

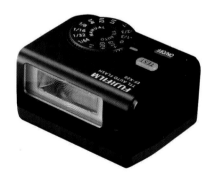

Image 34: The compact **EF-X20** was specifically developed for the X-Pro1 and is an ideal hot-shoe flash that can be mounted and removed in a matter of seconds thanks to its quick clasp. It is unfortunately not cheap, and it can't be pivoted.

The EF-X20 was developed as a retro flash for the X-Pro1, but it works with many other FUJIFILM cameras, including the others in the X series. Its design brings to mind the TLA200 flash for the Contax G2 film camera. The flash's lamp can neither be turned sideways nor

pivoted up and down, which makes this compact shoe-mount flash around half as large as the EF-20 that features a comparable power output. The EF-X20 can also act as a wireless slave flash. When used in this manner, its output setting must be controlled manually—it is triggered optically by the camera's flash. The slave flash also takes into account any preflash intended to reduce red-eye and ignores it.

Image 35:
The **EF-20** and the
**EF-X20** in a direct
comparison of size.

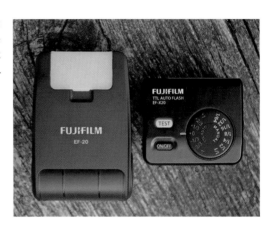

## REMOTE FLASH

All three of the FUJIFILM flash units can be used remotely, but Fuji surprisingly doesn't offer an appropriate cable that would enable the automatic flash exposure metering and control to work when doing so. Canon offers calculated help here in the form of the relatively pricy OC-E3 flash cable, whose contacts are compatible with Fuji's system.

But be careful: this doesn't mean that you can shoot in automatic mode using Canon flash guns with the X-Pro1 or other Fuji cameras. Fuji and Canon use compatible hardware contacts but different software protocols.

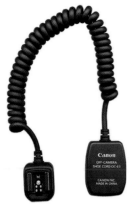

**Image 36:** Canon's **OC-E3** TTL flash extension cord with Fuji-compatible contacts.

If you don't want to spend the money on an original OC-E3 cable from Canon, you can use an inexpensive, compatible knockoff from China, which you should be able to find on the market. Exercise caution, however, and look for decent quality so you don't end up having problems with your contacts due to unregulated manufacturing tolerances.

I recommend using rechargeable Ni-MH batteries from Sanyo Eneloop for your flash units. These are superior to conventional batteries because of their slow self-discharge, among other reasons.

## ADDITIONAL HANDGRIP

The range of bags and cases, lens hoods, protective filters, thumb supports, shutter-release buttons, and various other toys for the X-Pro1 is limitless, but I would like to call your attention to one specific extra accessory: the HG-XPro1 handgrip.

**Image 37:** Many X-Pro1 users prefer to shoot with the **HG-XPro1** handgrip.

Sure, it's not cheap, it makes the camera somewhat larger, and it covers up the battery chamber cover and the memory card port, but this additional handgrip makes the camera noticeably easier to handle for many users. It also shifts the camera's tripod mount to be centered on the X-Pro1's optical axis. Test it out at your retailer of choice!

Image **38**: The X-Pro1 with the additional handgrip, the EF-20 flash unit, and the 18mm f/2.0 lens.

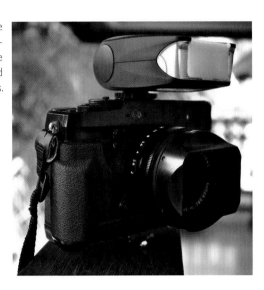

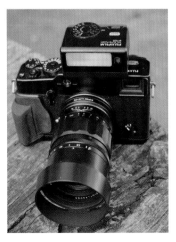

Image **39**: The X-Pro1 with the additional handgrip, the EF-X20 flash unit, and an adapted 75mm f/1.8 Voigtländer Heliar lens.

# 2 SHOOTING WITH THE X-PRO I

## 2.1 HERE WE GO!

Are you ready to get started with your X-Pro1 system? Here are a few tips for an all-purpose configuration and for handling the camera:

- Set the X-Pro1 to auto ISO (SHOOTING MENU 1 > ISO > AUTO [3200]) and auto DR (SHOOTING MENU 1 > DYNAMIC RANGE > AUTO). This setup gives the camera the maximum amount of flexibility and will immediately provide you with a high-quality result. Don't worry about high ISO values! The X-Pro1 produces great images all the way up to ISO 6400. The ISO values that are increased by one or two exposure values when the dynamic range function is activated do not actually mean a true increase in ISO sensitivity (even in the best light, the camera's automatic ISO may opt to shoot with ISO 400 or 800). Countless other cameras use these methods too (such as those from Nikon, Canon, and Sony), but they are not always as honest with their ISO values as the X-Pro1 (section 2.5).

- It's best to use the RAW+JPEG mode (SHOOTING MENU 1 > IMAGE QUALITY > FINE+RAW). This will allow you to delay making decisions about various image settings such as film simulation, sharpness, contrast, color, noise reduction, white balance, etc., and to concentrate on photographing your subject. You can take some time to consider various settings and compare their results either by availing yourself of the

camera's internal RAW converter (PLAYBACK MENU 1
> RAW CONVERSION) or by using a software program
on your computer (see "Internal vs. External RAW Con-
version" in section 2.7).

- The optical viewfinder (OVF) will never delineate the
exact same image frame that the camera will actually
capture. This parallax effect is physically unavoidable
and also influences the accuracy of the autofocus,
especially for objects that are somewhat close to the
camera. You can partly compensate for this fact by
navigating to SHOOTING MENU 3 and then activating
the CORRECTED AF FRAME function (see section 2.2).

- The X-Pro1 features a hybrid viewfinder, which can
show either an optical or an electronic image based on
your preference. This doesn't mean that you need to
select one or the other display option. Quite the oppo-
site, actually: you can use both options in parallel and
use the viewfinder selector on the front of the camera
as often as you like to switch between the OVF and the
electronic viewfinder (EVF). The EVF lends itself to
precise focusing, while the OVF provides a distortion-
free real image of the scene (see section 2.2).

- You'll normally want to use Area AF for your autofocus
mode (SHOOTING MENU 3 > AF MODE > AREA). This
mode gives you the highest degree of flexibility and
focus precision by allowing you to choose the position
and size of the autofocus field freely, especially when
using the EVF (see section 2.4).

- The standard shooting setting for most situations will
be single autofocus (AF-S—position the focus mode
selector on the front of the camera so it is pointing
toward S) and single-frame exposure (DRIVE button >
STILL IMAGE) (see section 2.4).

- The X-Pro1 is a mirrorless system camera—not a reflex camera. Don't expect your X-Pro1 to operate like a DSLR or you'll be setting yourself up for bitter disappointment. Photographers who are upgrading from the X100 will have a good foundational knowledge, but those who are switching from DSLR cameras will need to reorient themselves. But don't worry—this book will help with just that!

- In contrast to DSLR cameras, the X-Pro1 uses contrast detection autofocus (CDAF) as its method of focusing. This method is fundamentally different from phase detection autofocus (PDAF), which is common with reflex cameras. Object edges shouldn't be the target for the X-Pro1's autofocus, you should instead attempt to focus on surfaces (that ideally exhibit stark contrast). In addition, make sure that no objects within the autofocus frame are positioned at different distances from the camera. A good rule of thumb for quick and precise focusing is to make the selected AF frame as small as possible and as large as necessary (see section 2.4).

- The operation of the X-Pro1 features various short-cuts that you can use to make your everyday shooting easier:

  - Holding the Q button for a few seconds brings you directly to the menu for custom shooting profiles (section 2.7).

  - Press and hold the MENU/OK button down to lock or unlock the arrow keys of the selector.

  - A long press of the Fn button will bring up this button's configuration menu, where you can assign one of any number of functions.

- Press the DISP/BACK button for a couple seconds to activate (or deactivate) the camera's silent mode. When this mode is turned on, the X-Pro1 functions quietly and inconspicuously. It won't make any artificial noises and it abstains from using both the flash and the AF-assist lamp. The latter, however, you should definitely otherwise use, because it will noticeably improve the effectiveness of the autofocus in poor lighting conditions (SHOOTING MENU 4 > AF ILLUMINATOR > ON).

- You can switch into and out of the macro mode quickly by pressing the MACRO button twice in short succession (i.e., double-clicking on it) (see "Close-ups" in section 2.4).

- When using the camera's playback mode, you can press the command dial (yes, in addition to turning this dial, you can also press it) to enlarge the current image as much as possible to inspect its sharpness. In contrast, pressing the command dial while in shooting mode and using the manual focus magnifies the image in the electronic viewfinder to help you focus. This function even works when you are currently using the OVF (see "Image Playback" in section 2.2).

- Pressing and holding the viewfinder selector will allow you to switch manually between the two magnification levels of the OVF that are normally automatically determined.

Image 40: In addition to turning the **command dial**, you can also press it.

Image 41: The **viewfinder selector** on the front of the camera.

- Rather than selecting a function in the shooting menu by pressing the OK button, you can press the shutter-release button halfway down (to the first stopping point). Pressing the shutter-release button halfway down while in playback mode switches the camera directly into shooting mode.

- You can wake the camera up from its sleep mode (SETUP MENU 2 > AUTO POWER OFF) by pressing the shutter-release button halfway down as well (see "Batteries and Chargers" in section 1.1).

- Make things as easy as possible for yourself and your X-Pro1: activate the quick start mode (SETUP MENU 2 > QUICK START MODE > ON), avoid using the energy save mode (SETUP MENU 2 > POWER SAVE MODE > OFF), and instead bring along one or more fully charged replacement batteries. Also, use the fastest memory card you can find (see "SD Memory Cards" in section 1.1).

- If you need to be able to take multiple exposures in quick succession, it may make sense to disable the automatic image preview (SETUP MENU 2 > IMAGE DISP. > OFF). This will allow you to keep your sights on your subject without interruption.

- Whenever possible, press the shutter-release button halfway down in anticipation of the decisive moment when you will actually release the shutter and capture your subject. When the shutter-release button is depressed halfway—unless configured otherwise—the

camera takes and saves various measurements related to focus and exposure and determines the desired aperture. Doing so will minimize the delay the camera experiences when you actually snap your shot. This tip also applies to situations in which you manually expose and focus your shot or use an adapted lens. The one exception is the so-called autofocus trick for moving subjects (see "Focusing on Fast-Moving Objects" in section 2.4).

- Clean the image sensor regularly by navigating to SETUP MENU 2 > SENSOR CLEANING and by using a cleaning bellows designed for the purpose (see "Cleaning the Sensor" in section 1.1).

- Before you leave your home with your camera equipment, double-check that your batteries are charged and inserted correctly into your camera and flash units by turning them on briefly. You wouldn't be the first person to leave his or her batteries at home in the charger or to have inserted them incorrectly. (Unfortunately, I'm speaking from personal experience here.)

## RAW OR JPEG?

If you spend any time in the relevant online forums, you'll discover that there's hardly a debate that generates more discussion than the question of whether it's better to shoot in RAW or JPEG format. Since this back-and-forth has been raging for years already, you can assume that there's no single right answer.

For this reason, I don't have any intention of trying to resolve the question, but I would like to address it specifically as it relates to the Fuji X-Pro1 and reassert my earlier recommendation that you keep your cake and eat it too by shooting with both formats: RAW+JPEG (SHOOTING MENU 1 > IMAGE QUALITY > FINE+RAW).

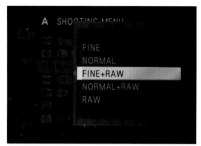

**Image 42: Image Quality:**
You can opt to shoot in JPEG (FINE or NORMAL), RAW, or both formats simultaneously. The X-Pro I offers the best degree of flexibility and quality with the FINE+RAW setting.

Since this ongoing issue is always complicated by misunderstandings, I'd like to clear up a few things at the outset:

In the days of film photography, there was a negative and photo prints were made from that negative. Some photographers developed their own prints, but most amateurs brought their negatives to a photo lab that would produce prints of the desired size (for cost reasons this process was mostly automatic). This unfortunately meant that it was common for different photo labs to produce prints from the same negative that looked different—and the discrepancy between them was often enormous. While most specialist labs would produce good prints, drug store labs would often disappoint with bland, unattractive, or arbitrary color results.

Today the RAW file is the digital equivalent of the negative, and a JPEG file is the digital counterpart of an actual photographic print. This means that there are many different possibilities for interpreting a RAW file and "developing" a JPEG from it. Each and every RAW file can be interpreted in such a way as to produce any number of JPEGs, some with better results than others. Cameras are accordingly evaluated in part based on how well they can convert RAW files to JPEGs—and many photographers who use the X-Pro1 sing the praises of Fuji's legendary colors.

By opting not to save RAW files—the digital negatives—
you're reducing the X-Pro1 to a sort of instant camera:
after pressing the shutter-release button, the camera
displays one JPEG, which you can accept or delete. Take
it or leave it.

Why should you be content with the first result from
your camera's internal processing lab? And why would
you want to wrack your brain trying to figure out how to
program your camera to interpret a specific RAW file in
the best way possible? Wouldn't it be more pleasant to
allow yourself to concentrate on your subject as well as
the focus and exposure settings of your shot? Wouldn't
you rather leave all of the digital post-processing (white
balance, push/pull, film simulation, sharpness, color,
contrast, noise reduction, dynamic range extension, color
space, etc.) for later when you not only have time and
leisure but also can sit in front of a larger PC monitor to
evaluate your images?

Basically the X-Pro1 offers two possibilities for interpret-
ing and developing your saved RAW files into attractive
JPEGs:

- Using the camera's integrated RAW converter (PLAY-
  BACK MENU 1 > RAW CONVERSION). This is more or
  less the uncomplicated, quick, and simple counterpart
  of the conventional and partially automated photo lab.

- Using external software on a personal computer (such
  as Adobe Lightroom 4 or Silkypix). These programs are
  more complicated and better approximate the process
  of developing photos by hand in a specialized lab.

Image 43: The X-Pro I features an **internal RAW converter** that allows you to develop your digital negatives (RAW files) into attractive JPEGs. You can customize various settings, including white balance, color, sharpness, film simulation, noise reduction, and dynamic range even after you have snapped an exposure.

A free but somewhat older version of Silkypix called RAW File Converter EX comes with the X-Pro1 on an included CD-ROM.

Let's continue our comparison of film and digital technology:

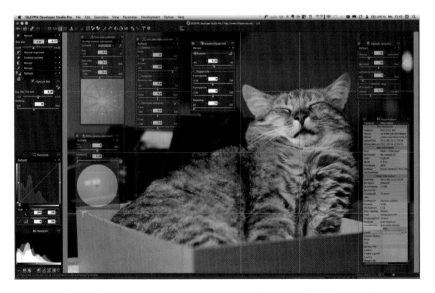

Image 44: **External programs** offer maximum control over the RAW conversion process. These include Adobe Camera RAW (ACR), Adobe Lightroom 4, and the often maligned Silkypix from Japan. The X-Pro I comes with an older version of the latter. The illustration shows a screenshot of Silkypix 4 for Macintosh during the process of developing an exposure shot at ISO 6400.

As is the case with film negatives, RAW files contain much more information than a finished print or JPEG file. A RAW file includes all of the raw data that the sensor absorbs while it exposes an image (which explains the file's name). The X-Pro1 writes RAW files with a color depth of 12 bits per RGB color channel, which amounts to 4,096 various brightness values. JPEGs conversely contain only 8 bits per channel, which amounts to only 256 brightness values. This difference means that you can get a lot more out of a RAW file when working with it on your computer than you can out of a JPEG.

If this is all true, why would you want to shoot in the RAW+JPEG mode instead of only the RAW files? Not saving JPEGs would be saving memory space and would allow the camera to operate all that much faster!

There's a good reason for this: you can only preview exposures on your camera in JPEG format. This means that your camera has to produce a JPEG out of every RAW file it creates (even in the RAW only mode) to provide you with a preview file, so that you have something to examine in playback mode.

The JPEG that the camera produces when you opt to save RAW files exclusively is low resolution—often so low that it is impossible to tell whether the image is in focus when it is enlarged to full size. Shooting instead in FINE+RAW mode obviates this problem, though. With this setting, the camera saves the RAW "negative" in addition to a second file: a high-resolution JPEG "print." You can use this JPEG for precise focus control immediately after you snap it by pressing the command dial, thereby enabling the zoom function. (To enable this, you need to navigate to SHOOTING MENU 1 > IMAGE SIZE and select one of the options with a capital L for large.) Moreover, the high-res JPEG file is a good point of reference for developing the RAW file later with the hope of achieving better results.

You could also opt to shoot in NORMAL+RAW mode instead of FINE+RAW, which doesn't actually affect the resolution of the JPEG. This setting does produce a file with greater compression, however, and the attendant compromises of image quality. Dedicated RAW shooters should also pay attention to this fact, because the camera saves only JPEGs without any RAW files in some modes (such as motion panorama as well as ISO, film simulation, and dynamic range bracketing). In these cases, the X-Pro1 silently switches the image quality setting from NORMAL+RAW to NORMAL, which means the only image it writes to the memory card is a quality-reduced JPEG. And what X-Pro1 user likes to skimp on quality?

When you create a JPEG using the internal RAW converter (PLAYBACK MENU 1 > RAW CONVERSION), the X-Pro1 automatically uses the highest quality setting. In other words, it produces a JPEG with maximum resolution and size regardless of the camera's image size, format, and quality settings when the exposure was actually captured.

You can read more information about internal and external RAW conversion under "Internal vs. External RAW Conversion" in section 2.7.

Even if you intend to shoot only in JPEGs and don't plan to use any external software to develop RAW files, it still makes sense to shoot in the RAW+JPEG mode (with an image quality setting of FINE+RAW). This is because the internal RAW converter of the X-Pro1 offers the opportunity to develop alternate JPEG "prints" of your RAW file even after exposure by adjusting various settings.

Additionally, if shooting exclusively in RAWs to develop them later with external computer software is your aim, then you should still opt for the image quality setting FINE+RAW. The high-res JPEG file that is saved separately will act as a point of reference that you can use to develop your own images from the raw image data. It also allows you much better control over the image focus.

## SETTING THE IMAGE SIZE AND FORMAT

In addition to the image quality, you can also set the image size in the shooting menu. This setting applies to the JPEG file that the camera creates and not to the RAW file, which always comprises the sensor's full resolution.

By navigating to SHOOTING MENU 1 > IMAGE SIZE you can select from three resolutions (Large, Medium, and Small) as well as three image formats (3:2, 16:9, and 1:1). To the right of the various size and format options, you will find a number that indicates the capacity for the remaining exposures you can save to the SD card with each of those size settings. The respective number of pixels given your current settings is displayed below.

Once again for good measure: however you customize your settings here, they will only affect the JPEG files that the camera produces immediately after pressing the shutter-release button. If you were to work with a RAW file later—either by using the internal RAW converter or by using an external program—it would exhibit the

maximum camera resolution as well as the sensor's full aspect ratio of 3:2.

If that's the case, what's the point of setting the image size at all?

There are several reasons: The camera's light metering, for example, is influenced by the current JPEG settings. If you want to shoot images with a ratio of 16:9 or 1:1, the light metering works more effectively when the image format is set accordingly. Parts of the image that are superfluous (because they will be automatically cropped out) won't affect the metering.

Furthermore, it's easier to target your desired image area when the image in the camera's viewfinder matches up with the appropriate frame for your image format.

Finally, the X-Pro1 adjusts the size and shape of the autofocus field according to your selected image format. This means that you can continue to use all of the camera's AF fields even when you are shooting in the unconventional 1:1 format.

**SUMMARY**

The RAW data that the X-Pro1 saves always contains color versions of your exposures with the highest possible resolution at the aspect ratio of 3:2. You can, however, adjust the size and shape of the JPEG files that the camera creates immediately after snapping an image. You can set the quality (compression) of these JPEGs by going to the IMAGE QUALITY submenu and selecting NORMAL or FINE. I recommend using the setting FINE+RAW. You can define the settings for resolution (the number of pixels) in your JPEG files by going to the IMAGE SIZE submenu and selecting a size of L, M, or S as well as an aspect ratio of 3:2, 16:9, or 1:1. I recommend using the L size in all cases. Last but not least, if you convert the RAW data of an already exposed shot using the internal RAW converter, you will always create a JPEG file that is of the best possible quality (FINE), has the highest possible resolution (L), and is in the standard aspect ratio 3:2.

# 2.2 HYBRID VIEWFINDER AND MONITOR

The X-Pro1's novel viewfinder was probably one of the features that led you to choose this camera. The combination of the OVF, the EVF, and the LCD monitor makes the X-Pro1 a truly flexible recording device.

Press the VIEW MODE button to switch between the main LCD display and the hybrid viewfinder. This cycles through the following options:

• Active LCD monitor
• Active hybrid viewfinder
• Active eye sensor, which determines whether the display should be shown on the LCD monitor or in the hybrid viewfinder

The eye sensor is located directly to the right of the viewfinder and switches the display over to the hybrid viewfinder as soon as the photographer's face (or some other object) covers it up.

When the hybrid viewfinder is activated (and you are in shooting mode), you can switch between the optical and the electronic viewfinder displays using the viewfinder selector on the front of the camera. A diopter adjustment with an appropriate lens may be necessary to make this fully functional for your personal vision (see "Diopter" in section 1.1).

Standard display          Customized display          Info display

Image 45: **Different Displays:** You can use the DISP/BACK button to cycle through three views for the LCD display and two for the viewfinder. When using the hybrid viewfinder, you can choose between a standard view and a customized view. The extra view on the LCD monitor is the info view, which contains yet more information about the camera's current operating settings.

All three viewing options (OVF, EVF, and LCD) offer the choice of the standard and customized display. The LCD monitor has the additional option of providing the info display with additional information about the current settings of the camera. Since the info display doesn't include a live image, you will want to use it with the eye sensor activated (VIEW MODE button).

The DISP/BACK button allows you to cycle through the two—or actually three—displays in whichever view is currently active (OVF, EVF, or LCD). To change the display of the OVF, the optical viewfinder needs to be currently active when you press the DISP/BACK button. This makes it possible, for example, to have the customized display in the electronic viewfinder, the standard display in the optical viewfinder, and the info display on the LCD monitor all at the same time.

You can program which information you'd like to appear in the customized view by navigating to SHOOTING MENU 4 > DISPLAY CUST. SETTINGS. You'll need to set this up once for the optical viewfinder (submenu OVF) and once for the electronic viewfinder and LCD monitor (submenu EVF/LCD).

**SUMMARY**

The VIEW MODE button allows you to switch the display between the hybrid viewfinder and the LCD monitor and to activate the eye sensor. The viewfinder selector on the camera's front controls whether the OVF or the EVF is active. And the DISP/BACK button enables you to choose which display you'd like to see in the currently active view mode (OVF, EVF, or LCD). Finally, you can program which details you would like to be shown in the customized display for the OVF independently of the EVF and LCD monitor by opening up SHOOTING MENU 4 > DISPLAY CUST. SETTINGS.

Let's take a closer look at the X-Pro1's individual view modes and displays.

### THE OPTICAL VIEWFINDER (OVF)

The OVF offers an undisguised and distortion-free view of the real world. By activating and programming the customized display, the OVF can also relay countless helpful details about your exposure with the help of digital indicators.

Image 46: A Look through the Optical Viewfinder:
(simulated): (1) exposure compensation/exposure indicator, (2) depth of field bar, (3) shutter speed, (4) shooting mode, (5) image size and quality, (6) capacity of remaining exposures on the memory card, (7) AF/magnified viewfinder frame, (8) image frame, (9) distance scale, (10) ISO setting, (11) aperture.

One highlight of the optical viewfinder is that is has two different magnification levels, which allow it to work with focal lengths between 18mm and 60mm.

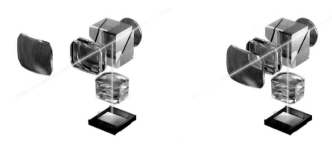

Image 47: The X-Pro1's **optical viewfinder** offers two different magnification levels. Level 1 *(left)* is optimal for wide-angle lenses starting at 18mm. Level 2 *(right)* is designed for normal lenses with a focal length of 35mm and up. When switching from level 1 to level 2, the camera slides a magnification lens into the optical axis of the viewfinder.

When shooting with an X-Mount lens, the camera automatically detects its focal length and sets the OVF to the appropriate magnification level by adding or removing an additional magnification lens to the optical axis of the viewfinder. The two magnification levels are optimized for focal lengths of 18mm and 35mm. If you use a different focal length, the superimposed frame for the image outline updates accordingly.

Image 48: **Conventional Viewfinder** *(top row)* and **Multiview Viewfinder** *(bottom row)*: Without any additional magnification, the X-Pro I's OVF is optimized for a focal length of 18mm *(left)*. If you attach a lens with a focal length of 35mm *(middle)* or 60mm *(right)*, the superimposed right rectangle adjusts to the actual image frame by becoming smaller—at a focal length of 60mm, the display is hardly practicable.

The multiview capability of the viewfinder solves this problem *(bottom row)*. For lenses that have a focal length of at least 35mm, the OVF automatically switches to a higher magnification level, enlarging the entire viewfinder image instead of shrinking the frame. The rectangular indicator for the image frame of a 35mm lens *(middle)* fills up the viewfinder, and the frame for the 60mm lens *(right)* also appears noticeably larger.

You can manually switch between the two magnification levels by holding the viewfinder selector for a couple of seconds while the OVF is activated.

The optical viewfinder offers an instantaneous view of reality and helps you to decide when to pull the trigger in the critical moment. The fact that the viewfinder offers a field of view that is larger than the actual image area is also extremely helpful—the OVF window area is larger than the digital frame. This allows you to discern and react to moving subjects that appear in your viewfinder before they are in the actual image frame. You can also see everything through the optical viewfinder when a strong neutral density filter blocks out substantial light to the lens (e.g., for long exposure shots).

The optical viewfinder also has disadvantages: it doesn't "see" the exact image that the camera does. This is because it lies on a different optical axis from the lens, creating a parallax error that all optical viewfinder cameras exhibit.

Human vision is also based on input from sensors on two different optical axes: our left and right eyes. This trait allows us to illustrate the parallax effect with a small experiment. Hold your pointed index finger at a short distance from your nose. Now view it alternately with your left and then your right eye and you will see how your finger appears to "jump" from one side to the other. Next, move your finger farther away from your face and repeat this test. The difference between the appearance of your finger as seen with your left and right eye should be much smaller now.

The X-Pro1 also experiences this effect since the lens and the optical viewfinder are on different optical axes. This characteristic gives rise to two undesirable phenomena:

- The white image frame that you see in the optical view-finder doesn't correspond exactly to the actual image frame that the camera exposes. In reality, the X-Pro1 exposes a slightly larger area than what appears in the optical viewfinder's digital rectangular frame. The camera errs on the side of caution and frames something like 85 percent of the actual exposure area.

- The measuring field for the autofocus shifts in the same way that the image frame itself shifts as a result of parallax error. This creates the possibility that you target a specific (usually small) object in the OVF, only to have the camera actually focus beyond the object by a hair's breadth.

Just as was the case with our small experiment, both effects are more pronounced when the subject is closer to the camera. The greater the distance between the lens and the object, the less significant the problem becomes and the more you can forget about it.

In contrast to other (often more expensive) viewfinder cameras, Fuji attempted to mitigate the problem of viewfinder parallax for the X-Pro1. After successfully measuring the distance for a shot (by pressing the shutter-release button halfway and allowing the autofocus to settle on a distance), the rectangle indicating the image frame shifts and adjusts in size accordingly.

The camera also attempts to adjust the AF detection areas to balance out any undesirable effects stemming from parallax. To enable this feature, you must open SHOOTING MENU 3 > CORRECTED AF FRAME and select ON.

Two white autofocus fields will now appear in the OVF (only in the AF-S mode): one will be delineated by a solid border and the other, which will be slightly below and to the right of the first one, will be indicated by a dashed line. The solid border indicates the field for objects that are far away and the dashed border marks the field for objects at the minimum distance (about 32 in)—if the subject were any closer, the camera would need to switch into macro mode and switch from the OVF to the EVF.

After you have successfully focused your shot (by pressing the shutter-release button halfway), a third frame with a green border will appear in between the two white AF fields. This is what the camera is actually focusing on due to the parallax effect. If this green rectangle doesn't include the subject you'd like to focus on, adjust your camera so that it does surround your object exactly. Then refocus the camera by letting go of the shutter-release button and pressing it again to the halfway point.

You can, alternatively, use the EVF, which will always show exactly the same image frame that the camera actually "sees."

**IMPORTANT**

Viewfinder parallax means the OVF cannot be used in macro mode. The minimum distance to compensate for the problem of parallax effectively when using the OVF is around one meter from the camera.

When the power save mode is active, the OVF display doesn't include a live histogram. This is one of the reasons why I recommend that you don't use this energy saving mode.

## THE ELECTRONIC VIEWFINDER (EVF)

The EVF displays the exact image that the camera "sees." In other words, it will look similar to the actual result of your exposure. There are no optical shifts and no parallax problems. The EVF and the LCD screen on the camera's back reproduce the image that the camera sensor captures through the lens.

This point is what makes the EVF so valuable. While the scene that you see through the optical viewfinder will always be sharp and well exposed, you will be able to detect any major problems with the exposure or focus in the EVF display before you actually release the shutter. Even the best cameras, including the X-Pro1, have a much smaller dynamic range than human sight.

While our eye can register extreme contrast in a scene (such as dark shadows at the same time as white clouds), the camera will show either blocked-up shadows or blown-out highlights in the EVF, depending on the exposure control settings. This gives you the opportunity to react to the problem and adjust the exposure parameters accordingly (see section 2.3).

The EVF has much more utility than just this, however, since it also displays the camera's current JPEG settings (see section 2.7).

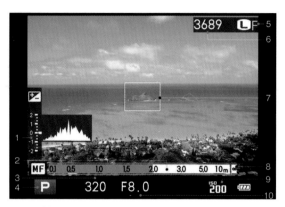

Image 49: A Look through the Electronic Viewfinder: (simulated): (1) exposure compensation/exposure indicator, (2) depth of field bar, (3) shutter speed, (4) shooting mode, (5) image size and quality, (6) capacity of remaining exposures on the memory card, (7) AF/magnified viewfinder frame, (8) distance scale, (9) ISO setting, (10) aperture.

These settings include, among others: the film simulation (Provia, Velvia, Astia, Sepia, etc.), the color saturation, and the contrast settings for highlights and shadows. This means that the EVF allows you to preview the results of the various settings you have programmed on your camera.

The EVF and LCD display are not without shortcomings, however. Aside from the limited resolution, the largest drawback to using these view modes is a certain time lag between reality and what appears on these digital displays. In combination with the slight shutter lag, this delay can mean that the decisive moment in critical situations can pass you by.

**SUMMARY**

Neither the optical nor the electronic viewfinder will serve all of your photographic needs on its own. The particular benefit of having a hybrid viewfinder is the opportunity to combine both view modes and use them both as much as possible. As you use your X-Pro1, avail yourself of the view-finder selector on the front of the camera and frequently switch back and forth between the optical and the electron-ic views. There's no reason why you can't use the EVF to set your focus precisely and then switch to the OVF to make sure you can release the shutter at just the right moment.

## THE LCD MONITOR

The LCD monitor functions just like the EVF and accord-ingly shares its advantages and disadvantages. Bright lighting conditions can limit its utility, but it enables you to move the camera away from your face, which attracts less attention. You can also form unconventional per-spectives (such as above your head or from your hip), but the monitor doesn't fold out and you can't swivel it, so this plus has its limitations. The monitor is especially practical when shooting from a tripod.

The info display, which I've already discussed in this chapter, lends itself nicely to being used in combination with the eye sensor for the view mode. With this setup, the LCD monitor will display the camera's current set-tings, while you can determine the image frame with the hybrid viewfinder. Switching between the two displays will become automatic.

## LCD/EVF BRIGHTNESS

You can adjust the brightness of the LCD monitor and the electronic viewfinder by navigating to SETUP MENU 2 > LCD BRIGHTNESS, but the more convenient method is to use the Quick Menu (Q button). As usual, the setting

will apply to whichever display (EVF or LCD) is currently active based on the VIEW MODE button settings or input from the eye sensor.

The camera automatically adjusts the brightness of the digital indicators in the optical viewfinder based on the ambient light.

### IMAGE PLAYBACK

Press the green playback button on the camera's back to examine your exposures on your camera. When doing this, you again have the option of using the EVF or the LCD display to view them. Use the VIEW MODE button to control where the images are displayed or, if you have the eye sensor activated, the camera will automatically determine which screen to use.

Image 50: The **playback button** is located within reach of your thumb on the back of the camera.

The X-Pro1 remembers your preferred display settings for both the shooting and playback modes. You could, for example, set the camera to use the LCD monitor for taking pictures (shooting mode) and to use the viewfinder for viewing them (playback mode)—or the other way around. With my X-Pro1, I prefer to use the eye sensor while both shooting and reviewing my images. That way the image or information is always right in front of me. I only turn off the eye sensor and use the VIEW MODE button to set the display options

manually in situations where other objects or unfavor-
able light conditions may inadvertently activate the eye
sensor.

> There are two options for switching back to the shooting
> mode while in the playback mode. You can either press the
> playback button again, or you can simply press the shutter-
> release button down halfway.

The X-Pro1 also offers various display options for
the playback mode, which you can select with the
DISP/BACK button. In contrast to shooting mode, the
LCD monitor and EVF will always display the same
information.

In the exposure display (INFORMATION ON), you
will see the picture with various indicators displayed
over it that reveal information about the settings used
when the image was snapped. The full image display
(INFORMATION OFF) shows just the picture without
any information. The favorites display allows you to rate
your images with one to five stars using the up and down
selector keys. You can use these ratings to help you
sort and select your images later. The detailed display
relays extensive information as well as a histogram. It
also indicates overexposed (blown-out) highlights with a
flashing black/white exposure warning.

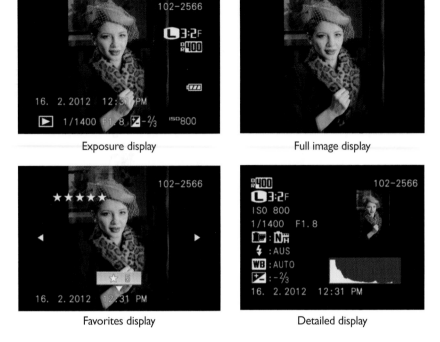

Image 51: **Displays in Playback Mode:** Press the DISP/BACK button to cycle through the four playback displays.

With the exception of the favorites display, you can use the up and down selector keys in the other three displays to reveal yet more information. There are an additional two screens of exposure information as well as a screen featuring the full image with a green cross indicating the autofocus's target. Keep in mind that this cross marks the position of the AF point in the exposure after you focused the image but before you made any final adjustments to the image frame.

You can either use the left and right selector keys to flip through the exposures you've already taken, or you can use the command dial.

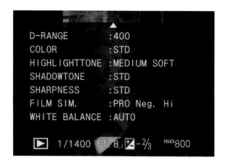

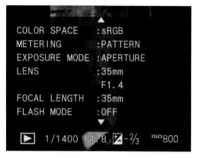

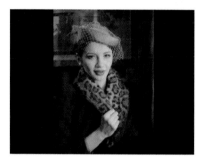

Image 52: While in playback mode, use the selector keys (up and down) to access further information about an exposure. There are two additional screens of information as well as a full reproduction of the image with a green cross to indicate the point of focus. These additional pages are not accessible while in the favorites display.

The magnifying buttons (the second functions of the DRIVE and the AE buttons) zoom in and out gradually on the exposure. When in playback mode, you can press the zoom-in button to enlarge the image.

Alternatively, pressing the command dial will automatically enlarge the image to the maximum magnification level, which is my preferred method. This shortcut zooms in directly on the area that the AF selected as the focus point of the exposure.

The selector keys allow you to examine the different details of your image while the image is enlarged. Pressing the command dial a second time will bring you immediately back to the full frame of the image.

Image 53: There are two ways to **enlarge images while in playback mode**: you can either press the zoom-in button or you can press the command dial. Doing so will allow you to be in a better position to judge the quality of your exposure. Once the image is enlarged, use the selector keys to navigate around the picture. The indicator on the left shows the current level of magnification and the small window over the full image will help you orient yourself as you scan the different image areas.

The zoom-out button (which is the second function of the AE button) will bring up various gallery views in playback mode that can reveal several photos at the same time to give you an overview of which shots you've already captured. The zoom-in and zoom-out buttons allow you to navigate through the different gallery levels, and pressing the command dial will automatically reset the display to the single full-frame perspective.

**Image 54:** Pressing the zoom-out key several times will allow you to view multiple images at the same time in a gallery format. You can actually view up to 100 images simultaneously.

You can navigate through this overview of your exposures by using the left and right selector keys or by turning the command dial. Press the zoom-in button to gradually reset the view to looking at one single image or press the command dial to immediately jump back. The illustration shows two of the four available gallery views.

To delete an exposure, press the delete key (AF button) while in playback mode and confirm the command by pressing the OK button. If you want to delete more than one image at a time, navigate to PLAYBACK MENU 1 > ERASE > SELECTED FRAMES and mark the images you wish to remove with the OK button. After you have finished marking your selection, press the DISP/BACK button and select OK to confirm.

## 2.3 EXPOSURE AND METERING

A well-exposed image ultimately and always depends on the selection of an appropriate combination of aperture and shutter speed.

The lens's internal aperture regulates the amount of incident light: the smaller the aperture (i.e., the higher the f-stop setting), the less light will shine through the lens and onto the sensor. A high f-stop also deepens the camera's depth of field, which is the range of distances from the camera in which objects will appear in focus.

The shutter speed controls how quickly the camera's internal focal plane shutter opens and closes, or, in other words, the length of time after releasing the shutter that the quantity of light determined by the aperture is able to reach the sensor. Shorter durations permit less light to reach the sensor (you can think of each pixel as a mini reservoir for photons), longer durations allow more. Short exposure times (like 1/2000 second) capture the action of a specific moment and freeze it in place, while longer times (e.g., 1 second) often lead to motion blur and other intentional effects.

If the quantity of captured light overwhelms the capacity of the light reservoirs (i.e., the pixels) on the sensor, the final image will feature the phenomenon called blooming, which is an intense overexposure that causes a loss of detail and texture. Conversely, if too little light is captured, the affected dark areas of the image literally disappear beneath the image noise. The captured signal, in other words, is too weak for the sensor to distinguish between the details of the image and the background noise.

For these reasons, correctly exposing photos with digital cameras is of great importance. Photographers must attempt to expose their image so that the important details of their subjects are neither blown out by blooming nor engulfed

by image noise. This is unfortunately easier said than done, because the dynamic range of everyday scenes (the range between their brightest and darkest areas) constantly overpowers the capabilities of digital camera sensors. We will concern ourselves with the question of correct exposure several times in the remainder of this book when considering topics such as ISO settings (section 2.5), extension of the dynamic range (section 2.6), JPEG settings (section 2.7), and RAW conversion (section 2.7).

In this section, I'd like to lay the groundwork for these discussions by going over the X-Pro1's four exposure modes and three methods of metering, as well as an indispensable option for ambitious photographers: the ability to correct the camera-determined exposure manually.

## EXPOSURE CONTROL

The X-Pro1 offers the four typical exposure modes, which you're probably familiar with from working with other cameras:

- **Program automatic, P**: The camera will automatically choose an effective combination for the aperture and shutter speed.

- **Aperture priority with automatic shutter speed, A**: You set the aperture manually, and the camera selects an appropriate shutter speed.

- **Shutter priority with automatic aperture, S**: You set the shutter speed, and the camera determines the aperture.

- **Manual exposure, M**: You determine both the aperture and the shutter speed and are therefore entirely responsible for correctly exposing your shot.

Let's take a closer look at these different settings.

### PROGRAM AUTOMATIC, P

To configure your camera to be in the program automatic exposure mode, adjust both your lens aperture ring and your shutter-speed dial to the **A** position, for automatic. The camera will then automatically select a combination of aperture and shutter speed (i.e., exposure time) based on the lighting conditions of your shot. When your X-Pro1 is configured for this exposure mode, a P will be displayed on the LCD monitor and in the viewfinder, which indicates that the program automatic mode is active.

If you don't like the combination of aperture and shutter speed that the camera automatically selects, you can use the program shift feature by pressing the left and right selector keys on the back of the camera. The left key will make the aperture narrower while increasing the exposure time. The right key will conversely open up the aperture while decreasing the exposure time. When you shift the shutter speed and aperture settings in this way, the camera will display these settings in yellow instead of the usual white, indicating that you're not using the camera's automatically determined selections.

You can only use the program shift feature under specific circumstances:

- The auto ISO must be disabled (section 2.5).

- The auto DR must be disabled (section 2.6).

- No flash unit with active automatic TTL exposure mode may be in use (section 2.9).

If your X-Pro1 fails to react when you press the left or right selector keys while in the program automatic exposure mode, there's a good chance that one of these requirements is not met.

Despite these limitations, the program automatic mode outperforms its reputation. It can detect information about the optical characteristics of the lens that's currently attached, including its set focal length (especially with zoom lenses), and use this information to determine the best combination of aperture and shutter speed for specific lighting conditions.

This mode is ideal for spontaneous snapshots when you don't have enough time to manually select the aperture and/or shutter speed and for occasions when you need to hand your camera to someone who isn't familiar with it (or with photography at all).

**HINT**

When using the program automatic exposure mode, the camera will never choose an exposure window that is longer than ¼ second.

APERTURE PRIORITY WITH AUTOMATIC SHUTTER SPEED, **A**
In aperture priority mode, you set an aperture and the camera selects a shutter speed that complements your selection. To program your camera for this mode, turn the shutter-speed dial on top of the camera to the **A** setting and select your desired aperture by simply adjusting the lens aperture ring.

The camera conveniently offers intermediate steps of 1/3 aperture stops (exposure values). The active display—either the main monitor or the viewfinder—will indicate that you are in this mode with an **A** for aperture priority.

As previously indicated, a large f-stop (i.e., a narrow aperture) will produce a large depth of field (which can be ideal for landscape shots, for example), and a small f-stop (i.e., a large aperture) will produce a shallow depth of field ideal for isolating subjects in front of out-of-focus backgrounds (which can work well for portraiture). The concrete measure of the depth of field for a shot depends on focal length and the distance of the subject from the camera (more on the X-Pro1's autofocus below).

Image 55: Selecting the Aperture Priority Exposure Mode: Set the lens aperture ring to your desired value and adjust the shutter-speed dial to **A** for *automatic*. You can also configure your camera for the other three exposure modes by making similar adjustments.

The aperture not only influences the depth of field; it also affects the imaging performance of the lens. As a rule, the lenses for the X-Pro1 achieve their best performance with apertures between f/5.6 and f/11. A wide-open aperture has a tendency to lead to blurring and shadows around the edges of an image. On the other end of the spectrum, the narrowest apertures can produce diffraction blur. These effects are measurable and can accordingly be assessed with tests; in practice, however, they play a smaller role than many pixel peepers would like to admit. For example, it's not prudent to choose

Image 56: **Aperture and Depth of Field (1):** This image was shot with the 35mm f/1.4 lens at the full aperture (f/1.4) and the corresponding shallow depth of field.

your exposure settings based on your lens's optimal range for diffraction blur if it means you have to forfeit shooting with a depth of field that would improve your image.

**HINT**

In aperture priority mode, the camera won't ever select an exposure time of longer than 30 seconds.

Image 57: **Aperture and Depth of Field (2):** This image was shot with the 18mm f/2.0 lens and a very narrow aperture (f/13), producing a large depth of field and an image that is sharp in the foreground as well as the background. The modest diffraction blur that occurs at high f-stops falls more in the measurable than the visible range.

### SHUTTER PRIORITY WITH AUTOMATIC APERTURE, **S**

The shutter priority setting is analogous to aperture priority: here, you choose the desired shutter speed and the camera automatically selects an appropriate aperture. For this, you'll want to bring the lens aperture ring to the **A** setting for automatic. You'll see an **S** in the viewfinder and on the monitor for shutter priority.

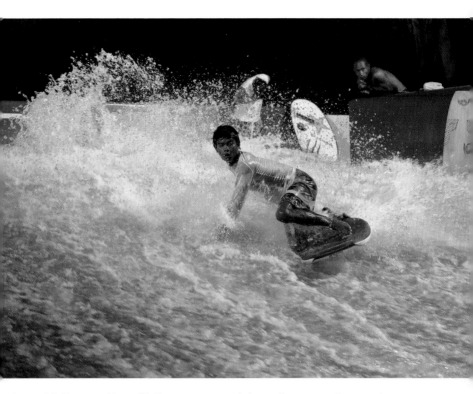

**Image 58: Exposure Time (1):** Short exposure windows allow you to freeze action shots. This image was shot with the 60mm f/2.4 lens at maximum aperture and ISO 2500. The 1/250-second exposure time succeeded in making time (and the surfer and spray) appear to stand still.

In shutter priority mode, you can set the shutter-speed dial to your desired value, choosing exposure times that range from 1/4000 second to 1 second, with each step on the dial two times faster (or slower) than the step before it. You can also opt for intermediate steps by using the left and right selector keys. For example, if you turn the shutter-speed dial to 250 for 1/250 second, you can then use the left and right selector keys to choose the values 1/200 and 1/160 as well as 1/320 and 1/400 second. Whichever value you select will be displayed on the monitor or in your viewfinder.

**Image 59: Exposure Time (2):** Long exposure times allow you to blur movements and smooth out surfaces of water. This image was shot with the 35mm f/1.4 lens. I used a software program called NIK HDR Efex Pro to compose it out of three different brightly exposed images to circumvent the sensor's limited dynamic range. Each individual image was taken with an exposure window of several seconds. Not only is the surface of the water soft and smooth; the fountain is also a haze thanks to the motion blur induced by the slow shutter speed. The aperture setting (f/11) created an appropriate depth of field for the scene. Exposures such as these require the use of a tripod, or at least something stable to rest your camera on, and possibly a neutral density gray filter.

To use exposure times of longer than 1.5 seconds, turn the shutter-speed dial to the **T** setting and use the selector keys to choose an exposure window up to 30 seconds long.

Go to SHOOTING MENU 2 > LONG EXPOSURE NR to turn on a setting that will reduce noise and improve image quality in long-exposure shots. This will double the effective time that the camera needs to work on an image, however.

## MANUAL MODE M

In manual mode, you select both the aperture and the shutter speed. Neither the lens aperture ring nor the shutter-speed dial should be set to **A**, and you will see an **M** for manual mode indicated on the active camera display.

*Important:* You can't rely on the histogram when setting the aperture and shutter speed in manual mode. Instead you need to pay attention the exposure indicator on the left side of the monitor.

Image 60: When shooting in **manual mode**, the live histogram doesn't show the distribution of tonal values for the image that is actually captured. You should thus ignore it and opt instead to heed the digital exposure indicator on the left side of the display to figure out whether your aperture and shutter speed settings will under- or overexpose the image (in relation to the exposure measured by the camera). In this example, the scale for the image on the left shows a slight underexposure (when using an exposure time of 1/25 second), and the scale for the image on the right reveals a slight overexposure (when using an exposure time of 1/20 second). To take a picture in the manual exposure mode that is optimally exposed from the perspective of your camera, you need to adjust the aperture and shutter speed so that the marker in the exposure indicator is located at 0. In the other exposure modes, this scale functions as an indicator for the exposure compensation (see section 2.3 under "Metering").

As with shutter priority mode, you can also work with longer exposure times in the manual mode by setting the shutter-speed dial to **T**. The upper limit here is also 30 seconds.

You can use even longer exposure times when working in the manual exposure mode by setting the shutter-speed dial to **B** (for *bulb*). With this setting, the shutter will stay open for as long as your finger holds the shutter-release button down. Since using your finger is cumbersome and can easily lead to images ruined by camera shake even when using a tripod, it's much better to use a commercially available, lockable cable release that you can screw into the camera's shutter-release button.

The maximum exposure window when using the bulb setting is 60 minutes. Again, going to SHOOTING MENU 2 > LONG EXPOSURE NR and turning this feature on will deliver long-exposure images with less noise and problems (e.g., the elimination of hot pixels). As mentioned previously, however, this feature will double the processing time for each exposure, because after each capture, the camera requires the same amount of time again to run the so-called dark-frame subtraction process.

COLOR CODES AND EXPOSURE CONTROL

Everything is so colorful! The X-Pro1 displays the values for aperture and shutter speed on the monitor or in the viewfinder in white, blue, yellow, or red. What do all these colors mean? Let's quickly go through each exposure control mode:

## Program Automatic, P

Aperture and shutter speed **white** ▶ Camera-determined set-
tings; exposure is okay.

Aperture and shutter speed **yellow** ▶ The user has altered
the camera-determined
settings by using program
shift; exposure is okay.

Aperture and shutter speed **red** ▶ The exposure is either
under- or overexposed;
exposure is *not* okay.

In program automatic mode the values for aperture
and shutter speed will appear in red when an image
is still overexposed despite using an exposure time of
1/4000 second and the narrowest possible aperture, or
when an image is still underexposed despite using an
exposure time of ¼ second and the maximum aperture.
When this situation arises, you'll need to use a different
ISO setting (section 2.5).

## Aperture Priority, A

The X-Pro1 displays your manually selected aperture in **blue**
in this setting.

Shutter speed **white** ▶ Exposure time is less than 1 second;
exposure is okay.

Shutter speed **yellow** ▶ Exposure time is between 1 second
and 30 seconds; exposure is okay.

Shutter speed **red** ▶ The maximum exposure time of 30
seconds is not sufficient; exposure
is not okay (underexposure), or the
minimum exposure time of 1/4000
second is insufficient; exposure is *not*
okay (overexposure).

Red shutter speed values indicate that you should use a different aperture so the camera can select a shutter speed that will lead to a properly exposed image.

### Shutter Priority, S

The X-Pro1 displays your manually selected aperture in `blue` in this setting.

Aperture `white`    ▶ Camera-determined aperture based on the shutter speed; exposure is okay.

Aperture `red`    ▶ The camera can't select an aperture that works with the selected shutter speed; exposure is *not* okay (either under- or overexposure).

### Manual Exposure, M

Aperture & shutter speed `blue`    ▶ User-determined settings; the exposure status is indicated in the exposure scale.

Exposer Time `Yellow`    ▶ Exposure time is between 1 second and 30 seconds; the exposure status is indicated in the exposure scale.

When an exposure time is longer than the inverse of the selected focal length (based on a conversion to the classical 35mm format), the camera provides a shake warning in the viewfinder or on the monitor in the form of a small yellow camera symbol. When using the 60mm f/2.4 lens, for example, this warning will appear when shooting with an exposure time of greater than 1/90 second; when using the 35mm f/1.4 lens, with times longer than 1/50 second. To counteract camera shake you can employ a tripod or stable base, steady yourself

against something, or opt for a shorter exposure time. There's no universal rule because some photographers have hands that are shakier than others. Since the three lenses with fixed focal lengths described in this book don't feature optical image stabilization, though, it's worth taking this warning about camera shake to heart.

## METERING

This much you already know: the X-Pro1 features a manual exposure mode as well as three additional exposure control options that enable it to determine an appropriate aperture and/or shutter speed automatically. But how does the camera "know" which exposure settings will work? And how do photographers know whether the camera is right or whether they need to intervene to correct the exposure settings?

I will forestall any potential illusions you may develop right at the start: The camera doesn't know what the correct exposure for a scene is. The best it can do is to guess, which is why you and your camera have three methods of metering light: multi metering, average metering, and spot metering. Don't expect miracles from these sophisticated (in some ways) methods, though. Have a look at this example to see what I mean.The X-Pro1 portrays uniform black or white subjects as almost equal light gray areas with all three metering methods. Each method, however, shows differences in terms of the brightness of the gray tone that the camera selected: the multi metering *(top row)* exposed the black subject *(left column)* and the white subject *(right column)* more liberally so the images ended up being brighter. Average metering *(middle row)* and spot metering *(bottom row)* both exposed the subjects more conservatively, resulting in noticeably darker images.

But don't take your X-Pro1 back to the store out of frustration. There's nothing amiss here; almost all

**Image 61: Metering Methods and Subjects of Different Brightness:**
One of the columns in this example consists of photographs of a white piece of paper and the other, photographs of a black iPad case. I took all the pictures in the program automatic exposure mode and in the exact same lighting conditions. I also made sure the subject filled up the entire image frame and was intentionally out of focus.

*Row 1* shows both subjects with multi metering, *row 2* with average metering, and *row 3* with spot metering. Can you identify which column depicts the white piece of paper and which column shows the matte black leather case? It's not easy, because the camera depicted both the white and black subjects as gray. It's actually easier to discern the differences between the three metering methods (the rows) than it is to see a difference between the black and white subjects (the columns).

And now for the solution: the *left* column shows the black case; the *right* column, the white piece of paper.

cameras function this way. In practice you will need to correct the X-Pro1's exposure settings now and then—for example, when you'd like to photograph a white field of snow or a pitch black wall. And if you happen to be shooting a black wall in the middle of a white field of snow, then your manual adjustments will be especially critical. Later in the book, you'll learn how to handle situations like these, but first let's discuss how the X-Pro1's three metering methods work.

## MULTI METERING
Multi metering, which is also often called matrix metering, is the X-Pro1's most sophisticated light metering method—and the most popular by far. The camera divides the image into many small fields (a matrix) and analyzes the composition, color, and brightness for each area. This information is then compared with saved templates of common subjects (such as a backlit face or a snow-covered winter landscape) to determine the correct exposure (hopefully). Multi metering usually produces good results and is the best choice when you need to work quickly or don't want to devote a lot of thought to your exposure settings.

## AVERAGE METERING
Average metering is in some ways the brainless opposite of multi metering: it generates a mean exposure value for the entire frame area. This method lends itself particularly well to landscape photography and tends to produce images that are conservatively exposed. Average metering only rarely produces overexposed pictures, so it can be helpful when shooting a sky with bright clouds, for example. On the other hand, you will often need to brighten up dark and middle tones afterward when editing your images. We'll touch on this theme again in the next chapters.

## SPOT METERING

When using spot metering, the camera only factors in information from a small point in the middle of the image, which amounts to approximately two percent of the entire image frame. Due to viewfinder parallax, you should avoid using this method in combination with the optical viewfinder when shooting objects that are relatively close to your camera. Spot metering determines the exposure of the measured area of your image as though it were a gray card with 18 percent reflectance. The camera assigns a medium brightness to the metered area (middle gray) that corresponds to Zone 5 in the Zone System developed by Ansel Adams for balanced exposure.

Experienced photographers enjoy using spot metering, because it allows them full control over the exposure. You can measure the brightest and darkest areas of an image, for example, to determine the range of contrast for a photograph. Or you can meter a gray card set in front of your subject to determine the exposure in the same way that an external handheld incident light sensor would.

In scenes with difficult lighting conditions, such as a backlit portrait, spot metering can help you portray a part of your picture in the best light. If the area of the scene in question is not located at the center of your shot, first meter it with the center of the frame (by pressing the shutter-release button halfway), then turn the camera to your final desired position while you keep the shutter-release button halfway down.

Spot metering can be a powerful tool, but it can also lead you astray quickly. This is a mode best used when you have time to set it up for a specific subject, not when you have a need to point quickly and shoot.

*Which light metering method is best?*

In our example (image 62, which was admittedly and intentionally difficult), none of the methods were particularly convincing. In the end, the metering performance has less to do with the method than the photographer—his or her abilities, habits, and needs.

I personally use multi metering predominantly and switch over to the spot and average methods in specific situations that play to their strengths, such as landscape shots for average metering and difficult light situations that require additional attention for spot metering.

What it comes down to is finding the appropriate correction for the camera's metered exposure. The camera's live histogram is a useful tool here. More on that in a moment, but next I would like to describe briefly how you program the X-Pro1's light metering methods.

## SELECTING A METERING METHOD

Press the AE button on the left side of the camera's back and choose multi, spot, or average metering with the left and right selector keys. Confirm your choice by pressing the OK button, by pressing the shutter-release button halfway, or by pressing the AE button again. You will see a symbol in the viewfinder or on the monitor that indicates the metering method that is currently active.

## EXPOSURE COMPENSATION

You can surmise the importance of exposure compensation just by observing that Fuji endowed the X-Pro1 with a mechanical dial solely for this purpose in immediate range of the right thumb on top of the camera. This exposure compensation dial allows you to adjust the camera's metered and suggested exposure up or down by two exposure values (EV) in increments of 1/3 EV.

◀ Image 62: **Light Metering Methods:**
This example illustrates how the X-Pro1's three different light metering methods work. This high-contrast test scene features a foreground with a dark tree trunk, a much brighter empty field, and a sky with very bright clouds.

When using multi metering *(top)*, the camera analyzed the contents of the image frame and decided on a (somewhat lazy) compromise: the tree trunk still shows some detail, the field is properly exposed, and the sky is overexposed, appearing white and devoid of almost any detail.

Spot metering *(middle)* honed in directly on the dark tree trunk and assigned it a middle gray value. This resulted in a tree trunk that is (artificially) light while the remaining elements in the image are even brighter. This method resulted in several areas for which the sensor couldn't capture any detail at all.

Average metering *(bottom)* assigned greater value to the large bright areas of the image than to the dark tree trunk. The result is a much more conservative exposure and a darker image. Here we see detail in the sky for the first time, but the tree trunk now appears underexposed.

On first glance you might not agree, but the average metering produced the best results in this instance, despite the underexposed areas. While blown-out highlights are impossible to fix, blocked-up shadows can be rescued with image-editing software. More on this in the following pages.

The camera displays the level of compensation on the exposure scale found near the left edge of the viewfinder or monitor display.

Unfortunately, the digital indicator for the compensation correction is not particularly conspicuous (at least as of now), which means that often you will inadvertently forget to change the correction setting from one shot to the next. Make a habit of checking the indicator in the viewfinder or the actual compensation dial before snapping each new exposure—not least because it may happen that the compensation dial was accidentally shifted in your equipment bag or when you were changing out a lens.

## EXPOSING CORRECTLY WITH THE LIVE HISTOGRAM AND EXPOSURE COMPENSATION

As we've already seen, the "correct" exposure isn't always the best one—as is the case when photographing a white wall. In reality, we often have to improve on the camera's best effort. To some degree this is a question of experience: veteran photographers instinctively know how the camera will behave in certain circumstances and make appropriate adjustments accordingly. Others play it safe and make use of the automatic exposure bracketing (DRIVE button > AE BKT). The most common tool for mirrorless system cameras such as the X-Pro1, however, is the live histogram, which delivers useful guidance in every exposure mode except manual.

The live histogram is available to you in the custom viewfinder or monitor display. If needed, press the DISP/BACK button to navigate to this viewfinder display from your current one. Make sure that you have the histogram activated by going to SHOOTING MENU 4 > DISP CUSTOM SETTINGS and that the X-Pro1's energy save mode (SETUP MENU 2) is turned off.

The live histogram reveals the approximate distribution and frequency of tone values in an image before the sensor captures it. The left side of the histogram shows the black and dark tonal values and the right side, the white and bright ones. The spaces in between correspond to the various intermediate values. The higher the levels for each area of the graph (i.e., the taller the "mountain"), the more frequent those particular brightness values are within the image frame.

Remember that the live histogram doesn't work properly in the manual exposure mode (**M**). In this mode, you'll need to rely on the exposure scale and your own

experience. The histogram also does not produce reli-
able results with very dark subjects in the three other
exposure modes (**P**, **A** and **S**).

**Image 63**: By using the **live histogram** you can identify over- and underexposed areas of
an image—and make the corresponding compensation adjustments—before you press
the shutter-release button.

The example on the *left* shows a well-balanced exposure: the tonal values are
evenly distributed and they don't extend beyond the left (dark) or the right (bright)
sides of the diagram.

The example in the *middle* is another story: here the mountains pile up on the
right side of the histogram. This is a clear indication of overexposure, as is the clear gap
on the left side of the graph (where the shadows are indicated). In cases like this, it's
necessary to reach for the exposure compensation dial to move those mountains from
the right.

The example on the *right* corresponds to a conservatively exposed image. In this
case, you need to ask yourself whether this effect is intentional (as it might be, for
example, if you're shooting a dark subject that shouldn't look artificially bright).

If it's not, then you can correct the exposure using the steps described above to
balance out the distribution of tonal values. In particular, photographers who work
with external RAW development software can counteract these exposure conditions
with the compensation dial. This practice is also sometimes called ETTR (expose to the
right)—which I'll cover on page 212.

The live histogram reveals the brightness distribution for
your subject. You can investigate this distribution closer
by taking a test shot and having a look at the result in
the detailed display of the playback mode (press the
DISP/BACK button). Let's look at this detail for the three
images I shot using the different metering methods,
with a particular eye toward the respective playback
histograms.

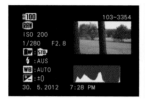  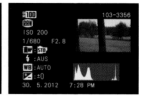

Image 64: **Comparing the Histograms of the Three Metering Modes:**
In the *left* example, which was the multi metering method, the camera attempted a balancing act. About two-thirds of the histogram represents the landscape, then there is a gap, and on the right edge you can see the values for the sky pile up, signaling overexposure. Though you can't see it in this still shot, the camera also indicates this overexposure with a flashing warning on the areas of sky depicted on the monitor.

The example in the *middle* demonstrates the result from spot metering. The obviously overexposed sky is now indicated on the histogram with an even thinner white stripe at its right border. On the camera monitor, the camera offers an exposure alert with a blinking warning over the entire area of sky. The dark tree trunk, which the camera used for metering the shot, is represented by the hill in the middle of the histogram (and is depicted with a brightness equivalent to middle gray).

On the *right* is the image created with average metering. Here you can see the values for the sky in the histogram, indicating that these areas aren't overexposed. Accordingly there is no blinking warning on the camera monitor. You can tell, however, that the remaining areas of the image—the trees and the field—are somewhat crunched on the left side while there is a large empty space on the right side of the graph. You can also see a bit of room to the right of the values for the sky, which means a brightness compensation of +1/3 EV can optimize this image and shift the sky values just over to the edge of the histogram's range.

How can we create a correctly exposed and attractive photo out of this high-contrast example? It's easy: with a combination of the best possible exposure and the appropriate processing of the captured RAW file.

We can optimize the exposure by using average metering and setting the compensation dial to +1/3 EV. Doing so shifts the brightness values for the sky, which are critical to the image, to the right edge of the histogram, meaning it's still within the sensor's functional range. The other tonal values that are located on the left side of the histogram will get a bit more air and be exposed brighter.

Since we're shooting in the FINE+RAW setting, we have
the additional choice of processing the image with the
internal RAW converter or using an external one.

If opting for the internal RAW converter (PLAYBACK
MENU 1 > RAW CONVERSION) use the following
settings to adjust the standard JPEG parameters to
develop the image: film simulation Astia, highlight tone
medium soft, shadow tone soft. These settings reduce
the contrast and boost the dark areas particularly well.
More information about JPEG settings can be found in
section 2.7.

Image 65: We can bring the contrast of our test image under control by using the
**average metering method**, adjusting the default JPEG parameters (film simulation
Astia, highlight tone medium soft, and shadow tone soft), and applying an exposure
compensation of +1/3 EV. The dark and bright areas of the image have kept their
detail and the gap that existed between the main subject and the sky in the histogram
is much smaller now. Next to the screen shot of the camera's playback display, I've
included an illustration of the RGB histogram produced by the image-editing software
Apple Aperture 3, which shows more detailed information of the JPEG file that I trans-
ferred to my computer. You can further optimize the image with this editing software,
or—as I discuss in section 2.6—by extending the dynamic range of the exposure.

Using an external RAW converter, you can manipulate the tonal values stored in an exposure almost at will. The following example was created using Adobe Lightroom 4, a program that's very popular with photographers and, as of May 2012, supports the RAW format from FUJIFILM's X-Pro1.

ISO 200    f/2.8    1/500    35mm

Image 66: You can use **Adobe Lightroom 4** (or any other RAW converter that's compatible with the X-Pro1) to manage difficult lighting situations. In this case I was even able to fill in all the gaps in the histogram and create a seamless gradation of tonal values between the main subject and the sky. It's worth mentioning that this is only possible when the necessary image information is present in the RAW file—especially in the highlights. If the image data for the highlights are lost (as a result of overexposure), the best RAW converter in the world won't be able to bring them back.

### AUTOMATIC EXPOSURE BRACKETING

When you're not certain about how to expose an image or how much to compensate the exposure for a specific situation, you can use the automatic exposure bracketing feature. The X-Pro1 will then take three exposures with different exposure settings in short succession. You can decide which image turned out the best later when you examine the results in the playback mode (detailed display) or on your computer.

Press the DRIVE button and select AE BKT to use this feature. Here you will need to select one of three

available options: ±1, ±2/3, or ±1/3. Confirm your selection by pressing the OK button, tapping the DRIVE button again, or pressing the shutter-release button halfway. Now your camera will take not just one image, but three: one with normal exposure (based on your current settings) as well as one corrected up and another corrected down by 1/3, 2/3, or 1 EV.

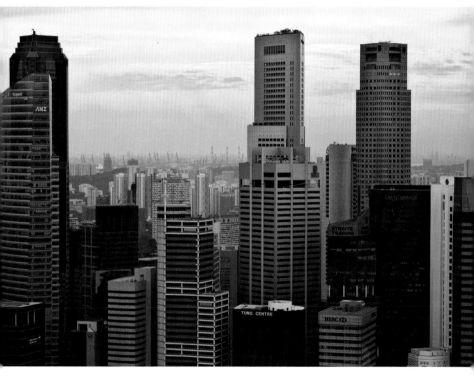

Image 67: Playing It Safe with Automatic Exposure Bracketing:
Determining the optimal exposure for a subject right off the bat is easier said than done. Using the automatic exposure bracketing feature, you can snap three images in rapid succession that each exhibit different exposure characteristics. Then you can examine the results and decide which is the best exposed. This function lends itself best to static subjects that won't run away from you or situations that don't require you to release the shutter at a precise moment. I shot this high-contrast image with a preproduction camera and preproduction 60mm f/2.4 lens at ISO 200 and ended up selecting the version that was compensated −1/3 EV as the best.

As of August 2012 this feature unfortunately has a disadvantage. After pressing the shutter-release button, the X-Pro1 locks up until all three exposures of the bracketing are completely saved to the SD memory card. If you are using the image quality settings I recommend— FINE+RAW—this process can take several seconds. This is another reason I recommend using the fastest memory card on the market. It is hoped that Fuji will fix this shortcoming with a future firmware update.

## HDR EXPOSURES

High dynamic range (HDR) pictures are a common use for images resulting from automatic exposure bracketing. HDR images are made up of several individual shots that were each exposed differently and composited to create a final picture with a large dynamic range. Photographers usually achieve this by using HDR software such as Photomatix Pro from HDRsoft or HDR Efex Pro from the plug-in provider NIK Software.

**Image 68: HDR Version of Our Test Subject:**
I used the software program HDR Efex Pro to compose this photo out of three JPEGs
that were captured using the auto exposure bracketing feature set at ±1 and multi
metering. HDR exposures often have a surreal and unnatural quality. There is also
a trend, however, to use HDR to create not only striking effects, but also to create
natural-looking exposures with an extended dynamic range. Many cameras even offer
built-in HDR functions.

The automatic exposure bracketing feature of the X-Pro1
is not ideal for HDR images, because it only produces
three individual shots with a maximum exposure variance
of ±1 EV. This wouldn't suffice for many serious HDR
applications because many subjects exhibit a wider con-
trast or a larger dynamic range than you can capture with
just three images. Those who excel at HDR photography
often use up to seven exposures exhibiting an additional
exposure variance of ±3 EV in 1 EV increments.

You can produce this kind of range on the X-Pro1 by using the automatic exposure bracketing feature in combination with the exposure compensation dial. You'll need to use a tripod or at least a very stable base for your camera and you shouldn't adjust your image frame throughout the entire process.

For example, complete the following steps to create a series of seven shots with exposures of −3, −2, −1, 0, +1, +2 and +3 EV in relation to the camera's automatic metering:

1.  Press the DRIVE button and select AE BKT with the option ±1.

2.  Take the first three exposures of your subject.

3.  Now set the exposure compensation dial to +2 EV.

4.  Take the next three exposures of your subject.

5.  Now set the exposure compensation dial to −2 EV.

6.  Take the last three exposures of your subject.

You now have nine exposures stored away at seven different levels of exposure. The images that were corrected by −1 EV and +1 EV were snapped twice, so you can select whichever version turned out better. When you're not sure, opt for the exposures from the initial three-shot burst since they were snapped in shorter succession and have less potential to result in ghosting. Ghosting is the result of objects or people that have moved between the individual exposures. When the individual images are composited, anything that has moved will appear as transparent "ghosts" in multiple locations.

Though more and more cameras—and even some mobile devices—feature built-in, user-friendly HDR functionality, FUJIFILM in general and the X-Pro1 in particular still require true craftsmanship as far as HDR goes.

**HINT**

When combining multiple automatic exposure brackets, your camera may automatically adjust the white balance for each series of shots. If you plan to use an external RAW converter to develop your pictures later, this isn't a problem, because you can bring the white balance settings into line later. But if you plan to transfer the finished JPEGs from the camera directly to an HDR imaging program, it's wise to lock the white balance before getting started. You can learn more about the topic of white balance in section 2.7.

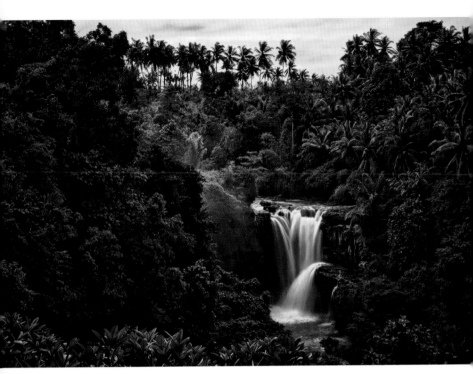

**Image 69: Automatic Exposure Bracketing Combined with the Compensation Dial:**
For this rain forest idyll, I mounted the X-Pro1 to a small table tripod. In order to slow down the shutter speed, I attached an ND1.8 neutral density filter to the 35mm f/1.4 lens, which effectively allowed me to slow the shutter by a factor of 64 by blocking six stops. I snapped seven exposures with a preset aperture of f/8 (in aperture priority mode and with multi metering), exhibiting exposure compensation levels of −3, −2, −1, 0, +1, +2 and +3 EV. Then I transferred these JPEGs to my computer and used HDR Efex Pro to assemble an HDR image with a significantly increased dynamic range and added some final touches with Apple Aperture 3.

# 2.4 FOCUSING WITH THE X-PRO 1

Like most compact and system cameras, the X-Pro1 relies on contrast detection autofocus (CDAF) technology. This focusing method has several advantages over the phase detection autofocus (PDAF) method used by single-lens reflex cameras:

- CDAF systems are very accurate and require no adjustment. There are no front- or back-focus issues (in contrast to DSLR cameras).

- In principle, with CDAF the entire area of the image sensor is available for AF metering, even around the edges.

- AF frames can be defined in almost any number, shape, size, and position. This allows you to focus directly on your desired target without needing to retarget the camera.

The CDAF also has significant drawbacks in comparison to the PDAF technology:

- CDAF systems like the one in the X-Pro1 work more slowly than PDAF systems. They're also not able to track objects that move toward the camera or away from it. In other words, the camera can't predict where a fast-moving object will be at the moment of exposure.

- CDAF systems focus best on high-contrast surfaces while the PDAF systems focus best on edges. Photographers who are used to shooting with DSLRs will need to reorient themselves and shouldn't expect the X-Pro1's autofocus to behave similarly to the AF system in a single-lens reflex camera.

The X-Pro1 offers two autofocus modes: AF Single (AF-S) and AF Continuous (AF-C). These two modes are only modestly different because the camera's AF system is not capable of tracking objects in anticipation of where they are going to be.

The most commonly used mode is AF-S because it offers the most flexibility. There is also the option to focus manually (MF). You can tell the camera which mode to use by adjusting the focus mode selector on the camera's face to the desired setting: S, C, or M.

## FUNCTIONALITY

It's helpful to understand how the X-Pro1's CDAF works so you can use it effectively. The principle is actually straightforward and hinges on one idea: from the camera's perspective, an object is optimally in focus when its contrast is greatest.

Imagine you're standing in front of a wall that's been painted with the black-and-white pattern of a chess board. If the wall is not in focus, you won't see clearly defined squares of black and white; you'll see blurry gray areas—some lighter and some darker. The more clearly you focus on the wall, the sharper the edges of the squares will become; the contrast will increase. At the point of optimal focus, the edges will finally be sharp as a knife and exhibit maximum contrast.

The X-Pro1's autofocus works very similarly: it focuses until the object in the current AF frame exhibits the greatest degree of contrast. The camera doesn't know which direction to focus, so it just guesses. If the contrast increases, the focusing mechanism continues in that direction. If the contrast decreases, it tries the other direction and continues until it has passed its goal and the contrast begins to diminish again. Then it changes its direction again, iteratively going back and forth until it settles on the optimal (i.e., highest-contrast) position.

This process takes time (and energy), which is why the CDAF method is somewhat slower than the efficient PDAF method used in single-lens reflex cameras. It is, however, very precise.

## TEN PRACTICAL AUTOFOCUS TIPS

Here are a few basic tips based on the functionality of the CDAF and the construction of the camera:

- The contrast-detection technology works best and quickest when the AF frame is targeted on a high-contrast subject. Whenever possible, avoid focusing on low-contrast, monotone subjects in low-light circumstances and opt instead to target high-contrast objects.

- Don't focus on the edges of objects. Instead try to fill up the AF frame completely with your targeted object.

- When shooting a low-contrast subject in dim lighting, use the X-Pro1's built-in AF-assist lamp. Turn this on by navigating to SHOOTING MENU 4 > AF ILLUMINATOR. With this option activated, the camera will automatically shine this assist light in poor lighting conditions, which will lead to noticeably better AF performance for subjects that aren't too far away from the camera. Do note, however, that this lamp won't turn on when silent mode is activated. To turn silent mode on and off, hold down the DISP/BACK button for a few seconds.

- As an alternative to the AF-assist lamp, you can use a flashlight or any other light source to briefly illuminate your subject while focusing and then save the focus setting by pressing the AE-L/AF-L button.

• Make sure that there aren't any objects in the AF frame that are positioned at different distances from the camera. Otherwise, there is a risk that the X-Pro1 will settle on the wrong object or even fail to find a satisfactory point of focus (after searching for a while). In the latter case, the AF frame border will turn red instead of its usual green to indicate an AF warning.

• When in the AF-S mode, you have the further choice of two submodes: Multi and Area, which you can select by going to SHOOTING MENU 3 > AF MODE. As a general rule, you'll probably want to use Area AF since this is the only mode that allows you to define the size and location of the AF frame manually. You can also quickly switch back and forth between the Multi and Area AF submodes in the Quick Menu (Q button) or define the Fn button accordingly. To reset the purpose of the Fn button, hold it down for a few seconds.

• A general rule when using the AF-S mode: make the AF frame as small as possible and as large as necessary. The X-Pro1 allows you to use five different-sized AF frames when shooting in Area AF and when using the EVF or the LCD monitor. To change the size of the AF frame, press the AF button when in shooting mode and turn the command dial. To revert the AF frame back to its standard size, press the command dial. After you've determined which size you would like to use, confirm your choice by pressing the AF button again or pressing the shutter-release button halfway. To repeat: circumstances permitting, use the smallest possible AF frame; only choose a larger one when the targeted area is too low-contrast for a smaller one.

- Another tip for working with the single autofocus (AF-S): When shooting with the Area submode, take advantage of the opportunity to define the location of the AF frame manually. Press the AF button and then use the four selector keys to pick one of the EVF or LCD monitor's 49 available AF frames. Make your selection based on where the target area of focus will be in your image. This will save you from needing to retarget the camera after focusing and prevent the uncertainties attendant with this method. Post-focus pivoting is popular with DSLR photographers but can lead to focus errors because of the resulting shift in the focus plane, especially with subjects that are relatively near the camera, short focal lengths, and an open aperture. To jump directly back to the central AF frame, you can simply press the OK button instead of using the selector keys.

- When it comes to focusing on small or critical objects, keep in mind that you should work either with the EVF or the LCD monitor. The OVF, as already discussed, is affected by parallax and subsequently has only 25 AF frames available, and their size can't be changed. My earlier advice to turn on the corrected AF frame by going to SHOOTING MENU 3 > CORRECTED AF FRAME is helpful here; it should always be activated, but you'll only be able to focus with true accuracy by using the EVF or the LCD monitor. Make use of the viewfinder selector to switch between the OVF and the EVF when focusing. It's often safer to focus precisely on a specific detail with the EVF, then lock the focus setting with the help of the AE-L/AF-L button, and finally switch to the optical viewfinder to snap the image.

- The most precise method of focusing is the MF mode. Even here, you can press the AF button to define a desired part of the frame for the focus and then use the AE-L/AF-L button to bring that area into focus automatically. The camera will indicate successful focusing with a beep. Then activate the magnified viewfinder by pressing the command dial, and use the focus ring on the lens to fine-tune the focus manually.

Now let's take a closer look at the individual focus modes.

### SINGLE AUTOFOCUS (AF-S)

The single autofocus (AF-S) is the most commonly used method for focusing automatically with the X-Pro1. To program the camera to operate in this mode, move the focus mode selector on the front of the camera to S.

The single autofocus has two submodes: Multi and Area AF. You can switch between these two options by opening up SHOOTING MENU 3 > AF MODE. Alternatively, you can use the Quick Menu (Q button) or assign the AF submode selection to the Fn button by holding it down for a few seconds.

The AF-S mode with the Multi option activated is more or less a fully automatic method for focusing. The camera determines by itself which of the 49 AF frames should be used. As soon as you press the shutter-release button halfway, the camera analyzes the current contents of the image frame and chooses a particularly high-contrast area that it in turn attempts to bring into focus. If the camera executes this process successfully, a green AF frame will appear and a short beep will sound. If it is unsuccessful, the AF frame will display red and you will see "AF!" in the viewfinder as a warning. The focus setting will remain stored (along with the exposure settings) as long as you keep the shutter-release button partly depressed.

One advantage of the Multi method is that it is relatively quick and reliable even in bad light and with low-contrast subjects. Another is that it is completely automatic; you don't need to think about it at all and you can literally shoot from the hip.

The decisive disadvantage of using the Multi sub-mode is the fact that you don't know if the object that the camera focuses on is actually the part of your picture that you'd like to have in focus. This is especially a problem for subjects with different levels (foreground, middle-ground, and background). This focus setting lends itself to shots where the elements in the image are all more or less the same distance from the camera, such as a group of people in front of a wall or a landscape panorama. It also can be useful in situations that don't allow you enough time to define the frame for the autofocus manually before you need to press the shutter the rest of the way down to capture the scene.

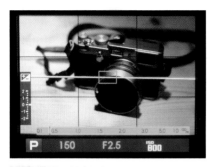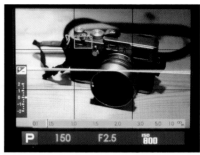

Image 70: Single Autofocus (AF-S) and Multi:
When programmed in this way, the X-Pro1 will automatically decide on an AF frame. The disadvantage: you don't decide what part of your image should be in focus—the camera does. In this example the X-Pro1 could decide to focus either on the lens or on the body of this X100.

The second submode of the AF-S, Area AF, requires that you (not the camera) select one of the 49 AF frames (in the OVF only 25 are available). When you subsequently press the shutter-release button halfway, the autofocus will bring the area you have identified into focus. Everything else functions exactly as it did in the Multi submode (green or red AF frame, confirmation beep, AF warning, focus lock, etc.).

Press the AF button to define your desired AF frame in the AF-S Area submode, and then use the left, right, up, and down selector keys to choose from the 49 (or 25 in the OVF) AF frames. If you are shooting with the LCD monitor or EVF, you can also adjust the size of the AF frame by turning the command dial. There are a total of five different sizes available. Pressing the command dial resets the AF frame back to its original size, and pressing the OK button returns the frame back to the center.

To confirm your settings for the location and size of the AF frame, press the AF button again or press the shutter-release button halfway (a quick tap will do). A white border will now indicate the AF frame in your desired location and at your desired size when you look through the viewfinder or at the LCD monitor.

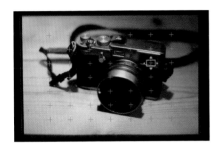 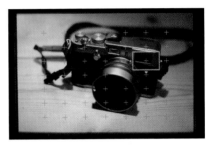

Image 71: Single Autofocus (AF-S) and Area:
With this setting you must program the size and position of the AF field yourself. Press the AF button and then use the selector keys to adjust the location of the AF frame and the command dial to adjust its size.

My recommendation, again, is to make the AF frame as small as possible and as large as necessary. The reason for this is fairly obvious: the smaller the AF frame, the more precise the AF system can be in targeting the object within the frame. Don't aim at edges—try instead to direct the autofocus to an object that fills the entire area of the AF frame. If there is more than one high-contrast object in the selected AF frame, the camera won't know which it should bring into focus.

This method will only work when the surface pattern of the object framed by the smallest-possible AF field

size provides enough contrast and detail for the X-Pro1 to run its focusing system successfully. If this isn't the case, it's advisable to increase the size of the AF field and give the camera more to work with. The X-Pro1 allows you to pick from five different sizes for the AF frame for good reason. Make use of them!

Image 72: When **shooting at close range** with a minimum depth of field, it's especially important to use the smallest AF frame possible and to direct the autofocus to the exact area of the image that you would like to have in focus. Doing so will mean you can avoid needing to pivot your camera after focusing, which will increase your chances of attaining a razor-sharp result. I shot this example image with the XF60mmF2.4 R Macro lens and an aperture of f/4 while holding the camera. I then developed the RAW data using Adobe Lightroom 4 and Apple Aperture 3.

Use the EVF or the LCD monitor when precise focusing is paramount. Because of the unavoidable parallax effect, the optical viewfinder is too inaccurate for critical work For less critical subjects (e.g., large, distant objects or landscapes), the 25 autofocus frames in the OVF are perfectly sufficient.

In any case, you should turn on the corrected autofocus frame for the OVF by going to SHOOTING MENU 3 > CORRECTED AF FRAME and selecting ON. With this option activated, the camera will display two borders for every AF measuring frame—one solid and one made of dashes. The solid border indicates the position of the AF frame for objects that are far away (at infinity); the dashed border that is somewhat below and to the right corresponds to the focus region for objects nearby (about 32 inches). After you successfully focus on an object by pressing the shutter-release button halfway, a third, green AF measuring frame that is adjusted for parallax will appear between the other two—this green border indicates the actual position of the AF frame based on the detected distance of the target. If the green frame surrounds the area or object that you want to be in focus, then you're all set. If it doesn't, then abort the shot and try again with an adjusted image frame.

    The distance indicator in the viewfinder display can be another clue as to whether the camera focused correctly. For example, if you've targeted an object that is less than two yards away, but the camera's distance scale indicates five yards, then something has obviously gone awry.

**TIP**

When the X-Pro I starts to focus on an object in AF-S mode, it always makes its first attempt at the last used or found distance setting. For instance, if the last object you focused on was two yards away, then the camera starts its next focusing effort with that exact distance setting. You can thus improve the performance and speed of your autofocus by presetting the AF before an all-important moment.

To do this, locate a subject that is about at the same distance as your eventual target and start the focusing mechanism by pressing the shutter-release button halfway. When your actual subject appears in the scene (e.g., a playing child), the autofocus will have less work to do and will therefore be able to find its target faster and more reliably.

### CONTINUOUS AUTOFOCUS (AF-C)

With continuous autofocus (AF-C), the camera constantly works to focus on the central area of the image frame marked with a crosshair—even when you don't have the shutter-release button halfway depressed. All you need to do is point your camera at any target.

This function is often misunderstood. Photographers switching from DSLRs often confuse it with predictive object tracking, which the X-Pro1's contrast detection autofocus is not capable of performing. AF-C actually performs more like the method that I described in the previous tip: it attempts to focus constantly on the approximate distance of whatever object is targeted in the crosshair. This method enables the X-Pro1 to focus quickly and reliably when things finally "get serious" because the autofocus usually only has to make a small adjustment to get from the preset focus to the actual current one.

As you see, the continuous autofocus only provides an advantage if you can't or don't want to follow the advice in the aforementioned tip. Moreover, this mode has some real disadvantages: it requires lots of energy (the AF is constantly in action, after all), and only the one central AF field is available for use—the size and position of which can't be adjusted. Furthermore, you can only speculate about the actual size of the AF frame in this mode based on the ambiguous crosshair, and when using the AF-C in combination with the OVF, you won't have access to a parallax-corrected AF frame.

Admittedly, some photographers believe that the AF-C can work faster and more reliably than the AF-S in certain critical situations (poor lighting, low-contrast subjects, shots in close proximity). For subjects that prove challenging for the AF-S, it certainly can't hurt to switch over to the continuous autofocus and test it out.

### THE AE-L/AF-L BUTTON

When you press the shutter-release button of the X-Pro1 halfway, the camera meters the light and activates the autofocus based on the subject currently in the image frame. Both values—exposure and the distance determined by the autofocus—stay saved as long as you continue to keep the shutter-release pressed halfway down.

In practice, though, many photographers prefer to execute and save each of the two values independently. The X-Pro1 (like many other cameras) offers the AE-L/AF-L button for just this reason: with its help, you can determine and save the exposure and/or focus settings without needing to hold your finger on the shutter-release button.

AF-L stands for autofocus lock, AE-L for auto exposure lock. By using this button, you can easily apply focus and/or exposure settings to more than one shot.

You can program the exact functionality of the AE-L/AF-L button yourself in the shooting menu. Go to SHOOTING MENU 4 > AE/AF-LOCK BUTTON to program the button to meter and save only the exposure, AE LOCK ONLY; to apply only to the focus setting, AF LOCK ONLY; or to save both values, AE/AF LOCK.

In the SHOOTING MENU 4 > AE/AF LOCK MODE submenu, you can decide how you want the X-Pro1 to save these values. One option is to have the camera save them only for as long as the AE-L/AF-L button is pressed (AE&AF ON WHEN PRESSING); the other option is to have the button function as a switch (AE&AF ON/OFF SWITCH). If you select the latter option, the camera will save the exposure and/or autofocus settings when you first press the button and they will stay saved until you press the button another time.

It's your choice how to program this button to suit your habits, preferences, and assignments—that's the reason these options exist. In practice and often when I'm shooting, the following option presents itself as a logical setting: AF LOCK ONLY and AE&AF ON/OFF SWITCH.

The reason? It's often desirable to separate the focus setting from the automatic exposure. While the circumstances affecting exposure constantly change (your image frame shifts a tiny bit or a cloud wanders in front of the sun), you often would like to use an optimal focus setting for several exposures of the same subject without needing to start the focus mechanism from scratch for each image in a series. A green AF frame will appear in the viewfinder or on the LCD monitor if the autofocus is currently locked.

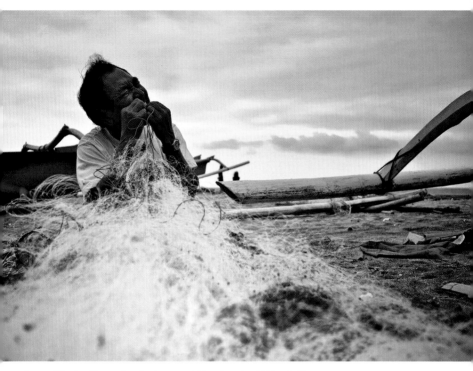

**Image 73: An Example of a Practical Use for the AF-Lock Function:**
The charm of this image depends in part on snapping the exposure at just the right moment. To achieve this with the X-Pro1's relatively sluggish CDAF system it is often best to establish and save the autofocus setting for the subject in advance of the actual exposure(s). In this instance, I programmed my camera for AF LOCK ONLY and AE&AF ON/OFF SWITCH following the logic I just described. Next I set an appropriate size and location for the AF frame and pressed the shutter-release button halfway to focus on the fisherman's head. When the camera had brought the frame into focus, I pressed the AE-L/AF-L button to lock the focus setting. Now I was free to shoot an entire series of exposures that show the fisherman in various moments. Keeping the shutter-release button halfway depressed now was only for the purpose of saving the exposure settings—the focus settings remained constant. If the fisherman had changed his position, I would have expunged the saved focus settings by pressing the AE-L/AF-L button again, focused the camera on his new position, and then saved the updated focus settings with another press of the AE-L/AF-L button. With a bit of practice, this process will become second nature and you will only need to run the X-Pro1's precise but time-consuming autofocus when you actually need to. If you use this method, you'll be able to capture critical moments with success more often and you'll be able to apply an optimal focus setting to more than one image in a series.

The AE-L/AF-L has its pitfalls too (at least with firmware version 1.11—the most current as of this book's press date): If the button is activated, it will lock up any changes to the exposure settings even when used in the way I've recommended with AF LOCK ONLY selected. Any adjustments made to the lens's aperture ring, the shutter-speed dial, or the exposure compensation have no effect. You can still adjust these rings and dials mechanically with the AF lock active, but the adjusted settings won't become active until the moment you release the AF lock. To get around this firmware oversight (which is present in every FUJIFILM camera I'm familiar with), you need to quickly turn the AF lock off and then on again. This will cause your new exposure settings to become effective.

Don't worry, though: as long as you don't press the shutter-release button halfway down, the current focus settings will stay saved, even if you temporarily disable the AF lock.

## IMPORTANT

In AF-S or AF-C mode, the camera does not establish and save a new focus setting each time you turn on the AF lock by pressing the AE-L/AF-L button. It instead saves and locks whatever the current focus parameters are (i.e., the last-used focus setting).

Conversely, in the button's other function as AE lock (i.e., storing the exposure metering), it does take and save a new light measurement as soon as the AE lock is turned on with a press on the AE-L/AF-L button.

### FOCUSING IN THE DARK
Low-light conditions make contrast less detectable—a fact that can naturally pose some problems for a CDAF

system. The quick fix for this is to increase the contrast for the subject you intend to photograph with artificial light. The X-Pro1 offers an AF-assist lamp for just this purpose, which you can activate by going to SHOOT-ING MENU 4 > AF ILLUMINATOR and then selecting ON. Since this light shines mostly on the center of the image area, it's best to position the AF frame in a central location when using it. Do note, however, that the AF illuminator doesn't function in silent mode, which you can turn on and off by pressing and holding the DISP/BACK button for several seconds. When silent mode is active, the camera not only doesn't make noise, it also disables the flash and any auxiliary lights.

An alternative to using the AF illuminator is to use temporary lighting such as a flashlight or switching on the light in a room. Then the autofocus can establish the correct setting and you can save it by using the AF lock before turning off your temporary light. Make sure that you have the AE-L/AF-L button programmed to lock only the focus settings (AF LOCK ONLY); otherwise the camera may (incorrectly!) use an exposure setting based on the temporarily brightened conditions.

If the subject you intend to capture is so far away that the AF-assist lamp or another temporary light source wouldn't help improve its contrast, you can try to focus on another object that is about the same distance from you but exhibits a stronger contrast. Set the focus based on this object and save it with the AF lock. This also works for situations in which you don't want to call attention to yourself with the AF-assist lamp, in which case it's wise to turn on the silent mode just to be safe. You can also give the AF-C mode a try if the AF-S is unable to focus sharply on a stubborn subject.

The manual focus mode (MF) is a last resort for photographing difficult subjects.

## MANUAL FOCUS (MF)

Turn the focus mode selector on the front of the camera to M if you wish to shoot in the manual focus mode. When shooting in MF mode, the autofocus is not inactive. Actually, quite the opposite: pressing the AE-L/AF-L button initiates the autofocus search. If the camera success-fully establishes a focus, it will sound a brief tone, and you can then use the automatically determined focus as a starting point and make small adjustments using the lens's focus ring.

The magnified EVF (or LCD display) can be a big help when manually focusing an image since it depicts a drastically enlarged portion of the image frame. To toggle the magnified viewfinder on and off, press the command dial when in MF mode.

To select the part of your image frame you would like the camera to bring into focus, and to enlarge it when you use the magnified viewfinder, proceed in the same way that you would in the Area AF-S mode. First press the AF button; then use the four selector keys to choose your area of choice. The OK button automatically relocates the highlighted area back to the central frame position in this mode as well.

Using the focus ring and establishing a focus read-ing with the help of the AE-L/AF-L button both function the same whether the viewfinder image is magnified or not. The order in which you use these three tools—AE-L/AF-L button, focus ring, and magnified viewfinder—and how often you use them is entirely up to you. You should, however, select an area of the frame to be brought into focus or magnified as soon as you start trying to focus manually for an exposure. Once again, this allows you to avoid ruining your focus by pivoting the camera after fine-tuning it.

**IMPORTANT**

The magnified viewfinder won't be accessible immediately after shooting until your exposures are completely saved to the SD memory card (firmware version 1.11). Since it's a good idea after taking a few shots to examine the last focus setting and do some fine-tuning, this limitation is rather unpleasant (and another reason to use the fastest memory card available).

The method for manual focusing described here also works when you use the optical viewfinder, by the way. When you use the OVF, the camera automatically switches to the EVF when you activate the magnified viewfinder display.

The focus ring of XF lenses is electronic. This focus-by-wire technology means the focus mechanism won't have the immediate response that you are probably used to from working with mechanical lenses. After you turn the focus ring there is an ever-so-slight delay before the camera reacts. It therefore makes sense to use the AE-L/AF-L button as an aid when focusing manually and to rely on the focus ring principally for fine-tuning.

### DISTANCE AND DEPTH OF FIELD INDICATORS
The distance scale displayed in the viewfinder and on the monitor features a small red stripe to indicate the (approximate) distance at which the focus is set. A white bar on this scale gives information about the depth of field for the current exposure; it displays the range of distances from the camera in which objects will appear sharp in the final image.

When using the autofocus modes—AF-S or AF-C—this indicator is only available if the shutter-release

button is pressed halfway. In the MF mode, conversely, the display is always available, but the depth of field bar isn't meaningful until you press the shutter-release button halfway. This is because the camera when in the exposure mode **P** (program automatic) and **S** (shutter priority) only measures the final exposure value once the shutter-release button is partly depressed, and this is when the camera chooses which aperture to use and consequently defines the depth of field.

Image 74: **Distance and Depth of Field Indicator:** This scale is available in all exposure and focus modes. It conveys information about the focus setting (vertical red line) and the depth of field (white bar) based on the aperture in use. The depth of field indicator is very conservative and only marks the range in which objects retain the maximum focus in the final image even when zoomed to 100 percent.

The focus distance indicator (vertical red stripe) is especially helpful when using the OVF, because you can easily tell if the camera has focused incorrectly with just a quick look. If you're trying to shoot a portrait of a person who is two yards removed from your camera but the distance indicator displays that the focus is set at eleven yards, then something has obviously gone wrong.

Image 75: **Balinese Woman in Temple:** ▶
Exposure parameters: XF60mmF2.4 R Macro, ISO 200, f/3.6, 1/150 second. Developed from the RAW file with a beta version of RPP 64 that's compatible with the X-Pro 1 and polished off with Apple Aperture 3.

There's some debate about the usefulness of the depth of field scale (i.e., the white bar in front of and behind the focus distance indicator). The reason? Fuji is particularly conservative with its methods and calculates the depth of field based on a circle of confusion with a diameter of just 0.005mm. More traditional depth of field measurements use the much larger basis of 0.02mm. Objects that fall within the depth of field that the X-Pro1 indicates appear completely sharp even when enlarged to the pixel level (at the 100 percent zoom view).

To get a real sense for the practical depth of field, you can assign the Fn button to preview it (SHOOTING MENU 3 > Fn BUTTON > PREVIEW DEPTH OF FIELD). Then, after pressing the Fn button in the aperture priority (**A**) and manual (**M**) exposure modes, the camera will stop down to the preset aperture and you can observe the depth of field in the EVF. When in MF mode, you also have the added benefit of being able to use the magnified viewfinder display (by pressing the command dial).

### CLOSEUPS (MACRO MODE)

As you know, the X-Pro1's optical viewfinder (OVF) is affected by a parallax error that becomes more significant as the distance between the camera and your subject becomes shorter. At any distance less than 32 inches, the autofocus shuts down in the OVF. To continue using the AF, you need to activate the macro mode for closeup exposures.

While in shooting mode, you can turn the macro mode on by pressing the MACRO button on the back of the camera—a flower symbol will appear in the viewfinder and on the LCD monitor when it is turned on. As a shortcut, you can turn the macro mode on and off by tapping the MACRO button twice quickly and waiting

for two seconds or pressing the OK button immediately (pressing the shutter-release button halfway works, too). The camera automatically switches from the OVF to the EVF when you activate the macro mode.

Image 76: Sharp focusing is paramount for **macro exposures** because of the shallow depth of field, as you can see in this image taken at the botanical gardens of Singapore. It's best to use a tripod (a piece of advice I follow all too infrequently). Use the AF button and the four selector keys to position the smallest possible AF frame, which doubles as the frame for enlarged viewfinder in manual focus mode, directly over the portion of the image that you want to be sharp. After you have established focus, avoid pivoting the camera to reframe your image. Exposure parameters: XF60mmF2.4 R Macro, ISO 320, f/2.4 (full aperture), 1/90 second.

When in the manual focus mode, you don't necessarily need to turn on the macro mode to shoot closeup subjects—the focus search that starts when you press the AE-L/AF-L button searches over the X-Pro1's entire focal range. In macro mode, however, the camera uses a focusing method that is optimized for subjects in close

proximity. Don't make the mistake of forgetting to turn off macro mode when you've finished capturing closeups.

## FOCUSING ON FAST-MOVING OBJECTS

How to focus on fast-moving objects is a hot-button issue that tends to spark intense debate on the Internet. Unrealistic expectations tend to fuel the issue—usually from photographers switching over from DSLRs, who demand that a CDAF camera like the X-Pro1 behave in the same way as a PDAF single-lens reflex camera. The X-Pro1 can't live up to those expectations any better than any mirrorless system camera with a large sensor. The oft-made assertion that the X-Pro1 is unsuited for action shots, however, is mistaken. Taking this type of exposure just puts an added bit of responsibility on the photographer.

### OPTION 1: THE AUTOFOCUS TRICK

One possibility to capture fast-moving subjects with the X-Pro1 is the so-called autofocus trick. It's best to set the camera to AF-S for this method, which takes advantage of one of the camera's special features: if you press the shutter-release button all the way down in one motion—without stopping at the halfway point—the camera prioritizes the focus above anything else. In other words, if you depress the shutter-release button in one quick motion, the camera captures the exposure immediately after the autofocus settles on its target (or abandons its search).

Image 77: **Shooting with the Autofocus Trick:** ▶
This horse was trotting toward the camera at a rate of around 12mph. To capture it with the X-Pro1's CDAF, I set the camera to AF-S and then tracked the horse's head with my AF frame for 1-2 seconds while I held the shutter-release button completely down and waited until the camera locked its focus and exposed the image automatically.

Follow these steps:

- Set the camera's focus mode to Area AF-S and switch to the EVF or LCD monitor.

- Select an appropriate AF frame that you can use to follow the subject in your viewfinder.

- Now track the subject in your viewfinder (and don't press the shutter-release button halfway). Make sure that the selected AF frame stays over the portion of your image frame that you ultimately want to be in focus.

- Press the shutter-release button completely and hold it down as you continue to track your subject in the viewfinder and as you keep the AF frame located on the position you want to be sharp.

- The camera will then focus on this portion of the subject and, as soon as the focus locks, expose the image. It snaps a shot, however, even if the autofocus search fails to settle definitively on anything. In this case, your result will likely be unusable.

This autofocus trick has an obvious disadvantage: the camera ultimately decides when the image is captured, not the photographer. You can minimize the focus time (reducing the lag between pressing the shutter-release button and capturing the exposure) and increase the likelihood of a successful AF search by priming the camera and lens before the critical moment: press the shutter-release button halfway down to set the focus at the distance you anticipate for your moving subject at the moment when you would like to capture it.

You can also try and use the autofocus trick in tandem with the AF-C focus mode. If you choose this route, you will be limited to using the crosshair at the center

position of your frame as the position for your subject. This method, in other words, limits your choices when it comes to composing your shot.

## OPTION 2: PREFOCUSING ON THE ACTION

When using the autofocus trick, the photographer doesn't actually have the final say about when exactly the X-Pro1 should capture an image; therefore it is better suited for situations when the exact timing is less critical than a sharp exposure.

If you would like to have control over the exact moment of exposure or if you're shooting a subject that's moving at a greater velocity, you can focus on the action in advance and then use the optical viewfinder to choose the right moment to release the shutter. Prefocusing is best accomplished by using the MF mode to focus on an object that is approximately at the same distance of remove from the camera as the subject you'd like to photograph. To reduce the trigger lag, press the shutter-release button halfway shortly before the exposure and hold it in that position until the right moment.

Image 78: **Focusing Ahead of Time:**
This shot of an Airbus A330 some 16 yards above my head as it came
in for landing on the Caribbean island of St. Maarten came down to
tiny fractions of a second. To successfully capture the moment with
the XF18mmF2 R lens, I used the OVF in combination with manual
focus, which I set in advance by focusing on a beach hut that was also
about 16 yards away from me. I tracked the approaching jet in the
OVF, pressed the shutter button halfway to establish the metering
and exposure shortly before the critical moment, and then pressed it
down the rest of the way at just the right time. Exposure parameters:
exposure mode **S**, ISO 200, f/4.5, 1/4000 second.

## OPTION 3: ZONE FOCUSING

Zone focusing is a variation of option 2. This method also calls for the use of manual focus (MF). Instead of focusing on a specific distance, however, you focus on a range of the depth of field scale. In other words, you stop down the aperture until the depth of field is large enough to cover the zone in which you anticipate the action to occur.

This method of focusing is particularly common by representatives of the street photography genre, and it was and still is often used with traditional rangefinder cameras, with which the X-Pro1 at least shares an external resemblance. The X-Pro1's depth of field indicator, however, is too conservative for many photographers. If that's the case, it makes sense to rely less on the depth of field indicator in the viewfinder and more on your experience and gut feeling.

Image 79: **In the Zone:** The OVF once again was very helpful in creating this classic spectator-capture at the DTM race at the Norisring. I shot in exposure mode **S** with a preset shutter speed of 1/60 second. Despite the camera's calculation to use ISO 200, it selected an aperture of f/20. These settings in combination with the XF60mmF2.4 R Macro lens provided more than enough depth of field to cover a long stretch of the race course.

## 2.5 ISO, DETAIL, AND IMAGE NOISE

The X-Pro1's image sensor has a nominal sensitivity of ISO 200, making it twice as sensitive as "standard" sensors, which typically exhibit a sensitivity of ISO 100. You're probably familiar with ISO values from the world of analog photography, where they refer to film sensitivity. The more sensitive the film, the less light it requires for a well-exposed image. Sensitive films with high ISO numbers are therefore ideal for shooting at night or in poor lighting conditions. Their disadvantage is that visible image grain increases at the same time that the resolution and the dynamic range (i.e., the range of brightness tones) decrease. Photographers thus only use highly sensitive film when necessary.

Digital cameras like the X-Pro1 work similarly to film cameras in this regard, but you can't swap out the fixed image sensor with one that's more sensitive and able to use less light. The X-Pro1's image sensor retains its nominal sensitivity of ISO 200 for every exposure regardless of the ISO value you have set for your camera. If you set your X-Pro1 to ISO 400, for example, the exposures captured by the image sensor would be underexposed by one exposure value, or in other words one f-stop. Selecting ISO 800 corresponds to an under-exposure of two f-stops; ISO 1600 to three; ISO 3200 to four; and so on. Similarly, selecting ISO 100 means the sensor will capture an exposure that's overexposed by one f-stop.

If this is the case, why do our images appear to be correctly exposed regardless of the selected ISO setting? The camera manages this by carrying out signal amplification: it boosts the weak (i.e., underexposed) signal for the image by an amount that depends on the ISO setting you (or your camera) chose. This signal

amplification inevitably results in a loss of image quality. It intensifies the desirable parts of the signal (the image data) as well as any noise or flaws. Increased ISO values (and their progressively stronger signal amplifications) make the blemishes in your images clearer and clearer.

The amplification of the captured image data can happen by analog and digital means. FUJIFILM and other manufacturers use a combination of both methods: up to a certain ISO value, the camera uses the analog process and thereafter, the digital one—then these data are saved in the RAW file. For yet higher ISO values, the image data saved in the RAW file are digitally multiplied in the (internal or external) RAW converter. In each case, the brightness of the final image corresponds to the ISO "sensitivity" programmed on your camera.

By the way, the actual sensitivity of the X-Pro1's image sensor deviates a bit from its nominal sensitivity. Measurements from the well-respected website dpreview.com reveal that the image sensor's actual sensitivity is not at ISO 200, but actually approximately 1/3 to 1/2 f-stop lower, corresponding to a sensitivity more along the lines of ISO 160. This won't affect your day-to-day shooting unless you're shooting with an external (flash) exposure meter, in which case you'll want to configure your exposure meter accordingly—by either using a lower ISO value or adjusting with another correction.

The generous rounding up of the nominal sensitivity is something of a tradition with FUJIFILM. The slide film Velvia 50, which was very popular in the 1990s, supposedly had a nominal sensitivity of ISO 50 but in reality was more like ISO 40. Experienced photographers

knew this and adjusted their cameras and exposure meters to ISO 40 to expose their images a bit more liberally and counteract the weaker sensitivity of the film.

Such adjustments aren't necessary for a digital camera like the X-Pro1, whose metering system is coordinated with its sensor. Nevertheless, some photographers find that the X-Pro1 has a tendency to expose images on the liberal side, which in many situations requires a negative correction with the compensation dial. This tendency to create slightly overexposed images is a manifestation of two contemporary digital exposure techniques: on one hand, following the ETTR (expose to the right) rule of making optimal use of the histogram at its right edge, and on the other hand, using the automatic DR to extend an image's dynamic range, which we'll go into more in section 2.6.

When shooting in the FINE+RAW mode, you can choose ISO values between 200 and 6400. But again, if you opt for an ISO value greater than 200 (either by pressing the Q button or by programming the Fn button to serve this purpose), you're not actually increasing the sensitivity of the sensor. Instead, you are reducing the exposure window and/or using a smaller aperture to lessen the amount of incident light that will reach the sensor. This necessitates a subsequent amplification of the reduced signal, which leads to a reduction in image quality.

How drastic is this loss in quality, and what does it mean for your photography? On this particular issue, you're in luck with the X-Pro1. Exposing images at high ISO values is among its greatest strengths. While other cameras with an APS-C sensor produce images with noticeable noise or an unfortunate loss

of detail resolution, the X-Pro1 can still produce truly respectable results.

Three factors contribute to this:

• The X-Pro1's sensor benefits from new technology, and each new generation of sensors demonstrates better performance when it comes to image noise.

• The sensor's X-Trans pattern weighs the primary colors differently from the traditional Bayer pattern, improving the signal-to-noise ratio.

• The internal RAW converter in the X-Pro1 (as well as other X-series cameras) is world class. This affects not only the camera's representation of color, but also its noise reduction and detail reproduction.

The combination of these factors means you can create images with the X-Pro1 and its APS-C sensor that are on par with those created by DSLR cameras that have substantially larger sensors, such as the Nikon D700 or the Canon EOS 5D Mark II.

## ISO SETTING AND IMAGE QUALITY

On the following pages we will examine the X-Pro1's image quality at various ISO settings with a test subject: a kitschy and particularly dusty Christmas figurine that's perfect for detecting image noise and detail reproduction.

The retention of detail and the reduction of noise are adversaries, and the RAW converter needs to strike a compromise between them. You can't have both in an image with a high ISO setting (i.e., a strong sensor signal amplification): either the noise can be reduced at the expense of fine details, or the subtle details can remain at the expense of an effective noise reduction. The critical factor is how well the camera's internal

RAW converter is able to make this compromise. Laboratory measurements only tell half the story here, because image quality in this case doesn't just depend on how measurable the reduction of noise is; it also depends on how visibly attractive or unattractive it looks to the human eye.

Attractive noise? The idea isn't so far-fetched when you consider that image-editing software allows you to simulate the effect of image grain, characteristic of film, to give digital exposures a more "realistic" look. Image grain—the analog equivalent of digital image noise—is sometimes desirable. If a camera can make the unavoidable image noise present in exposures taken at high ISO values have the appearance of grain, then it won't look as bad to a critical eye.

While many cameras with an APS-C sensor already produce visible image interference at ISO 3200, it's smooth sailing for the X-Pro1. Even exposures at ISO 6400 lend themselves pretty well to standard print and presentation sizes.

The X-Pro1 also offers a so-called extended ISO range with values of ISO 12800 and ISO 25600, but you won't be able to save these images as RAW files. This extended range is only available when the RAW option is disabled and your camera is set to JPEG only mode.

Image 80: **ISO Test Series**:

I chose this dusty test subject because it's well suited to demonstrating image noise (color surfaces, shadow areas), detail reproduction (fine particles of dust), and dynamic range (blown-out highlights) at different ISO levels (the illustration here shows ISO 200). The images were taken with the default JPEG settings and are available to view in higher resolution online at 🌐 **www.dpunkt.de/XPro1/Abbildungen**.

Image 81: **ISO, Noise, and Details:**
At ISO 200, the X-Pro1 produces its baseline quality. The second row shows the same parts of the image at ISO 1600, the third at ISO 3200, and the bottom at ISO 6400. The differences in quality between the images shot at ISO 200 and ISO 1600 are too marginal to make clear here in print. At ISO 3200 interference and a loss of detail come into view—a fact that is all the more noticeable at ISO 6400.

Image 82: **Extended ISO Range:**
The options of ISO 12800 (above) and ISO 25600 (below) are only available in JPEG mode and are accompanied by visible image noise and a loss of detail.

Why is this the case? What's hiding behind the extended ISO range? Not much, actually. At these two high ISO settings, the X-Pro1 shoots RAW images at ISO 6400, but underexposes them by one or two exposure values and then boosts up the exposure again when the image data is converted to a JPEG. You can achieve the exact same effect by setting your camera to ISO 6400, turning the compensation dial to −1 EV or −2 EV, and then using the internal or an external RAW converter to "push" the image one or two exposure values.

Employing the extended ISO values results in an unavoidable loss of quality, so you should only use them in emergencies. You actually retain more flexibility if you

underexpose your image while shooting with ISO 6400 and FINE+RAW and then plan on adjusting the exposure manually during the RAW conversion.

Image 83: **The Test Subject with ISO 25600:**
You can see that as long as you don't overly enlarge the picture, this for-emergencies-only mode still offers quite acceptable results.

The extended ISO range also includes the option of shooting at ISO 100, which is again only an option if you are shooting exclusively in JPEGs. Here the process is inverted: the camera captures an image at ISO 200 and overexposes the RAW data by one exposure value. Then during the RAW conversion, it brings the exposure down by a value. This process—the counterpart of "pushing" an exposure—is called pull development.

This method produces images with minimal noise and a high degree of detail, particularly in the shadow

areas, which comes at the expense of the high end of the dynamic range. The highlights, or bright tones, suffer dramatically, making ISO 100 also a setting for use only in emergencies for images that don't feature high contrast or important highlight details.

**Image 84: The Test Subject with ISO 100:**
The loss of dynamic range at the high end of the spectrum is easy to see: the highlights here are partially blown out. The exposure warning in Apple's image-editing software Aperture (indicated by the red-marked areas in the two smaller images *below*) shows the difference even more clearly: the *left* image shows the subject shot at ISO 200, the *right* with ISO 100.

## SUMMARY

At high ISO settings, which often cause big problems with other cameras, the X-Pro1 still delivers excellent results. Nevertheless, you should only stray beyond the range between ISO 200 and ISO 6400 when there's no other option. ISO 100 results in a reduced dynamic range for highlights and ISO 12800 and ISO 25600 lead to very visible interference and a loss of detail. Moreover, these three settings of the "extended ISO range" are available only when your camera is programmed to save JPEGs only—writing RAW files with these settings is not an option.

### PRACTICAL ISO TIPS

There are four methods for changing the X-Pro1's ISO setting:

- Go to SHOOTING MENU 1 > ISO and select your desired ISO setting.

- Press the Q button and program your desired ISO setting in the Quick Menu.

- The ISO setting is one of the parameters you can save in the camera's seven custom shooting profiles. You can change the current ISO setting by selecting a shooting profile that has a different ISO setting. To select or edit a shooting profile, hold the Q button until the appropriate menu pops up on the display.

- Set the Fn button to access the ISO menu. This is actually the factory programmed function of this button. To program the purpose of the Fn button, simply hold it down until the assignment menu appears.

As a rule, lower ISO values produce better photographic results. You'll get the best image quality at ISO 200. Avoid ISO 100, opting instead to stop down the aperture, shorten the exposure time, or use an ND gray filter.

But don't be afraid of "high" ISO values! At ISO 400 and ISO 800, the X-Pro1 produces almost the same image quality that it does at ISO 200. This is especially true when you make use of the DR function (discussed in section 2.6), which enables you to extend the camera's dynamic range one or two f-stops upward. Not to jump too far ahead, but the DR function—depending on how it's set—requires a minimum ISO setting of 400 or 800. In addition, the result when using this feature is often better than if you were simply to expose your image at ISO 200 without using the DR function.

Also, keep in mind that you should try to optimize your image quality by using low ISO values only when it doesn't adversely affect your settings for aperture and/or shutter speed. What good does shooting at ISO 200 do if you have to extend the shutter window so long that camera shake or unwanted motion blur mars your shot? And what good does a low ISO setting do if you have to stop up the aperture so high that critical details of your image are no longer in the exposure's depth of field?

In other words, rather than setting the ISO independent of your other settings, choose it while considering them. These other exposure settings will ultimately have a greater influence on your end result than whatever "camera sensitivity" level you choose—as we already know, this really only concerns the degree to which the signal from the sensor is amplified.

In this regard, the X-Pro1 is particularly capable: in most cases, the human eye won't be able to detect a difference between images taken at ISO 200 and ISO 1600

when they're not significantly enlarged. For this reason, many photographers use the auto ISO setting and allow the camera to determine the most fitting ISO value by itself.

## AUTOMATIC ISO

If you choose any of the options in the ISO menu that have the word AUTO, then the camera will use the smallest possible ISO setting (i.e., ISO 200 or higher). On a case-by-case basis, the camera will raise the ISO as needed, but it won't ever overstep the upper limit that you define.

If you select AUTO (800), for example, the camera will use ISO settings between 200 and 800. When set at AUTO (3200), the camera uses ISO values between 200 and 3200.

So far, so good. But what concrete rules does the camera follow when selecting an ISO value between these two limits? Here's the basic rule: the camera doesn't attempt to raise the ISO until it no longer has any leeway to adjust the aperture and shutter speed to make the exposure work.

With the aperture, it's straightforward: In the **P** and **S** exposure modes, the upper limit is the maximum or the fully dilated aperture of whichever lens is currently attached. In the **A** and **M** modes, the camera uses the aperture value that is selected by the user.

Determining shutter speeds is a bit more complicated. In principle, the camera could allow the exposure window to run up to 30 seconds in the **P** and **A** exposure modes before it has to bump up the ISO setting even a smidgen. This would be entirely impractical and unrealistic, though, which is why it makes sense to establish a minimum shutter speed.

While many cameras (including the FUJIFILM X100) allow the user to set the minimum shutter speed for their auto ISO settings, the X-Pro1 determines this value automatically. An old and trusted rule from the world of 35mm photography comes into play here to help you avoid unwanted camera shake in your images: minimum shutter speed = the inverse of the focal length.

Since the X-Pro1 isn't a 35mm camera—it has an APS-C sensor—you must also include an elongation factor of 1.5 into the equation, making the minimum shutter speed in seconds = (1/[focal length x 1.5]). With the 18mm lens, the X-Pro1's minimum shutter speed (when the auto ISO is activated) is 1/27 second; with the 35mm lens, 1/52 second; and with the 60mm lens, 1/90 second.

Such a rigid rule, as you can imagine, won't be able to accommodate many everyday photography situations. While 1/52 second may be short enough for most photographers to take images by hand using the 35mm lens without camera shake, if you're shooting moving subjects (like a running child), you would want to shoot with a much faster shutter. Conversely, if you set your camera and lens on a tripod for a landscape photo, 1/52 second is much too short—1/20 or 1/8 second would be much more fitting.

Many people wish that the X-Pro1 allowed users to change the minimum shutter speed when using auto ISO. FUJIFILM will probably honor this wish eventually with a firmware update, but until then, you'll have to make do.

The obvious solution is to use the **S** exposure mode and set the exposure time yourself with the shutter-speed dial. In practice, this works very well; however, you are also at the mercy of Fuji's high-aperture lenses. As you will remember, auto ISO only bumps up the camera's

ISO setting when the maximum aperture doesn't suffice to take a correctly exposed image. With the 35mm f/1.4 lens, this of course means an aperture of f/1.4, which will produce a depth of field that is much too shallow for many situations.

Why not then use auto ISO in tandem with the **M** exposure mode to set your desired shutter speed and your desired aperture? This actually works. Switching your exposure mode to manual when using the automatic ISO selector will allow for so-called misomatic shooting: automatic ISO in combination with a manually selected shutter speed and aperture. Logically you should give your camera as much freedom as possible and select AUTO (3200) from the ISO menu. Sounds too good to be true? It is! The misomatic solution has two significant catches:

- In manual mode (as well as in the misomatic mode), the live histogram serves no useful purpose—it displays a distribution of brightness values that does not reflect the actual distribution of brightness values in your exposure.

- The camera's exposure compensation dial is useless in **M** mode, which is also true when the auto ISO is active.

In other words, in misomatic mode, you're entirely dependent on the camera's automatic exposure metering, because you are unable to make any exposure corrections manually.

How can you compensate for this disadvantage?

- Change the light metering mode. While the multi metering method tends to expose liberally, the average metering method exposes conservatively. This will help you to avoid overexposed areas in your images.

- Use the spot metering method. With experience, you'll start to develop a sense for which element in your image you should target for the light metering in order to expose your image successfully.

- If you want to expose your image darker than the camera normally would, first meter an image frame that's brighter than the frame you actually want to expose and then save the exposure settings with the properly configured AE-L button (or by pressing the shutter-release button halfway). Conversely, if you want to expose on the brighter side, first expose a darker frame and follow the same process.

- Use the camera's automatic exposure bracketing feature! As long as you are shooting something that can't run away from you—a landscape, for example— it's never a bad idea to expose multiple versions of it, from which you can later select the best. To acti-vate this function, press the DRIVE button and select AE BKT.

- If blown-out highlights are your biggest concern when using the misomatic mode, you can counteract them by enabling the DR function. Go to SHOOTING MENU 1 > DYNAMIC RANGE and then select either DR200% or DR400%. These settings will lead to RAW files that are more conservatively exposed by one or two f-stops,

respectively. When you develop your image data into JPEGs, either by using the internal RAW converter or an external one, you can balance this exposure. This method will give you one or even two aperture stops of wiggle room with your highlights. You can read more about the DR function in section 2.6.

---

**IMPORTANT**

Remember that the misomatic mode only appears to be an automatic exposure mode on the surface. In reality, you're still in manual mode even with the auto ISO activated. You are ultimately responsible for making sure the exposure of your images is correct. For this reason, the camera won't give you an exposure warning if it can't find an appropriate ISO value to match your manually selected aperture and shutter speed. Instead the X-Pro I indicates the resulting over- or underexposure of your shot on the left side of the display in the "light balance" that normally functions as the indicator for your exposure compensation setting.

---

As you can see, the seemingly simple concept of an automatic ISO function quickly becomes complicated in certain circumstances. In situations when the auto ISO function doesn't offer an acceptable aperture and/or shutter speed setting in the **P**, **A** or **S** exposure modes, the best solution is often to turn off the automatic function and select an appropriate ISO value for yourself. Sometimes the simplest solution is also the best.

## ISO BRACKETING

As an alternative to conventional automatic exposure bracketing (see "Metering" in section 2.3), you can use the X-Pro1 for ISO exposure bracketing. When using this function, the camera creates three differently exposed images, and the largest exposure variance between each image is ±1 EV. In contrast to the regular exposure bracketing, however, the three images are created not with different combinations of aperture and shutter speed, but with sensor signal amplifications of varying degrees—or, in other words, different ISO settings. It follows that the camera doesn't need to take three different exposures in short succession when executing this type of exposure bracketing. The sensor data from a single exposure will suffice—the X-Pro1 develops the same data into three different JPEGs.

One advantage of this method is that all three exposures are identical as far as the elements within the image frame, so you don't have to worry about ghosting artifacts when compositing an HDR image on your computer (see image 85). ISO bracketing therefore lends itself well to HDR subjects that feature moving objects.

To enable this function, press the DRIVE button and select ISO BKT. You can then set the range of exposure values for the sequence (±1/3 EV, ±2/3 EV, or ±1 EV).

**HINT**

Please note that the X-Pro1 does not write a RAW file to
the memory card when running the ISO bracketing feature.
Instead, it saves three different JPEG files that are identical in
terms of the photo's subject matter as well as the aperture
and shutter speed used to expose the shot. The only difference
between the images is the strength of the ISO amplification.

ISO bracketing is possible with any ISO setting between
200 and 6400, including all of the auto ISO options.
You can also use this feature in all four of the camera's
exposure modes and in combination with the misomatic
mode. When you can live with a JPEG and no RAW file,
the ISO bracketing function can work as a makeshift
replacement of the exposure compensation dial, which is
useless when shooting with misomatic settings.

**IMPORTANT**

The automatic ISO bracketing feature uses push/pull methods
to "develop" the image captured by the sensor. You can achieve
identical results by taking a RAW file that has been conventionally
exposed and using a RAW converter (the X-Pro1's internal
one or an external one—both work) to produce two additional
"prints," one with the corresponding overexposure and one
with the corresponding underexposure.

Image 85: With the **automatic ISO bracketing** feature, ▶
the X-Pro1 develops three different JPEGs from the same
RAW data. With this variant of exposure bracketing, the
maximum variance between each JPEG is also ±1 EV.
I used Photomatix Pro to composite the HDR example
shown here out of the three JPEGs that resulted from
the ISO bracketing feature (±1 EV = ISO 200,
ISO 400, and ISO 100).

# 2.6 EXTENDING THE DYNAMIC RANGE

Does the following scenario sound familiar? You take a picture of a landscape that looks wonderfully beautiful to the naked eye only to find out later that the blue sky no longer looks blue and the fascinating cloud formations are just white blobs. The reason for this and similar disappointments is that the scene captured in the image has a larger dynamic range than the camera.

Every camera sensor is capable of capturing only a certain range of contrast—that is, a limited range between the brightest and the darkest parts of an image. The X-Pro1's range covers about 9.5 f-stops or exposure values (EVs). In other words, there are 9.5 EV between the minimum amount of light required for the sensor to depict something more than black pixels and the maximum quantity of light beyond which the sensor registers white pixels. This is the dynamic range of the camera. Within this range, the X-Pro1 can depict levels of brightness between pure black and pure white.

Unfortunately the world doesn't abide by these limits, and many subjects exhibit a larger dynamic range than the X-Pro1 is capable of capturing. We see these limitations, for example, in backlit situations and when people are standing in the shadow of an entrance. Professional photographers (and film directors) reduce the dynamic range of their subjects by using additional light. That's why you'll see an entire arsenal of floodlights and reflectors on large film sets even on bright days.

Only the luckiest photographers have the luxury of elaborate lighting equipment. Most of us have to make do with natural lighting, which often produces contrast in our subjects that exceeds a range of 9.5 EV. When

you try to photograph these subjects with your X-Pro1, your images will either have blown-out white areas or blocked-up shadows, regardless of the combination of aperture and shutter speed you use. They may even have both! Contrasts that the human eye (or more accurately, the human brain) seems to process without any trouble pose near-impossible challenges for even the best cameras.

This section could end here on a frustrating note, but there are several approaches for dealing with this common problem. I already discussed one solution in section 2.3 under "Metering": high dynamic range (HDR). With this method, you take several shots of the same subject at different exposure settings. Then you (or your camera) can work to composite this series of exposures into one image, taking the dark areas (shadows) from the overexposed images and the bright areas (highlights) from the underexposed ones.

The X-Pro1 unfortunately does not offer an HDR mode (in contrast to many other cameras and even cell phones), so you will need to patch together your images on your computer using a software program designed for this purpose, such as HDR Efex Pro or Photomatix Pro.

HDR technology doesn't lend itself to all high-contrast subjects, though. For this reason, many photographers instead opt for a compromise: they base the exposure on the brightest element in their frame and accept the ensuing underexposure in darker areas. While it's impossible to restore information to blown-out highlights, effective post-processing can generally rescue blocked-up shadows.

This method is called *tone mapping*, and it consists of a reassignment of brightness values. Tone mapping is the same function as the "fill-light" slider in our modern

image-editing programs for external RAW develop-
ment: it brightens the shadows and dark midtones of
images that we consciously exposed too conservatively
until the relative levels of brightness throughout the
image appear balanced. The drawback of this method
is increased image noise in the shadows as well as a
reduction of brightness levels in these darker areas. But
generally this cost is well worth the gain: you can retain
detail in the bright areas of your image that otherwise
would be lost.

Extending the dynamic range is actually a method of
"dynamic range compression": when you intentionally
underexpose an image (i.e., basing the exposure set-
tings on the brightest part of the frame), the middle and
dark tones in the image are shifted further to the left
and piled up there on the histogram. The "decompression"
happens when you map the tones in your images,
bringing the dark and middle tones to lighter and more
appropriate levels of brightness. And voilà: the results
suggest that you extended your camera's dynamic
range. And technically that's exactly what happened—
admittedly at the expense of a bit more noise and less
nuance in the dark areas.

If you go to SHOOTING MENU 1 > DYNAMIC RANGE
and select AUTO to switch on the camera's automatic
DR function, the X-Pro1 takes care of this process for
you with the following steps:

1. The camera analyzes the subject and determines if its range of contrast exceeds the sensor's dynamic range.

2. If it does, the X-Pro1 exposes the image one (DR200%) or two (DR400%) f-stops more conservatively than normal in order to retain detail in the bright areas of the image (highlights). This is why it is necessary to have an ISO setting of at least 400 for DR200% and an ISO setting of at least 800 for DR400%.

3. The camera develops the JPEG by remapping the tones in the RAW data that was intentionally exposed too conservatively to bring the shadows and middle tones back to "normal." In turn, the amplification of the sensor signal is reduced by one (DR200%) or two (DR400%) exposure values.

## Image 86: Extending the Dynamic Range of the X-Pro1

This example illustrates how to rescue the bright areas of an image (highlights) that are beyond the sensor's dynamic range. Normally this would require a manual process in which the photographer would purposefully underexpose an image and then make the appropriate adjustments when developing the image in a RAW converter. The X-Pro1's DR function automates this process.

**Figure 1** (*left, above*) is a JPEG of the test subject taken with the camera's standard settings (DR100%) and without an extended dynamic range. Here you can see that the shadows and dark midtones are correctly exposed, but the sky has lost its color and the bright parts of the clouds have lost all of their detail. The sensor's blue channel has been overwhelmed: during the exposure, it was bombarded with more photons than it was capable of absorbing.

**Figure 2** (*right, above*) has been manually underexposed by one aperture stop. The sky and the clouds now look OK—they've been "rescued," because the more conservative exposure meant that less photons hit the sensor and its capacity was sufficient for the bright parts of the image. This also has the effect of making the dark areas of the image look underexposed—and that's exactly what they are. We've shifted the problem from the bright to the dark areas of the image.

**Figure 3** (*left, below*) shows the image after the shadows have been restored. I've taken the RAW file for Figure 2 and used Silkypix to edit it, using fill light to conduct tone mapping. The highlights retain their detail, while the shadows now look as they did in Figure 1 (*left, above*). The dynamic range has effectively been extended.

**Figure 4** (*right, below*) shows the results of allowing the X-Pro1 to rescue the highlights of the image by itself using the DR function. With auto DR activated, the camera selected DR400%, exposed the RAW file two aperture stops (exposure values) dimmer than normal, and remapped the brightness tones appropriately when developing the JPEG file. Measured in exposure values, the X-Pro1's dynamic range effectively increased from approximately 9.5 EV to 11.5 EV.

Above all, the X-Pro1's DR function is practical and simple. It automatically handles nontrivial work that photographers would otherwise have to do themselves in order to prevent the loss of detail in bright areas.

For photographers who don't work with RAW files and instead demand that their camera produce finished JPEGs, the DR function is essential. While the camera can capture images with 12 bits or 4,096 brightness levels, a finished JPEG is in 8-bit format with only 256 brightness levels. An intentionally underexposed JPEG (i.e., an exposure based on highlights) is much more difficult to correct with tone mapping than a RAW file that was exposed in the same manner. In particular, JPEGs may only have a handful of brightness levels available in the darker regions of an image, meaning the tone mapping process of raising and spreading out these levels can lead to undesirable results.

For JPEG photographers, the DR function is a real advantage, because when the camera conducts the dynamic compression and decompression by itself, it works with the RAW data captured by the sensor—all 4,096 brightness levels. Only after the X-Pro1 maps the tones does it convert the image to 8-bit format and produce a JPEG with 256 brightness levels.

**Image 87: The X-Pro I's DR Function in Action**

The three JPEGs here illustrate the effect of the DR function on a high-contrast subject. At the *top left* is the baseline image with the extended DR disabled (DR100%). Next to this image, on the *right*, is the result of shooting in DR200%, and at the *bottom left*, DR400%. You can see how the piled-up highlights at the right edge of the histogram are rescued from one image to the next—something you can also tell by the successively decreasing size of the red area indicating an exposure warning. The details in the image at the *bottom right* clearly illustrate the process's positive effect on the image's highlights—in this example, the sky and clouds.

## QUESTIONS AND ANSWERS ABOUT THE DR FUNCTION

The DR function unfortunately tends to lead to some confusion. That's why I've included a few of the most common questions and my attempts to answer them.

*When should I use the dynamic range function?*

The DR function is ideal for circumstances in which the subject of an image exhibits a larger range of contrast than the camera sensor is capable of capturing. When AUTO is set for the DR function, the camera will extend the dynamic range as needed based on the

detected range of contrast in the subject. It will choose either DR200% (an extension of the dynamic range by one exposure value) or DR400% (an extension by two exposure values). You can alternatively select both of these options manually. The automatic function tends to operate rather liberally—it often selects a higher DR setting than is actually necessary.

*Why shouldn't I always leave DR200% or DR400% active?*
    The DR function is a compromise: it extends the dynamic range at the cost of a bit more noise and a reduced tonal range in the shadow areas of your images. You should only turn it on when the benefits outweigh the costs and when you really need an extended range.

*How can I tell if the range of contrast in my subject will overwhelm the camera's sensor?*
    If you see cropped mountains piled up at the right edge of the histogram, it's a good indication that the bright parts of your image will lose their detail. If those parts of the frame are important to your image, you should attempt to rescue them—either by purposefully underexposing the shot (perhaps with the help of the exposure compensation dial) and then mapping the tones when developing the RAW file or by entrusting this work to the camera by availing yourself of the DR function.

*What is meant by "important parts of an image"?*
    Sometimes you want to intentionally play with extreme contrasts or allow portions of your image to be blown out. In these cases, you shouldn't rely on the camera's automatic dynamic range extension. The camera is "unthinking" and doesn't know what makes for a good image. It simply measures the exposure mechanically and uses this value to make its decisions. Don't let the camera dictate what your images look like; create

them yourself! If you want a stark contrast, set the camera to DR100% and expose the image according to the elements in your image that are important to you.

*How do the DR function and the ISO value mesh together?*

For the camera to underexpose the RAW file by 1 EV (DR200%) or 2 EV (DR400%), it must also use ISO settings of at least 400 or 800, respectively. Normally when these ISO settings are used, the camera amplifies the sensor signal. This boost is left out, however, when the DR function is enabled. In its place, the process of tone mapping must be used in the development of the RAW file. So make sure you set your camera to at least ISO 400 or 800—or better yet, to AUTO (800) or higher.

If you manually program an ISO value that won't work with the selected DR setting, the camera will automatically bring the DR setting down. If you have set the dynamic range to DR400% and the ISO to 400, for example, the camera will adjust the dynamic range setting down to DR200%. If you were to set ISO 200, it would go to DR100%. When this happens, the DR setting appears yellow and remains so until you bump up the ISO to an operative level. In other words, your manually selected ISO value has priority over the DR setting. But the DR settings do have priority over automatically selected ISO values. This is why I recommend that you use the DR function in tandem with AUTO (800) or higher.

*How does the DR function affect RAW files?*

It should be clear by now that the DR function can help produce attractive JPEGs for high-contrast subjects. But what about RAW files? The image data in these files are underexposed by one exposure value with DR200% and two exposure values with DR400%. If you develop your RAW files with your camera, the X-Pro1 will

compensate for this condition automatically. If you use external RAW converters, it depends on the specific program: Silkypix as well as Lightroom, or more specifically Adobe Camera RAW (ACR), also automatically detect the DR function and adjust the exposure settings accordingly. The results will vary from those produced by the camera, which isn't to say that one is better than the other. With RAW converters, you also have the opportunity to tackle the task yourself and manage the editing based on your specific preferences.

*Should I use the DR function if I plan on working with the RAW files?*

This is a tricky one, because the answer depends on your personal habits. If you plan to exclusively use RAWs and you don't plan on using the JPEGs prepared by the camera at all, then I recommend not using the DR function (i.e., set it to DR100%). Instead, use the live histogram to monitor your exposure levels while shooting and to make sure that no important elements in your image are crammed up against its right border. The benefits of this manual method are that your work can be more precise than the camera's automatic methods and you can control the tone mapping with all of your personal tricks and preferences in an external RAW converter.

Conversely, if you are interested in the camera's JPEGs (keyword: "Fuji colors"), you'll want to enable the DR function to make them as attractive as possible. The RAW files will then be exposed one or two exposure values more conservatively. Silkypix (including the free version of RAW File Converter EX) and Lightroom/ACR can balance this underexposure automatically when reading the RAW files.

You can undoubtedly underexpose your images much more precisely in manual mode than the X-Pro1 can on

its own. The automatic procedure is limited to crude steps of 1 EV and 2 EV. Experienced RAW shooters who prefer to have as much control over the photographic process as possible generally turn the automatic dynamic range off (DR100%).

What do I personally do? It depends on the day and my intentions for my images. In most cases, the negative effects on quality that the automatic DR function causes are insignificant for the size of images that I work with. If I want to squeeze every last drop of quality out of my camera and sensor, however, then I work exclusively with an external RAW workflow, shoot at DR100%, and expose as precisely as possible.

## IMPORTANT

The X-Pro1's live histogram always works independent of any settings for the DR function and is not influenced by the dynamic range. Please remember to only rely on the live histogram when using DR100%.

Image 88: Temples in Bali: ▶
This image was shot at DR400%, developed from the RAW file with Silkypix 4, and polished with Apple Aperture. Exposure parameters: XF35mmF1.4 R, DR400%, ISO 800, f/14, 1/400 second.

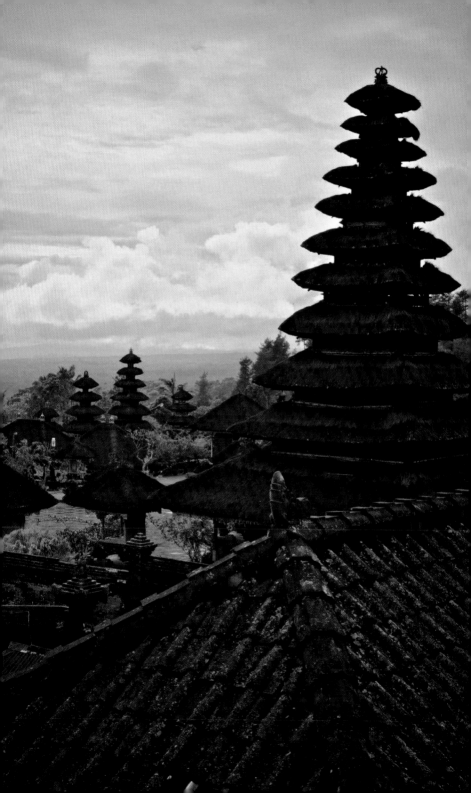

## TIPS FOR HANDLING THE DR FUNCTION

There are four ways to change the DR settings of your camera:

- Go to SHOOTING MENU 1 > DYNAMIC RANGE, where you can select from AUTO, DR100%, DR200%, or DR400%. If AUTO is selected, the camera will choose from the three other options: DR100% turns the dynamic range off; DR200% extends the dynamic range by one exposure value; DR400%, by two exposure values.

- Press the Q button and select the dynamic range directly from the Quick Menu.

- DR function is one of the variables that you can save in your custom shooting profiles. Therefore you can indirectly adjust the DR settings by choosing a different shooting profile. As a reminder, you can select or edit these profiles by pressing the Q button until the desired menu comes up on the camera's display.

- Assign the Fn button to control the DR setting. Remember, to change the purpose of the Fn button, hold it down until the menu for assigning its function pops up.

Image 89: After the Rain: ▶
Exposure parameters: XF35mmF1.4 R, DR400%, ISO 800,
f/13, 1/400 second. Developed from the RAW file with
Silkypix 4; finished with Aperture.

## IMPORTANT

Remember that DR200% will only be available if your ISO
is set to at least 400, and for DR400% the minimum ISO is
800. For this reason, I recommend selecting AUTO (800) or
higher for the ISO when you plan to use the DR function.

The camera prioritizes your manually defined ISO values
over the DR. When using the variable auto ISO feature,
the camera can and will adjust the ISO to the level
needed for the DR function to work properly.

Which DR setting should you use? Pay attention to the
live histogram. If there are cropped peaks crammed in
at the right side of the histogram, you have areas in your
image frame that are overexposed. If this is something
you don't want, then definitely use the DR function—
either DR200% or DR400%, based on the contrast range
of your subject. When in doubt, opt for AUTO and leave
the decision making up to the camera.

### DR BRACKETING

If you would like to see three different dynamic range
versions of the same subject, press the DRIVE button
and select DYNAMIC RANGE BKT. The X-Pro1 will then
capture three images when you press the shutter-release
button: one at DR100%, DR200%, and DR400%.

The drawback of this method is that the camera only
writes JPEGs to the memory card—it doesn't save any
RAW files. Moreover, the JPEGs will only be captured at
the lowest possible ISO setting (i.e., the best possible
quality) if you've turned on auto ISO. For photographers
who value RAW files, this function doesn't have much
to offer. In any case, it's useful to test how the three
different DR settings look with different subjects. You can
get the same effect by exposing an image at DR400%

**Image 90: Ogoh-Ogoh Festival**
The X-Pro1's internal RAW converter developed this JPEG, which (aside from crop-ping) is unedited. Exposure parameters: XF60mmF2.4 R Macro, DR400%, ISO 800, f/4, 1/800 second. JPEG conversion parameters that deviate from the default settings: white balance 5300K, Push/Pull processing +1/3 EV, film simulation PRO Neg. Hi, color m-high, sharpness m-hard, shadow tone m-hard, noise reduction m-low.

and then developing the RAW file with the internal RAW converter into two more versions: one at DR200% and one at DR100%. To use the RAW converter, go to PLAYBACK MENU 1 > RAW CONVERSION.

# 2.7 WHITE BALANCE AND JPEG SETTINGS

The X-Pro1 offers a practical feature regarding white balance, film simulation, contrast settings, color saturation, image sharpness, noise reduction, and the selection of a color space: not only can you define these settings before you capture an image; you can also change them afterward! The only requirement is that you must save the RAW file in addition to the JPEG so the X-Pro1's internal RAW converter has something to work with. This is another reason to choose SHOOTING MENU 1 > IMAGE QUALITY > FINE+RAW as your default image quality setting.

This is great news for photographers who are interested in getting finished JPEGs from their X-Pro1. Instead of agonizing over the perfect settings before every exposure—the X-Pro1 offers more than 33 billion(!) combinations of settings for converting a RAW file to a JPEG—you can concentrate on your subject, the focus, and the actual exposure while shooting. You can try out different variations to optimize your images with the aforementioned parameters later. That sounds like exciting and stress-free photography to me.

White balance and the various JPEG settings control how the camera interprets the RAW data collected during an exposure. The RAW file—the digital negative—remains unchanged during this conversion process. This section focuses on settings that can influence the "prints" that the camera develops from these negatives. It also explains how the X-Pro1 can continue to make new and different JPEGs from the same RAW files, just as you can with real negatives. In fact, you could produce more than 33 billion JPEGs from a single exposure that would differ in at least one setting.

## SETTING THE WHITE BALANCE

Light exhibits certain color temperatures that give objects a hue. Without taking a proper white balance, a gray object shown in a warm light (e.g., an incandescent bulb) will appear orange and in a cold light (e.g., a camera flash), bluish. The color of the object itself is actually neither orange nor blue—it's plain gray.

To ensure that gray objects appear gray in all lighting conditions, the camera needs to measure the color temperature of the light for each exposure and compensate for any detectable hues. The camera does this not only automatically, but very precisely and with remarkably few errors.

Some problems arise for the automatic white balance when a scene features multiple light sources, each producing a different color temperature. Which color temperature should the camera use as the baseline in such a case? It has no choice but to settle on a compromise—one that likely won't work for every situation and won't satisfy every viewer.

This isn't the end of the world, though, because you always have the option of adjusting the white balance—even afterward—using the internal RAW converter or a software program on your PC.

To change the X-Pro1's white balance, go to SHOOTING MENU 2 > WHITE BALANCE and choose from the menu options there. As is the case with the DR function and the ISO setting, you can also set the white balance by accessing the Quick Menu (Q button), by changing the custom shooting profile, or by programming the Fn button accordingly.

Any setting you select from the WHITE BALANCE shooting menu will apply only to the JPEGs that the camera produces, so it won't affect the data of the RAW files. The white balance is, however, stored in the so-called

metadata of the RAW file, so that a RAW converter can detect how the camera (or photographer) set the white balance at the time of exposure. When developing the RAW file later, the RAW converter will start with the stored white balance information as a baseline.

**HINT**

As with most settings that affect how the JPEGs are produced, the effect of your white balance setting will be visible in the live image displayed on the camera's LCD monitor or in the electronic viewfinder. This practical benefit means you won't have to make a complete stab in the dark when choosing the white balance—you can get a rough impression of how your selection or adjustments to the white balance (or any other JPEG settings) will affect your shot.

## AUTOMATIC WHITE BALANCE

The default setting for the white balance is SHOOT-ING MENU 2 > WHITE BALANCE > AUTO. With this option set, the camera will measure the ambient color temperature automatically before each exposure and adjust itself accordingly. This process functions so well that many of you will rarely use a setting other than AUTO—especially because you can continue to make additional changes and adjustments to the RAW file afterward.

Image 91: **Automatic White Balance:** The X-Pro1's default white balance setting delivers excellent results even in complex lighting conditions. This example image featured a blend of natural light from the right as well as artificial light from the upper left. The JPEG you see here came directly from the camera—it didn't receive any post-processing at all.

## WHITE BALANCE PRESETS

When you plan to shoot a series of exposures under constant lighting conditions (e.g., sunny or overcast skies), it can be practical to use an appropriate preset. This reduces the chance of misinterpreting the color temperature. It also ensures that different JPEGs in the series will be exposed with the exact same (predefined) color temperature setting.

The following seven presets are available in the WHITE BALANCE menu:

- DIRECT SUNLIGHT: for subjects in sunlight
- SHADE: for subjects in shadows
- DAYLIGHT FLOURESCENT: for exposures under "daylight" fluorescents
- WARM WHITE FLOURESCENT: for warm white light
- COOL WHITE FLOURESCENT: for cool white light
- INCANDESCENT: for use with traditional incandescent bulbs
- UNDERWATER: for underwater exposures or pictures of fish in large aquarium tanks and oceanariums

Image 92: **White Balance Presets:**
This illustration shows the same exposure with two different white balance settings: the *left* shows the image with the automatic white balance (AUTO) and the *right* shows what the SHADE preset looks like. The camera-selected setting may produce a more realistic result, but some viewers would find the warmer feel more attractive. These JPEGs are also directly from the camera's internal RAW converter without any post-processing treatment.

## MANUAL WHITE BALANCE

With the X-Pro1 you are able to measure the current color temperature on your own, or if it is already known, you may directly enter the value in Kelvin (K).

The X-Pro1 also allows you to measure the ambient color temperature manually or—if known—to directly input a value in Kelvin (K).

To measure color temperature yourself, go to SHOOTING MENU 2 > WHITE BALANCE > CUSTOM WHITE BALANCE and point the camera at a neutral white or gray object. Then press the shutter-release button all the way. If the measurement is successful, the message COMPLETED! will appear on the display and you can then use the OK button to confirm. If you see UNDER! or OVER! displayed on the monitor, first adjust the exposure and then try again.

The ideal neutral object for measuring white balance is a gray card, which you can buy in most photography stores. You can also get by with other color-neutral objects; just make sure that whatever you use is uniformly illuminated and not reflective. Get very close to whichever object you choose, because the camera does not need to focus on the object it uses to measure white balance.

By selecting SHOOTING MENU 2 > WHITE BALANCE > COLOR TEMPERATURE, you can set your desired color temperature directly in Kelvin (K). This menu offers a list of values between 2,500K and 10,000K. After you have highlighted your choice, press the OK button to select it.

This feature is particularly useful when you're shooting in a studio and already know the color temperature of your light. It is also practical when you want to create a distinctive warm or cold look in your JPEGs (by selecting a higher or lower color temperature setting than the actual environs, respectively).

**TIP**

The X-Pro I shows particular promise with infrared photography (as does the X100)—for example, in combination with an R72 infrared filter (e.g., from Hoya) that can be screwed onto the lens. For this purpose, use the lowest possible color temperature setting of 2500K for reasonably usable JPEGs and as a basis for external RAW development later.

### WHITE BALANCE COLOR SHIFT

After you set the white balance in shooting mode, the display offers yet another option called WB SHIFT. This feature allows you to alter the coloration of your JPEGs along the horizontal green-red axis and the vertical yellow-blue axis by using the selector keys. You'll be able to see the results of these adjustments on the LCD display or in the EVF.

**HINT**

You can set an additional color shift with every possible white balance option (AUTO, all the presets, and both manual methods). The camera remembers this setting individually for each white balance option.

You can also apply a white balance shift (along with any other white balance settings) after you capture your image, when you develop your RAW files. Select the image you are interested in from the playback menu and then choose PLAYBACK MENU 1 > RAW CONVERSION > WB SHIFT.

Image 93: **White Balance Color Shift:** You can alter the look of your JPEGs even after you expose them by programming the X-Pro1's internal RAW converter in various ways, including adjusting the white balance to cause a shift in color. To do this, use the selector keys to move the white dot around the color coordinate grid. The grid here illustrates a color shift of five steps in the direction of red and blue (R 5, B 5). The two sample images demonstrate the actual results of a shift in the white balance: in the *middle*, you can see an exposure taken with standard settings, and *below* you can see the effect of shifting the color two steps toward red and yellow (R 2, B −2). I also changed the film simulation from Provia to Astia and adjusted the color saturation to m-high and the highlight tone to m-hard.

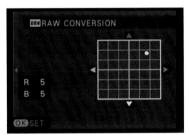

## FILM SIMULATION

If you recall the days of film photography, you'll remember that different films often produce different results. A roll of Fujichrome Velvia 50 slide film is miles apart from Fujicolor Pro 160C in terms of colors, saturation, and contrast.

Digital cameras, on the other hand, only have one sensor, which doesn't vary in character. FUJIFILM, however, offers various film simulations so that you can bring the look of analog color films into the world of digital photography. You can set these either in the shooting menu or when using the RAW converter in the playback menu. Alternatively, you can change the film simulation by accessing the Quick Menu, changing the custom shooting profile, or programming the Fn button accordingly.

In addition to the five color film choices, the X-Pro1 is able to create sepia as well as black-and-white digital images with various virtual color filters (red, yellow, green, neutral).

### COLOR FILMS

The X-Pro1 allows you to choose from three slide films (PROVIA, ASTIA, VELVIA) and two color negative films (PRO NEG. STD and PRO NEG. HI).

• PROVIA exhibits the weakest contrast and is the most neutral of the film simulations. It's also the camera's default setting. Its color saturation is understated and therefore sometimes appears "flat."

Image 94: Film Simulation ASTIA: This JPEG of the Ogoh-Ogoh festival ▶ in Bali was developed internally by the X-Pro1. Exposure parameters: XF60mmF2.4 R Macro, DR200%, ISO 400, f/7.1, 1/420 second. Development settings: film simulation ASTIA, color high, sharpness m-hard, highlight tone m-soft, shadow tone hard, noise reduction m-low.

- ASTIA offers softer looking highlights and noticeably more contrast in the shadows than Provia. The colors are more lively and produce the typical look of "Fuji Colors" with pleasant skin tones. Astia is one of the most popular film simulations among photographers.

- VELVIA delivers very saturated and striking colors with stronger contrast yet. This option is less suited for portraiture but is great for nature and landscape photography.

- PRO NEG. STD is an excellent choice for neutral portraits, because it exhibits soft contrast, modest color saturation, and excellent skin tones. This is a logical choice for situations with controlled light, such as in a studio.

- PRO NEG. HI is the contrast-rich version of PRO Neg. Std, with stronger colors and more pep. The strength of this setting is also in accurate and attractive skin tones.

Remember that the selected film simulation affects the live image display when in shooting mode. It also affects the live histogram in the EVF or on the LCD monitor. This applies to all other JPEG settings described in this chapter too. The viewfinder, monitor, and histogram all

Image 95: **Simulation of Color Slide Film:** The digital film simulations are ▶ not intended to imitate the traditional analog films of Provia, Astia, and Velvia exactly. They rather take distinguishing characteristics from their namesakes: Provia (*above*) is a good all-around choice and functions as the camera's default setting. Astia (*middle*) has a bit more pep and delivers subtle highlights. Velvia (*below*) delivers striking—sometimes exaggerated—colors and harsh transitions at the highlights. You can find larger versions of these illustrations at:

🌐 www.dpunkt.de/XPro1/Abbildungen

PROVIA

ASTIA

VELVIA

reflect your current JPEG settings. Independent of the settings you use when you expose an image, you can also adjust the JPEG parameters afterward in playback mode by using the RAW converter—as long as you save the RAW file.

After white balance, the selection of a film simulation will have the greatest effect on the look of your image. Before you devote any thought to the contrast or color settings of your image, you'll want to decide on a film simulation, and then make the other JPEG settings accordingly.

Image 96: Comparing Color Slide and Color Negative Simulations (1): ▶ For portraits and other shots of people, it's generally desirable to have an accurate and attractive reproduction of skin tones. The color negative simulations PRO Neg. Std (*below left*) and PRO Neg. Hi (*below right*) excel at exactly this quality. In the *top row*, you can see the comparison of the slide film simulations Provia (*left*) and Astia (*right*). In theory, all four of these simulations are designed for portraits. Provia and PRO Neg. Std have more neutral colors and softer contrast, however, while Astia and PRO Neg. Hi bump up the contrast and color saturation. Velvia isn't represented in this comparison because it's not particularly well suited for this type of subject. You can find larger versions of these illustrations at: 🌐 **www.dpunkt.de/XPro1/Abbildungen**

**Image 97: Comparing Color Slide and Color Negative Simulations (2):**
Provia *(top left)* exhibits a conventional and realistic look. Astia *(top right)* is bolder and leans toward purple a bit. PRO Neg. Std *(middle left)* is generally unsaturated and stays away from bright colors. PRO Neg. Hi *(middle right)* is a bit more daring in this regard, but less so than the three slide film simulations. As expected, Velvia *(bottom left)* takes the cake here—its colors almost appear overloaded. Again, you can find larger versions of these and many of the following illustrations at:

⊕ **www.dpunkt.de/XPro1/Abbildungen**

**Image 98: Comparing Color Slide and Color Negative Simulations (3):**
Provia (*top left*) looks a little flat and colorless with this subject. Astia (*top right*) pulls back the veil somewhat and delivers a bit more pep. PRO Neg. Hi (*bottom left*) is an alternative to Astia; however, here you would probably need to increase the color saturation. With Velvia (*bottom right*) that is altogether unnecessary. PRO Neg. Std isn't shown in this comparison, because while it is excellent for studio work, it's less ideal for a subject like this.

## BLACK-AND-WHITE CONVERSION

In addition to the five color film modes, the X-Pro1 can produce black-and-white JPEGs. You can create conventional black-and-white images or pair them with virtual color filters (when shooting black-and-white images with film you'd have to screw these filters to the end of the lens). Conventional conversions of color tones to gray values based on their luminosity (brightness) often produce boring results. A pronounced contrast between a dark red and a dark blue area in the original image could quickly become a gray mush with an unfiltered black-and-white conversion.

Color filters are used in black-and-white photography to retain these pronounced contrasts of color during the conversion process. A red filter darkens a blue sky so that it will appear dark gray or nearly black in contrast to the bright white clouds. Without this filter, you would end up with bright gray clouds on a bright gray sky. The X-Pro1 simulates this effect by running the RAW file (which is always in color) through a virtual color filter when it develops a JPEG. You have five black-and-white options available:

- MONOCHROME executes a conventional black-and-white conversion of the color RAW file.

- MONOCHROME + Ye FILTER produces a general boost in contrast for many subjects and is accordingly a good compromise.

- MONOCHROME + R FILTER darkens blue tones (e.g., a blue sky) and brightens faces and red lips.

- MONOCHROME + G FILTER differentiates green tones in images of natural settings, darkens faces and red lips, and emphasizes any blemishes of the skin.

- SEPIA tints the black-and-white conversion with sepia, giving the image an antiquated feel.

Image 99: **Using Filters with Black-and-White Conversions:**
The conventional MONOCHROME conversion (*top left*) is markedly different from a conversion that employed the G FILTER (*top right*): the filter darkened the red petals drastically. The Ye FILTER (*middle left*) produced a general increase in contrast, and the R FILTER (*middle right*) brightened up the naturally red blossom. The SEPIA (*bottom left*) conversion recalls the early days of film photography, and on the *bottom right* you can see the color source for these conversions, depicted with the Provia film simulation.

Unlike the color film simulations, the black-and-white conversions do not have the unique contrast curves typical of film. The conversion tends to be much more flat and unobtrusive so that the black-and-white images produced by the camera can still withstand a manual contrast adjustment on your PC.

Image 100: **Manual Contrast Enhancement in Black-and-White Conversions:** The X-Pro I converted the JPEG here with the MONOCHROME + R FILTER. I then edited the image in Apple Aperture 3 by applying a contrast curve typical for black-and-white film.

**HINT**

The X-Pro1 is not a black-and-white camera. As with nearly every other digital camera, it captures subjects in color, saves this data as color RAW files, and then later develops the images in black-and-white during the RAW conversion. Along with the usual suspects of Adobe Lightroom, Adobe Photoshop, and Apple Aperture, there are also highly specialized programs such as NIK Silver Efex Pro and Topaz B&W Effects that offer many more possibilities than the X-Pro1's comparatively rudimentary internal black-and-white options.

Nevertheless, it can still be useful for experienced black-and-white photographers to use the black-and-white film simulation mode. If nothing else, it will provide you with a preview image in the EVF and on the LCD monitor that can inform your later decisions and methods. In addition, it can be useful to save the JPEG produced by the camera as a reference when executing the external RAW conversion.

You lose nothing by switching your camera into black-and-white mode, because at any time you can always go in and reconvert the RAW data files into color versions with one of the five color film simulations.

## FILM SIMULATION BRACKETING

If you would like to get a quick overview of what the different film simulations would look like with a given subject, you can press the DRIVE button and select the option FILM SIMULATION BKT. When this feature is active, the camera will produce three JPEGs each time you release the shutter. You can control which three simulations the camera uses by going to SHOOTING MENU 1 > FILM SIMULATION BKT.

In principle this is a practical option for anyone who can't decide which simulation to use, or who would like to have more than one result from which to choose. However, the camera does not save any RAW files when this mode is activated. Selecting this option means foregoing the opportunity to develop and optimize your exposures again later with either the internal or an external RAW converter.

For this reason, I recommend that you generally avoid this mode and instead shoot with the FINE+RAW image quality setting so you will always have access to the RAW files. Snap your exposures with the film simulation that you are most likely to prefer—then, if needed, use the internal RAW converter to produces alternate options (PLAYBACK MENU 1 > RAW CONVERSION).

## COLOR

The color setting allows you to control the color saturation of your JPEGs. The intensity of the colors can be either dialed up or toned down. To do this, go to SHOOTING MENU 2 > COLOR and select one of the five available levels from (–2) LOW to (+2) HIGH.

As with most other JPEG settings, you can change the COLOR setting by pressing the Q button or switching the custom shooting profile. This setting cannot be assigned to the Fn button, however.

Image 101: **Color Saturation:** The JPEG setting COLOR regulates the intensity of color reproduction. The setting you choose works in combination with the color profile for whichever film simulation you are using. Using Provia in combination with (+2) HIGH for the COLOR still produces less saturated colors than Velvia does with a neutral COLOR setting. This illustration shows the film simulation Astia at three different color levels: COLOR (–2) LOW (*left*); COLOR (0) STANDARD (*middle*); and COLOR (+2) HIGH (*right*).

The color setting—as with most other JPEG settings—is really something you don't need to think about until after your exposure. With the help of the internal RAW converter (PLAYBACK MENU 1 > RAW CONVERSION) you can increase or decrease the saturation as needed. Finally, color is a matter of taste, but you should make sure that dialing up the color saturation doesn't result in an overflow of a particular color channel (and the ensuing loss of tone values).

## CONTRAST

Every image has three rough areas of tonal values: shadows, midtones, and highlights. When you increase the brightness of the highlights while decreasing the brightness of the shadows, you are increasing the contrast of the exposure.

When working in an image-editing program you can adjust the contrast control or apply an appropriate gradation curve to achieve this effect. Image 100 illustrates an example of such a curve, which was used to optimize the contrast of a black-and-white JPEG produced internally by the camera.

## CONTROLLING THE HIGHLIGHTS

By going to SHOOTING MENU 2 > HIGHLIGHT TONE you can control the areas of bright tonal values in your images. Here also you have five levels at your disposal, ranging from (−2) SOFT to (+2) HARD. You can also adjust this setting by opening up the Quick Menu (Q button) or changing the custom shooting profile.

Settings on the SOFT side will darken your highlights and settings on the HARD side will brighten them. STANDARD produces a neutral result.

Image 102: The **HIGHLIGHT TONE** Setting: ▶
This contrast setting regulates the reproduction in the bright areas of your images: SOFT darkens the highlights, STANDARD keeps their normal brightness, and HARD makes them even brighter. In this illustration, you can see the effect of the highlight tone setting clearly on the roof of the car, on the bright collar of the shirt, and in the sky. As you can see, you should adjust this setting with caution. Increasing the contrast too much can cause the highlights to blow out, resulting in a loss of image detail. Conversely, images for which the contrast is too soft appear unattractively flat. As with other settings, it's best to adjust the highlight tone with the internal RAW converter afterward to try out different options.

HIGHLIGHT TONE
(–2) SOFT

HIGHLIGHT TONE
(0) STANDARD

HIGHLIGHT TONE
(+2) HARD

## CONTROLLING THE SHADOWS

The counterparts to the highlights in an image can be controlled by going to SHOOTING MENU 2 > SHADOW TONE. This setting controls the contrast in the dark parts of your images. Here too five levels are available, from (−2) SOFT to (+2) HARD. Adjusting your image with values on the SOFT end of the scale will result in brighter shadows, and values on the HARD side will result in darker shadows. You can also change this setting by pressing the Q button or changing the shooting profile.

Image 103: The SHADOW TONE Setting: ▶
This setting controls the reproduction of shadows when the X-Pro I produces JPEG files. SOFT brightens the shadows and HARD darkens them. This effect can be seen clearly in the overcoat depicted in this photo. The coat's different levels of brightness are much easier to see when the shadow tone is set to SOFT. The coat and the tie are blocked up when the shadow tone is set to HARD. This again is a reason to err on the side of setting this parameter conservatively to avoid the unwanted loss of tonal values.

SHADOW TONE
(–2) SOFT

SHADOW TONE
(0) STANDARD

SHADOW TONE
(+2) HARD

Being able to regulate the highlights and the shadows separately gives you more flexibility than a conventional contrast control does. You can, for example, brighten the dark areas of an image without blowing out the highlights.

You can also use these contrast controls to simulate a traditional contrast control by adjusting the highlights and shadows in the same direction. Setting the tonal values in both areas to SOFT, for example, will reduce the contrast in your image, and setting them both to HARD will increase it.

Since these contrast settings greatly affect the appearance of your images, it's generally best to play it safe and avoid the extreme settings when exposing your image. You can always experiment with less conservative settings afterward by using the internal RAW converter to redevelop your images.

Image 104: Traditional Contrast Control: ▶
By adjusting the highlight tone and shadow tone in parallel, you can adjust the contrast of your exposures by conventional means. To do this, simply set the parameters identically for both areas of tonal values. The illustration shows the same exposure three times, with both the shadow and highlight tone set at SOFT, then at STANDARD, and finally at HARD.

SOFT – SOFT

STANDARD –
STANDARD

HARD – HARD

## SHARPNESS

If you ask a layperson whether he or she prefers images that are more sharp or less sharp, the answer is likely to be, "more sharp, of course!" In regard to image sharpness, or better yet, the resharpening of an image, though, the answer isn't so simple.

Resharpening an image actually makes it easier to discern detail. The details are accentuated and thus sharper. At the same time, however, the process causes the smallest details to be lost. This is why it's best to apply the sharpness setting in a measured fashion. Fortunately, this setting is available when using the internal RAW converter, so you can try out several different settings and choose the best after capturing your image.

In addition to bringing up the sharpness options when using the RAW converter, you can also do so by going to SHOOTING MENU 2 > SHARPNESS when in the shooting mode. The camera again offers five steps of intensity, ranging from (−2) SOFT to (+2) HARD. You can also open the menu to adjust the sharpness with the Q button or program varying sharpness levels into the different custom shooting profiles.

Image 105: Sharpness Setting: ▶
This illustration demonstrates the effect of the SHARPNESS setting, when programmed to SOFT, STANDARD, and HARD. With increasing hardness, the setting accentuates the contours of individual details, thereby giving the impression of a greater overall sharpness.

SHARPNESS
(-2) SOFT

SHARPNESS
(0) STANDARD

SHARPNESS
(+2) HARD

HINT

Different contrast settings can often give the impression of increased (or decreased) image sharpness. The stronger the contrast, the stronger the subjective impression of sharpness. A popular method of achieving this effect is to increase the microcontrast in the midtones of an image. The much-loved "clarity" slider in Adobe Lightroom is capable of doing this. Many photographers like to set their sharpness to a softer level, preferring to adjust it on their PC, perhaps by using an unsharp masking filter or a specific software program such as NIK RAW Sharpener Pro. The truth is, you can resharpen an image at any time—but it's much more difficult to remove sharpness after the fact without sacrificing detail.

### NOISE REDUCTION

Image noise most commonly arises when using very high ISO values. One way to keep image noise in check is by using the noise reduction function when converting your JPEGs. This method has a catch, though: the stronger you apply this setting, the more image details are lost. Applying noise reduction is a balance of retaining details while doing away with visual interference.

The X-Pro1 excels at this function, and SHOOTING MENU 2 > NOISE REDUCTION offers five different settings—ranging again from (–2) LOW to (+2) HIGH— to help you strike the optimal balance. This is another instance when you should delay worrying about the perfect setting until after you've exposed your image and are ready to process it with the camera's internal RAW converter.

As with most of the other JPEG parameters, you can define the noise reduction setting in the Quick Menu as well as in the custom shooting profiles.

Image 106: **Noise Reduction Setting:**
This image, snapped at ISO 3200, shows just how effective the X-Pro1 is at eliminating disturbing image noise while retaining desirable details when creating JPEGs. The three enlarged portions of the image show the results of applying the LOW, STANDARD, and HIGH noise reduction settings. Even in the lowest setting (*left*) you can see that the color noise is in no way bothersome. The standard setting in the *middle* is a decent compromise, but the HIGH setting (*right*) washes out a few details and is thus not ideal for this situation.

**HINT**

Many photographers prefer to carry out their own noise reduction using an image-editing software on their PCs, rather than trust the X-Pro I to do the job. In this case, set the NOISE REDUCTION to LOW. Since noise reduction is a setting that affects only JPEG files, you would need to attend to noise reduction anyway when developing your images in an external RAW conversion program or when using a specialized program such as NIK Dfine or Topaz DeNoise. The X-Pro I's X-Trans sensor captures images with so little noise, however, that distracting image noise is likely to surface only when using very high ISO settings above ISO 3200.

The STANDARD (0) setting is in most cases a decent compromise. The X-Pro1's noise reduction technology is so good, actually, that some external editing programs can't hold a candle to it. But this too is a matter of personal taste and ultimately depends on your subject. In particular, when using the black-and-white conversion feature, you can almost always set the noise reduction to LOW (–2).

### CUSTOM SHOOTING PROFILES

As we've seen, the X-Pro1 has a plethora of settings options: ISO, DR function, white balance, film simulation, color, contrast (highlights and shadows), sharpness, noise reduction. You may be wondering, "How am I supposed to define all of these settings quickly when I'm ready to snap an image? I want to take pictures; I don't want to stand around fumbling with my camera!"

Here is where the X-Pro1's seven custom shooting profiles come into play. They allow you to program each variable independently and then save them together in

a bundle. Then you can switch back and forth quickly among your predefined profiles.

DEFINING AND CHANGING CUSTOM PROFILES

To set up or change a custom profile, go to SHOOTING MENU 3 > EDIT/SAVE CUSTOM SETTING and select one of the seven profiles (CUSTOM 1 to 7). You can either import your current camera settings to one of the profiles (SAVE CURRENT SETTINGS) or input new definitions for ISO, DYNAMIC RANGE, FILM SIMULATION, WHITE BALANCE, COLOR, SHARPNESS, HIGHLIGHT TONE, SHADOW TONE, and NOISE REDUCTION.

You can also use a combination of the two methods by first saving the current settings and then adjusting them accordingly. When you're finished and you press the DISP/BACK button, the camera will ask if you'd like to save your settings. When yes, select OK; if you'd like to continue editing the selected custom profile, select CANCEL.

> **TIP**
>
> The Q button offers a shortcut to editing or changing your shooting profile. Press and hold the Q button until the EDIT/SAVE CUSTOM SETTING menu appears on the camera's active display.

### RECALLING A CUSTOM PROFILE

To activate one of the seven saved custom profiles, select SHOOTING MENU 3 > SELECT CUSTOM SETTING and chose your desired profile.

The Q button can also save you some time here: tap the Q button to bring up the Quick Menu and then select from C1 to C7 in the setting field in the top left. The shooting settings associated with each profile will display in the Quick Menu so you can get an overview of the definitions for each setting.

The third option to switch between custom profiles quickly is to program the Fn button to serve this purpose. Hold the Fn button until the configuration menu appears and then assign SELECT CUSTOM SETTING.

### EXAMPLES OF CUSTOM PROFILES

Which profiles should you save? Only you can answer this question for yourself—photographers not only have individual requirements and aims, but they also have their own stylistic preferences. This is exactly why the X-Pro1 has so many different programming possibilities. If there were one "optimal" universal setting, FUJIFILM could have done away with the various options. Nevertheless, here are a few recommendations for potentially useful custom profiles:

• **All-around profile:** In this profile, I save the settings that generally apply to everyday situations and quick snapshots. My typical settings for my all-around profile are automatic white balance, auto ISO, auto DR, Astia, and occasionally a decreased noise reduction set at medium low.

• **DR100% profile:** This is a variation of the all-around profile with the dynamic range setting fixed at DR100%. This profile allows me to use the live histogram for correcting the exposure and target the

brighter areas of my image more accurately when defining the exposure settings.

- **Black-and-white profile:** Any time I imagine an image would look good in black-and-white, I use this profile, which includes the black-and-white film simulation and increased contrast settings. The electronic viewfinder gives me a practical (black-and-white) preview of my subject.

- **Special profile:** I generally reserve one profile for special situations, such as shooting in a studio or taking infrared images, when it is practical to shoot with a color temperature setting predefined in Kelvin.

- **"RAW shooter" profile:** I use this profile when I know in advance that I will probably want to expose the image very carefully so that I can develop and edit it with an external RAW converter.

### A JPEG PROFILE FOR RAW SHOOTERS

No, the idea of a JPEG profile for RAW shooters is not a joke. While JPEG settings have no effect on RAW files, they do affect what image you can see in the electronic viewfinder (EVF) and on the LCD display. Moreover, the data for the live histogram is derived from the image that appears in the live view—in other words, it too is affected by your current JPEG settings.

What does this mean concretely? If you select VELVIA as your film simulation, for example, not only will you have a brightly colored JPEG; you'll also have a brightly colored live view preview with pronounced contrast. This image preview is reflected in the live histogram as well, and the Velvia simulation will cause the peaks of exposure to shift to either the left or the right limits quicker than if Provia were used instead.

The same goes for the contrast settings (HIGHLIGHT TONE and SHADOW TONE): if both parameters are set to

HARD then the highlights and shadows will shift beyond the right and left limits of the histogram faster than they would if both were set to SOFT.

As I've already said, the RAW file itself isn't affected by any of this—it collects all of the image information that the sensor is capable of capturing. Conversely, JPEGs rely on only a portion of the RAW data.

Do you see where this is going? The objective here is setting the JPEG parameters in a way that allows you to see the largest possible portion of the RAW data—because this is the information that interests us as RAW shooters. We want to squeeze everything possible out of our camera and its sensor—to get the absolute maximum and to leave nothing behind. We want to explore the limits of the dynamic range and expose as close as possible to its borders. And we want the live histogram to inform us of where these limits are as precisely as possible.

The JPEG settings influence how we expose and adjust our images because we make our decisions about exposure using the information we can gather from the histogram and the live image. We therefore want JPEG settings that produce the softest contrast in order to obtain a histogram that reveals the most useful information about dynamic range for RAW files. Here are my recommendations for this JPEG profile:

- **DYNAMIC RANGE > DR100%.** The live histogram supplies meaningful information only with this DR setting.

- **FILM SIMULATION > PROVIA**. This is the most neutral film simulation and also has the softest contrast. This setting will prevent highlights and shadows from unnecessarily being cropped at either end of the histogram.

- **HIGHLIGHT TONE > (–2) SOFT.** The RAW format of the sensor has an exposure reserve of approximately 0.4 EV in comparison to the processed JPEG format. You can access this reserve with an external RAW converter. The live histogram should be set to SOFT at its edges to prevent RAW shooters from exposing their images too conservatively.

- **SHADOW TONE > (–2) SOFT.** When you use DR100% with high-contrast subjects in order to use the live histogram to base your exposure on the bright areas of your image, the dark areas often end up appearing as blocked-up black areas. This SHADOW TONE setting of (–2) SOFT counteracts this problem, since it brightens the dark tonal values in the viewfinder (and in the live histogram).

## ETTR – EXPOSE TO THE RIGHT

The ETTR exposure technique is popular among RAW shooters because it takes into account the technical characteristics of the camera's sensor. The ETTR rule suggests that you should expose every image (regardless of its dynamic range) as far to the right of the histogram as possible without allowing any valuable highlight areas to become overexposed. The reasoning behind this is technical: since the X-Pro1 is a 12-bit camera, it can differentiate 4,094 (= 212) tonal values that it must pack into some 9 exposure values. Since the brightness gets cut in half for each exposure value, the brightest exposure value contains 2,048 (=4.096/2) tonal values, the second brightest only has 1,024, and so on. The lowest exposure value of the camera can only record eight different tones.

If you expose your images as brightly as possible, you will be relying on a greater number of tonal values. This will give you more tolerance when editing your images, especially since you can easily take an image that's been exposed to the right and "shift it back to the left" when developing the RAW file (and using a software program's exposure control feature). The noise behavior of the sensor provides an additional reason for following the ETTR line of thinking. Noise is much more of a problem in the shadows because the signal-noise ratio is much worse for darker tonal values. For subjects that are very dark and have a very weak contrast (e.g., a black cat on a black street), it makes sense to forgo attempting to expose your image realistically as black, and instead to brighten it up and expose it as gray—knowing that you can correct the exposure later with the RAW conversion. This method allows you to have more tone values and less noise.

ETTR is often misunderstood. It does not suggest that you should expose your images in such a way that you end up with overexposed areas and lost tonal values above the sensor's upper limit. Correctly applying ETTR methodology actually often requires that you shift the image left to make sure that any significant highlights are located directly at the right limit of the histogram. The highlights should just touch the right border; they shouldn't go beyond it!

Finally, keep in mind that shifting a dark and low-contrast image to the right inevitably leads to slower shutter speeds and/or smaller f-numbers. ETTR only makes sense when the subject is well-suited to adjustments in the exposure parameters. It's no good, for example, if you need to raise the ISO, or if you allow your camera to do so with auto ISO, in order to expose to the right. You're only making extra work for yourself, because any benefits will be counterbalanced by the cost of needing a stronger signal amplification.

### INTERNAL VS. EXTERNAL RAW CONVERSION

The X-Pro1 makes a RAW shooter out of everyone to some degree. This is because the camera's internal RAW converter allows even the most dedicated JPEG photographers to develop new and improved JPEGs from already-exposed images with just a few simple steps. As a user of the X-Pro1, you can be a relaxed spectator to the fervid wars fought in Internet forums on the subject of "RAW or JPEG." By using the recommended FINE+RAW setting, you're always on the right side and have all of your options available:

- You can hold onto the JPEG that the camera produces immediately after exposure when you are satisfied with the JPEG settings that were used.

- You can use the X-Pro1's internal RAW converter to develop the RAW file into alternate versions of the original JPEG file.

- You can transfer the RAW file to a computer and use an external RAW converter such as Lightroom, Silkypix, or Raw Photo Processor (RPP) to develop and edit JPEGs.

- You can also transfer the JPEGs you produce from the first two options to your computer and then continue to edit them there. The robust JPEGs that the X-Pro1 produces are intended to allow for post-processing. With that said, though, the compressed 8-bit image format (256 different tonal values) does have certain technical limits, putting it at an obvious disadvantage in comparison to the 16-bit files of external RAW converters.

When should you develop RAW files internally and when should you rely on an external RAW converter? Ultimately, this is a question of purpose and quality. Just to be clear: the X-Pro1's internal RAW converter produces excellent results as well as the much-loved Fuji colors. For most situations, the internal converter is more than adequate. Configuring your camera in the manner I've just discussed will allow the X-Pro1 to develop robust, attractive JPEGs that you can optimize on your computer without any trouble.

If you are interested in pushing the camera to its quality and resolution limits, though, I recommend that you use an external RAW converter. With the right settings, RPP and Silkypix in particular are capable of producing fantastic results. However, these programs are a science unto themselves and could be the subject of entire books.

**Image 107: External RAW Conversion:** ▶
When shooting with the X-Pro1, you can attain maximum sharpness, detail resolution, and control over colors and contrast with the help of an external RAW workflow. This example benefited from the use of RPP 64, Adobe Lightroom, Apple Aperture, and VSCO Film. Exposure parameters: XF60mmF2.4 R Macro, ISO 200, f/8, 0.4 second, automatic white balance.

Image 108: RAW (Internal) vs. RAW (External): Comparing Callouts:
To get the maximum performance from the camera sensor, you need not only competent post-processing, but also proper exposure technique. This means that exposing your images perfectly with ISO 200 and ETTR isn't enough if you want to explore the limits of the X-Trans sensor: you also need to shoot without any camera shake by using a stable tripod as well as a remote trigger or timer release, and you need to use an aperture that falls in the "sweet spot" for the lens (usually between f/5.6 and f/11). With this setup, there are noticeable differences between images created with the internal RAW converter and with a thorough external RAW development process. You can simply get more from the RAW data with an external converter—just set aside one or two hours for it. This illustration shows two callouts from the previous image: the *left* is a Velvia image produced directly by the camera; the *right* is the product of an external RAW workflow.

## OPTICAL CORRECTIONS

When the X-Pro1 produces a JPEG file for you to review immediately after snapping an exposure, it applies several corrections based on the optics of the lens (distortion, vignetting, chromatic aberrations) and saves information about these corrections as metadata in the RAW file. External RAW converters such as Silkypix or Lightroom can access these metadata and apply the necessary corrections automatically when developing an image.

The corrections applied by external RAW converters aren't always identical to those applied by the camera itself, however. The RAW conversion program RPP lacks the ability to apply any optical corrections.

You can think about the optical correction information saved in the RAW files as stage directions that different actors interpret in different ways. In the case of RPP, there simply aren't any actors available.

### COLOR SPACE

One other—and final—JPEG setting for the X-Pro1 is COLOR SPACE. This JPEG setting is something of an anomaly because you won't find it in the shooting menu: it's located in SETUP MENU 3. It also isn't located in the Quick Menu and you can't assign it to the Fn button or save it in the custom shooting profiles.

The X-Pro1 allows you to save JPEGs in two different color spaces: sRGB or Adobe RGB. Both color spaces have the same number of colors, but those colors aren't the same.

- sRGB is based on the technology of standard computer screens and is accordingly suitable for any images that you plan to post on the web (e.g., Flickr) or in social networks (e.g., Facebook), or to view on a desktop computer, laptop, iPad, or smartphone.

- Adobe RGB offers a larger range of colors than sRGB (with larger gaps between each individual color) and includes colors that can be represented in four-color printing (CMYK).

Which color space you should use depends entirely on what you intend to do with your images. For most applications sRGB will be the better choice (for compatibility reasons). sRGB is the color space that the LCD monitor and EVF use, and it is also the color space of most

computer screens, laptops, and smartphones. If you do decide to use Adobe RGB, you should definitely use a wide gamut monitor, which offers an extended color space display, to edit your images. Only with a special monitor of this sort can you actually display the colors in the extended range that are not available in the sRGB color space. Without such a monitor designed for this purpose, editing Adobe RGB images would be similar to flying blind.

In addition to sRGB and Adobe RGB there are several other extended color spaces. Modern image-editing programs often support more than a half dozen varieties. If you take your images to a service provider for printing, you should ask ahead of time what color space it prefers (usually it is sRGB). Anyone who works with laptops or "normal" monitors or plans to present his or her images online or in a digital format is best served by sRGB. I personally save all of my images exclusively in sRGB format.

This question about color space doesn't affect just the JPEGs that the camera produces; it also has implications for external RAW conversion. While RAW files themselves aren't saved in a specific color space, eventually you will have to save the converted RAW file, and then you will need to make a decision.

The X-Pro1 adds an additional underscore to the file name of any JPEG file saved in Adobe RGB format. For example, if the file DSCF4064.JPG were saved in Adobe RGB, it would be saved as _DSF4064.JPG. This also goes for the RAW file associated with a JPEG, as long as the camera was set in Adobe RGB when the image was exposed (e.g., _DSF4064. RAF). This convention isn't specific to Fuji products; it's an industry standard. For every JPEG you develop from a RAW file using the X-Pro1's internal RAW converter, you can select a color space anew. The X-Pro1 then uses the file naming convention described here.

## WORKING WITH THE INTERNAL RAW CONVERTER

As you already know, the X-Pro1 has its own internal RAW converter for developing JPEGs from RAW files at any time. This converter gives you complete control over the various JPEG parameters, the white balance, and the color space of the end product. The internal converter not only delivers the famous Fuji colors; it allows you to operate independent of external software that may be either difficult to use or not (yet) compatible with the X-Pro1's cutting-edge RAW format.

When in playback mode, you can go to PLAYBACK MENU 1 > RAW CONVERSION to bring up the internal RAW converter and use it to develop the selected RAW file. You will then have the following options available:

• With PUSH/PULL PROCESSING you can retroactively correct the exposure upward or downward in steps of 1/3 EV. This function is analogous to the exposure control feature of an external RAW conversion program.

- DYNAMIC RANGE allows you to reduce the highlights in an image that was exposed at DR200% or DR400% by one or two aperture stops, for example, in order to raise its contrast.

- FILM SIMULATION allows you to choose from the camera's ten different color and black-and-white film modes.

- WHITE BALANCE allows you to access the various white balance presets and define a color temperature in Kelvin (K) manually.

- WB SHIFT brings up the color shift matrix for the white balance, where you can use the selector keys to tweak the color tone within the selected white balance setting.

- COLOR controls the color saturation of the conversion.

- With SHARPNESS you can choose from five levels that will affect the degree of sharpness processing that the conversion will include.

- HIGHLIGHT TONE and SHADOW TONE independently determine the contrast settings (tone curve) for the bright and dark areas of an image, respectively.

- NOISE REDUCTION regulates the strength of the noise suppression that the converter uses when producing a JPEG.

- With COLOR SPACE you can decide on the color space for the finished JPEG.

The options available in the RAW converter correspond to those in the shooting menu. Unfortunately, however, some of the descriptions vary slightly: for example, the option (−1) MEDIUM SOFT is called M-SOFT in the RAW converter.

If you'd like to develop a JPEG using exactly the same settings that you had in place when you exposed the image, simply press REFLECT SHOOTING COND.

What should you do if you want to develop a RAW file that is no longer saved on your camera's memory card?

No problem: you can copy RAW files created with an X-Pro1 (they don't have to be from your own camera) back onto an SD card at any time and then use the X-Pro1's internal converter to develop them.

Simply copy the RAW file (complete with the recognizable file ending .RAF) into a subfolder on your memory card to which your camera currently saves new image files. The directory path could be, for example: MEMORY CARD > DCIM > 104_FUJI. The number preceding the word FUJI is variable and dependent on the number of exposures that you have created with your camera.

If you have recently formatted your memory card and it doesn't yet have the proper file architecture, simply take a new exposure first and the X-Pro1 will automatically create the appropriate directories. Then you can insert the memory card into your computer's reader and save the RAW file that you would like to develop later in the appropriate image folder.

**IMPORTANT**

Transferring images from a computer to your camera is not possible with the included USB cable. You need to treat the memory card as an external drive and connect it directly to your computer. Then you can copy the desired images to the image folder (as though it were an external hard drive).

# 2.8 CONTINUOUS SHOOTING, PANORAMAS, MOVIES, DOUBLE EXPOSURES, AND THE SELF-TIMER

The DRIVE button allows you to set the X-Pro1 in several different exposure modes. You're already well acquainted with STILL IMAGE, the camera's standard setting. In this mode, the camera captures one single frame when you press the shutter-release button all the way down.

As long as the X-Pro1's cache doesn't fill up, you can snap several frames in STILL IMAGE mode in quick succession. The buffer memory can hold about 11 exposures shot at the FINE+RAW quality setting. Since the image data is written to the memory card in the background, the X-Pro1 is always ready to shoot.

The camera's various bracketing options should also be familiar from earlier in the book. A quick review:

• AE BKT produces three images at different levels of exposure. The corresponding RAW files are saved in this mode, as long as the image quality setting dictates they should be (see section 2.3 under "Metering").

- ISO BKT produces three JPEG files at different ISO values from one exposure. No RAW files are saved (see section 2.5).

- FILM SIMULATION BKT produces three JPEGs with different film simulations from one exposure. Here too, the X-Pro1 does not save any RAW files (see section 2.7 under "Film Simulation").

- DYNAMIC RANGE BKT creates three exposures at different DR settings and similarly saves no RAW files (see section 2.6).

| IMPORTANT |
| --- |
| One unfortunate quality of the exposure bracketing function is that the X-Pro1 disables the shutter-release button until all of the image data for the three images are completely saved to the memory card (firmware version 1.11). |

The DRIVE button is also home to a few other handy features:

- **CONTINUOUS shooting**
- **MOTION PANORAMA**
- **MOVIE**

Furthermore, the X-Pro1 allows you to meld two images exposed directly after one another into a single double-exposure with the MULTIPLE EXPOSURE feature. Inexplicably, you can't access this feature by pressing the DRIVE button—you need to go to SHOOTING MENU 4.

## CONTINUOUS SHOOTING (BURST MODE)

When the CONTINUOUS mode is selected from the DRIVE-button options, the X-Pro1 takes several exposures in a burst. You can choose between three and six images per second. The camera will snap images at the rate you determine for as long as you keep the shutter-release button fully depressed—or until the buffer memory reaches its limit. If you're saving RAW files, this cache reaches its limit at about 11 exposures, but if you're only saving JPEGs, you can shoot up to about 19. Once the buffer memory fills up, the camera will still (sporadically) capture additional images depending on when older exposures are successfully transferred from the buffer to the memory card.

> ## IMPORTANT
>
> When using the CONTINUOUS mode, the camera applies the exposure, autofocus, and white balance settings that are in place for the initial exposure to the entire series. These settings are not reconfigured for each individual capture.

The CONTINUOUS mode has some characteristics typical of Fuji:

- The file naming convention for the images captured in this mode is different from "regular" exposures: the file names for images in a continuous burst start with the letter S, for example: S0063422.RAF. If you import photos that are alphabetically sorted according to file name into your computer's image management software, any images belonging to a continuous series will pop up at the bottom of the list.

- Images that are part of a continuous series are treated differently from still images in the X-Pro1's playback mode: only the first image of the series is shown at the

full frame of the display. The rest of the exposures are displayed in a small window in the manner of a flip book. To examine the individual images in a series, you must press the down selector key. Then you can browse the series' images as you normally would, using the selector keys or the command dial.

Image 109: **Continuous Shooting Mode:**
Even when saving RAW files, the X-Pro1 can shoot up to six frames per second. The buffer memory, which can hold 11 RAW exposures, accordingly fills up in about 2 seconds. This means that good timing is critical for starting a series, because the actual window of time that the burst mode is fully functional is quite short. Also make sure to note the different file naming convention for images in a series: in contrast to other still images, the file names of images that are part of a series start with the letter S.

Image 110: **Playback of Images in a Series:**
When displaying a series of images in the playback mode, the camera presents the initial frame large and the others in a small flip-book preview. To examine the other images of the series more closely, you can use the down selector key and then browse through them as usual by using the selector keys or the command dial.

TIPS FOR WORKING IN BURST MODE

Since the X-Pro1 does not refocus or adjust the exposure or white balance after the first image in CONTINUOUS mode, it's a good idea to make sure you have these settings configured as accurately as possible before starting. Using the flash in burst mode is *not* possible.

• When you're using the X-Pro1's burst mode to track a moving object, it's possible for the exposure situation to change drastically during the series. The first frame may be backlit, for example, while the remaining images in the series could be exposed with side light or reflected light. As another example, your moving object may move from a shadowy area into direct sunlight. When you're trying to deal with circumstances such as these, opt for exposure settings that are a workable compromise for the entire series. You can set the exposure at an average setting by using AE lock (AE-L), by pressing the shutter-release button halfway, or by shooting in manual mode (**M**). The DR function also offers protection from blown-out highlights. If your subject exhibits a large dynamic range, consider using the DR200% or DR400% to protect against overexposure.

• When using burst mode, set your focus in advance of the action and make sure to press the shutter-release button right before your subject reaches your desired focus point. You can also stop down the aperture to get a focus zone with a larger depth of field and then press the shutter-release button as soon as the subject moves into this focus zone. To avoid trigger lags owing to the autofocus, make sure to use the AF lock (AF-L) to store the focus by pressing the shutter-release button halfway, or focus manually.

• Since the X-Pro1's cache can hold only 11 exposures, you have just a brief two seconds for continuous shooting. This means your timing needs to be impeccable. You'll want to make sure that you have the shutter-release button pressed halfway down for at least a few fractions of a second before you actually want to start the burst; otherwise you run the risk of trigger lag ruining your shot.

• Rely principally on the optical viewfinder (OVF) for fast-moving subjects, because it will allow you to perceive your subject without any time delay—this isn't true of the electronic viewfinder (EVF).

## PANORAMA IMAGES

With the DRIVE-button option MOTION PANORAMA, you can create panorama exposures with dimensions of up to 7680 x 2160 pixels. The camera does most of the work, assembling the panorama image automatically from a series of still images. Your job as the photographer is to press the shutter-release button and evenly swivel the camera vertically or horizontally until the preset image angle is complete.

You can choose between two image angles, M and L, which correspond to 120 and 180 degrees, respectively, and can be applied either horizontally or vertically. In size L, the final size of the exposure in horizontal mode is 7680 x 1440 pixels, and in the vertical mode, 7680 x 2160 pixels. Size M ends up being 5120 x 1440 pixels with the horizontal setup and 5120 x 2160 pixels with the vertical. You can also use the vertical option to create a horizontal panorama—you'll just need to hold the camera on its side as you pivot it.

After pressing the DRIVE button and selecting MOTION PANORAMA, you can define the direction you intend to move your camera with DIRECTION and the size of the panorama with ANGLE (M or L).

## IMPORTANT

Using the MOTION PANORAMA option will not produce any RAW data; it only creates a large JPEG file. This means that you'll need to decide on a FILM SIMULATION and a WHITE BALANCE before you take the exposure. Neither setting can be changed afterward. Since panoramic images usually cover a large amount of subject matter with varying light conditions, you should set the white balance based on the most important area of your shot.

In a similar vein, the camera sets the exposure and the focus based on the first exposure in the series for panoramic images, so it also makes sense to set the X-Pro I's focus and exposure in advance based on the most important part of your image—by using the AF-L or AE-L button, by focusing manually, or by storing the focus and exposure settings temporarily by pressing the shutter-release button halfway before you move the camera to its initial position and start to record the actual panorama.

Since panoramic images also tend to have a large dynamic range, it's usually wise to avail yourself of the camera's DR function and select DR200% or DR400%. Since MOTION PANORAMA doesn't produce any RAW data and saves only a large JPEG file, ETTR (see page 212) won't do you any good. The camera doesn't provide you with any RAW file for you to map the tones afterward.

As soon as you press the shutter-release button to start the MOTION PANORAMA, the X-Pro1 will capture the still images it needs, as long as you evenly pivot the

camera in the predetermined direction (indicated with an arrow in the viewfinder). You don't need to continue to hold the shutter-release button.

When the camera captures all of the images it needs to compose the panorama, it automatically stops. When creating a size M panorama, it can be somewhat irritating that the X-Pro1 sometimes takes more images than are necessary. If that's the case, simply continue to pivot the camera until it ends the process by itself.

### TIPS FOR USING THE PANORAMA FUNCTION

- Avoid scenes with moving objects, which will lead to undesirable ghosting artifacts when the feature creates the composite image. For example, a person who walks through a scene while you're capturing it in a panorama could appear several times as fragments in the finished JPEG.

- Shoot with a sufficiently large distance between your camera and your subject. One reason to do this is you want to be sure that your entire subject will fall into your predetermined depth of field. Another is to avoid unsightly distortions.

- Determine and set the focus, exposure, white balance, DR function, and film simulation settings *before* you capture a panorama—and be sure to base them all on the area of your image that you deem most important. Only in rare cases will the center of attention in a panorama fall within the initial frame. Make use of the AE-L, AF-L, or the half-depressed shutter-release button to establish the focus and exposure settings based on the focal point of your image, and then move the camera to its appropriate starting position. The X-Pro1 uses the same focus, exposure, and white balance settings for the entire panorama. Don't forget that the exposure compensation dial also functions

**Image 111: MOTION PANORAMA**
This image shows a horizontal panorama of the larger size (L). The JPEG file has a size of 7680 x 1440 pixels. At first glance everything here looks to be in order, but upon closer inspection you'll discover a few ghosting artifacts (double images) of people who moved during the exposure window that lasted several seconds.
Exposure parameters: XF18mmF2 R, ISO 400, f/10, 1/240 second.

with panoramic images—you can use it to set the "perfect" exposure for your subject before you start to record the panorama.

- Pivot the camera with your eye to the EVF—not with outstretched arms on the LCD monitor. The OVF is not usable while shooting panoramas.

- Try to find a level ground for your panoramic exposures and align your body so it is parallel with the middle of your planned exposure—not with the starting point of the panorama. This will help you avoid having to make unpleasant contortions, especially when creating L panoramas.

- When the X-Pro1 is exposing a panorama, there's an increasing time lag between what you will see in the

viewfinder and the subject matter that is actually
being captured. Don't let this bother you. It's also best
to ignore the warning that pops up in the viewfinder
telling you that you have deviated from the ideal line
of horizon. When you see this warning, it is already
too late for a correction (on account of the time lag).
Trying to correct the problem would actually lead to
more problems anyway. It's best to get used to pivoting
the camera smoothly, in a straight line, and not allow
anything to break your concentration.

- Using fast shutter speeds with the X100 in panorama
  mode often led to unsightly vertical lines in the
  finished image. Fortunately I have *not* had this
  experience with the X-Pro1 and have produced
  good results with quite short exposure times (even
  1/500 second). Fast shutter speeds minimize the
  chance that individual images of a panorama will suffer
  from unwanted motion blur that can derive from the
  uniform pivoting of the camera. I should mention,
  however, that I've seen a few comments in Internet
  forums warning users to be cautious using short
  exposure times when creating panoramas with the

**Image 112: Night Panorama at ISO 6400:**
This picture was shot at ISO 6400 with an exposure time of 1/500 second as a vertical size M panorama (5120 × 2160 pixels). While panning this image, I simply held the camera upright. Exposure parameters: XF18mmF2 R, ISO 6400, f/2, 1/500 second.

X-Pro1 on account of these unpleasant vertical lines. Since I can't exclude the possibility that the X-Pro1 will exhibit this behavior under certain circumstances, you should at least keep this warning in mind. In other words, *in the event* that your finished panorama image ends up with vertical bands exhibiting differences in exposure, you can probably solve the problem by using a slower shutter speed.

- If you would like to create a horizontal panorama with a higher resolution, select the vertical pan direction and hold your camera sideways as you pivot it horizontally.

- When you are using a tripod to create your panorama (which is generally advisable), you should align the camera in parallel with the horizon before exposing your image. Since the electronic level is not available in panorama mode, you can temporarily switch into another mode to do this.

- In general, use short focal lengths (e.g., 18mm or 35mm) with sufficiently large depths of field.

The longer the focal length, the harder it is to create a panorama by hand that is free from distortions and camera shake.

• Immediately after finishing your panorama, you should inspect it in playback mode and look for any compositing errors or ghosting artifacts. You can use both zoom buttons (the alternate functions of the AE and DRIVE buttons) or press the command dial to enlarge your panorama while viewing it on your camera. It's very frustrating to discover flaws in your panorama after you go home! In most cases you can repeat the shot to improve your results if you are aware of the problem at the scene.

## MOVIES

The X-Pro1 is a thoroughbred still-image camera. Its video capturing capability (DRIVE button > MOVIE) should be thought of as nothing more than a bonus, and little should be expected from it. In fact, it's best not to expect anything at all!

Nevertheless, in contrast to the X100 the X-Pro1 offers real "Full-HD" (1080p) with 1920 x 1280 pixels. You can adjust this resolution in the video mode's shooting menu (MENU/OK button), which you can find under the submenu VIDEO MODE. Here you can alternatively select "normal" HD (720p) with 1280 x 720 pixels. The refresh rate in both cases is 24 frames per second.

Other settings that you can define in the video menu before you start filming are FILM SIMULATION and WHITE BALANCE. The custom-defined white balance option (see "Manual White Balance" in section 2.7) is not available in this mode.

Even when its focus mode is set as AF-S, the X-Pro1 always functions in AF-C mode when capturing movies and thus constantly tries to refine its focus. In practice,

this is often more bad than it is good, because the contrast-driven autofocus is clearly not intended to be used this way. For this reason, I recommend you set the focus selector to M and manually focus with the AE-L/AF-L button and focus ring before filming. After you've already started recording, the AE-L/AF-L button is functionless, but you can continue to adjust the focus with the focus ring.

Since the X-Pro1 lacks an external microphone jack, you're stuck using the integrated stereo microphone for sound capture. This unfortunately picks up the clicks, whirring sounds, and hums that the mechanical parts of the camera and lens make. Using manual lenses from third parties tends to reduce this concert of distracting noise.

With the appropriate lens adapter, you can also attach high-end video lenses to the X-Pro1. Capturing the video entirely by manual means isn't possible, though, because the X-Pro1 constantly attempts to adjust the exposure by itself. You can choose the aperture with the aperture ring in advance, but not the exposure time: the shutter-speed dial does not work in MOVIE mode.

**TIP**

The X-Pro1 doesn't feature a quick-start button that allows you to start and end a video easily. To begin recording a movie, you need to first activate the video mode (DRIVE button > MOVIE) and then use the shutter-release button to start and end the capture. If this is too inconvenient for you, assigning the movie mode to the Fn button is also an option. This allows you to jump back and forth between the still image and movie mode with the touch of a button.

The exposure compensation dial is functional in MOVIE mode, but you have to set it *before* you start recording a movie.

### DOUBLE EXPOSURES

The double exposures function should belong in the menu options for the DRIVE menu, but it is instead located under SHOOTING MENU 4 > MULTIPLE EXPOSURES > ON. I interpret this as an indication that the feature was added relatively late in the design of the X-Pro1. You won't find it in the X100 (or in other FUJIFILM cameras with which I'm familiar).

This function is quite simple. While several DSLR cameras offer various types of compositing, the X-Pro1 only offers one.

In MULTIPLE EXPOSURE mode, the upper limit for the automatic ISO feature is 1600 and the DR function can only be set manually at DR100%, DR200%, or DR400%. This is a bit onerous if you usually shoot with the auto DR and auto ISO 3200, for example. When activating the multiple exposure mode, the camera will automatically set the ISO value to 1600 and the dynamic range to DR100%, which is probably not your ideal setup.

If you plan to use this feature frequently, it is a good idea to create a specific custom shooting profile (section 2.7) with more practical settings (such as auto ISO 1600). Then after you're finished with this function, you can revert back to your standard profile by accessing the Quick Menu. You can also assign the MULTIPLE EXPOSURE function to the Fn button, if that is desirable to you.

The operation of this feature is foolproof: take the first exposure and then follow the instructions on the display. One benefit of this feature is that it saves not only a JPEG

of the finished double exposure, but also a corresponding RAW file (if the camera is currently programmed to save RAW files). Do note, however, that the composite image is the only one that the camera writes to the memory card—the two individual images will be available to you neither as JPEGs nor as RAW files.

Image 113: **Double Exposure:**
The MULTIPLE EXPOSURE feature allows the photographer to combine two consecutive shots by laying one on top of the other—something familiar from older film cameras.

### SELF-TIMER

The X-Pro1 also has a self-timer that can be set to ten or two seconds. To select your duration of choice, go to SHOOTING MENU 1 > SELF-TIMER. You can also use the Quick Menu or assign this function to the Fn button.

- The ten-second option is intended to allow photographers enough time to move from behind the camera to be a part of the exposure (as with self-portraits or group shots).

- The shorter duration of two seconds is principally intended for situations when you are using a tripod and want to avoid camera shake due to long exposure times. This method allows the camera settle before it actually captures an image.

The self-timer remains active until you (or the camera) turn it off—it can be active for several consecutive exposures, in other words.

# 2.9 FLASH PHOTOGRAPHY WITH THE X-PRO1

As the time of writing, the X-Pro1 is the only camera from FUJIFILM that does not feature an integrated flash. So flash photography with this camera requires the use of an external flash. The X-Pro1 does feature a TTL shoe mount and a traditional sync connector for external (studio) flash units.

As long as you're comfortable modulating everything manually, you can use nearly every available flash unit on the market as well as most studio flash devices and remote flash systems with the X-Pro1. If you are looking for experience about a specific solution or combination of devices, a quick Internet search at one of the sources listed at the end of this book can be a good place to start.

In this book I'll concentrate on the three system flash units that are compatible with the X-Pro1: the EF-X20, EF-20, and EF-42 (see section 1.3). These flash units sup-

port the camera's TTL auto flash, whereby the X-Pro1 automatically modulates the amount of light that is emitted by the flash unit.

TTL stands for "through the lens" and means that the camera bases the flash exposure on the amount of light that shines through the lens and lands on the sensor. The camera sends a small preflash, meters the amount of reflected light, and then regulates the optimal flash output based on the results. The goal of this process is to create a natural balance between the ambient light and the light from the camera's flash.

If you attach a FUJIFILM system flash unit to the X-Pro1 and turn it on, there will be five flash modes available under SHOOTING MENU 5 > FLASH MODE. These flash modes are not all available in every exposure mode (**P**, **A**, **S**, and **M**; see also section 2.3). Here's a quick overview:

- automatic flash (AUTO) / **P**
- forced flash (FORCED FLASH) / **P**, **A**, **S**, **M**
- slow sync (SLOW SYNCHRO) / **P**, **A**
- synchronization to the second shutter curtain (2ND CURTAIN SYNC.) / **P**, **A**, **S**, **M**
- suppressed flash (SUPPRESSED FLASH) / **P**, **A**, **S**, **M**

You can also access these flash modes in the Quick Menu by pressing the Q button.

## AUTOMATIC FLASH

In the AUTO flash mode, which is only available in the program automatic exposure mode, **P**, the X-Pro1 determines when to the flash will fire. You can tell that the camera has decided to use the flash for an exposure by the small *flash symbol* that appears in the viewfinder or on the LCD display as soon as you press the shutter-release button halfway.

When the camera uses the flash, the minimum shutter speed is determined by the well-known formula 1/(focal length x 1.5). If you are using the 35mm lens, the X-Pro1 always uses an exposure time of 1/52 second or less in AUTO flash mode—independent of the selected ISO setting.

This means that if you have the ISO set at a low value (perhaps ISO 200) and you're shooting in dim lighting conditions, the camera cannot adequately incorporate the natural light. You should either use a higher ISO value (or use the auto ISO feature) or you should switch the flash mode to SLOW SYNCHRO (see below).

## FORCED FLASH

FORCED FLASH functions exactly as the AUTO mode does except that it's available in all four exposure modes (**P**, **A**, **S**, **M**) and the flash always fires regardless of the lighting conditions. In the program automatic and aperture priority modes (**P**, **A**), the minimum shutter speed rule still applies: 1/(focal length x 1.5) or shorter—in **A** it applies regardless of the aperture you have selected. Pay attention to the ISO setting in relation to the ambient light here or switch the flash mode over to SLOW SYNCHRO.

In the **S** and **M** exposure modes you have control over the shutter speed and can incorporate more of the ambient light into your shot by choosing a longer exposure window. Don't overlook the risk of camera shake or unwanted motion blur with these slower shutter speeds.

In exposure mode **M**, you have complete control over how much natural lighting affects your image. The TTL system contributes the appropriate amount of light from the flash wholly automatically.

## SLOW SYNCHRO

The flash mode SLOW SYNCHRO is available in the exposure modes **P** and **A**. This mode does away with the rule of thumb for the minimum shutter speed. Depending on the brightness of the subject, the X-Pro1 uses an exposure window of up to 1/8 second (regardless of the focal length). If you want longer exposure windows, you need to use the **S** and **M** exposure modes.

In the event that you don't want the parts of your image that are illuminated by the natural lighting to blur, you should use a tripod. Also keep in mind that the flash always fires immediately at the start of the exposure, just as the camera opens the shutter. In other words: the camera synchronizes the flash to the first shutter curtain. If you are trying to photograph a car driving by at night with a slow shutter speed, the light traces of the headlights will be recorded as ambient light, while the car, which is much darker, will be illuminated by the light from the flash and appear to be more or less frozen in place.

The problem is, when the flash is synchronized to the first curtain, the light traces will continue forward in the direction of the car's travel. This creates an irritating impression because it looks as though the car were traveling in reverse. The solution? Synchronize the flash to the second shutter curtain!

## SYNCHRONIZATION TO THE SECOND SHUTTER CURTAIN

The flash mode 2ND CURTAIN SYNC. functions identically to the forced flash, except it delays firing the flash until the end of the exposure window, just before the shutter closes. This method is known as synchronizing to the second curtain.

This flash mode is available in all four exposure modes (**P**, **A**, **S**, **M**) and the flash will fire regardless of the ambient lighting conditions. In the **P** and **A** modes the general rule once again applies: minimum shutter speed = 1/(focal length x 1.5) or shorter. Again in aperture priority (**A**) this rule applies independent of the aperture you have selected.

In order to get the most from this feature, you should use this flash mode in combination with either the **S** or **M** exposure modes so you can make use of longer exposure times.

Image 114: **Synchronizing to the Second Curtain:**
Intentionally achieving motion blur can be an effective stylistic decision, but certain aspects of the image should often still appear mostly in focus. The use of light from a flash to complement the otherwise sufficient natural lighting conditions can be valuable, because it adds a second, brief flash during longer exposure windows. This method is not unlike a double exposure in that way. If you're photographing motor vehicles or other moving objects it's advisable to synchronize the flash to the second shutter. Exposure parameters: XF18mmF2 R, ISO 200, f/16, 1/30 second, EF-20.

## SUPPRESSED FLASH

The SUPPRESSED FLASH setting disables the flash function entirely. It prevents any flash that is connected to your camera, turned on, and ready to fire from discharging.

Please note that when SILENT MODE is activated, all flash functions are also completely suppressed. To turn SILENT MODE on and off, press and hold the DISP/BACK button for a few seconds.

## RED-EYE CORRECTION

All of the X-Pro1's TTL flash modes can be used in combination with a red-eye removal feature. The problem of red-eye comes up frequently in portraiture as a result of the light from the flash reflecting off the retina. These reflections occur when the light from the flash discharges close to the optical axis. Put another way, you're likely to get red eyes if your shot is set up in a way that requires you to fire the flash directly in front of your subject, which is usually the case with most integrated and shoe-mount flash units. If you illuminate your subject indirectly from above or from the side, this problem never or only rarely comes up.

To turn the red-eye correction feature on for all exposure modes, go to SHOOTING MENU 5 > RED EYE REMOVAL > ON. The X-Pro1 addresses this phenomenon in two ways:

- The camera prompts the flash unit to emit a preflash, which causes your subject's pupils, which normally would be dilated in the dim lighting conditions, to constrict. This minimizes the amount of reflected light from the retina.

- The X-Pro1 detects the presence of a face in an exposure and removes any remaining red-eye problems when it creates the JPEG file.

**Image 115: Red-Eye Correction:**
When this function is activated, the camera emits a preflash and subsequently removes any remaining red-eye problems in the JPEG file. This process prevents reflections from the retina from showing up in your images or takes steps to remove them after the exposure.

**TIP**

When the red-eye removal tool is active, you can program the camera to save the untouched JPEG in addition to the edited version. To do this, go to SHOOTING MENU 5 > SAVE ORG IMAGE > ON.

You can also use the X-Pro 1's red-eye correction feature retroactively on images that have already been exposed. Find the problematic image in playback mode and then go to PLAYBACK MENU 1 > RED EYE REMOVAL.

### FASTEST FLASH SYNC SPEED

The official shortest exposure time that the X-Pro1 can use with a flash unit is 1/180 second. In practice, however, flash exposures free from problematic shadowing effects are often successful at 1/250 second. Nevertheless, this technology-related restriction (the camera has a focal plane shutter) is a blow to people used to the X100 or other central shutter cameras that have very brief flash sync speeds. For DSLR converts, this limitation should be "business as usual."

In the exposure mode **P** and **A** the camera limits the exposure time to 1/180 second when the flash is activated—anything shorter is not possible. In the **S** and **M** exposure modes, conversely, you can set your own shutter speed, but at your own risk. The camera

will obey, but for exposures that are shorter than 1/250 second, you may end up with visible shadowing effects and an uneven illumination of the exposure.

## FLASH EXPOSURE CORRECTION

As mentioned, the TTL logic establishes the ideal flash output for the camera based on a specific subject. This is wishful thinking, though, and you will need to adjust the flash manually—just as you would with regular exposures— to attain a level of exposure that looks optimal to you. The camera and the photographer don't always see eye to eye, and ultimately the photographer is always right.

One method of correcting flash exposure is to regulate the output of TTL flash units directly: the EF-20 allows you to adjust its output by ±1 EV in steps of 1/2 EV; with the EF-X20, it's also ±1 EV, but in steps of 1/3 EV. Another method is to control the flash through the X-Pro1. To do this, go to SHOOTING MENU 5 > FLASH. There you have access to a correction range of ±2/3 EV in steps of 1/3 EV.

How do the two methods of controlling flash output interact? Quite simply: they add up. In combination, you can adjust the TTL flash output up or down by a maximum of ±1 2/3 EV (±1.66 EV).

## CONTROLLING THE AMBIENT LIGHT

You can control the flash output with the flash exposure compensation techniques discussed above. At the same time, you can continue to control the parts of your image that are *not* affected by the flash in exposure modes **P**, **A**, and **S** with the exposure compensation dial. This dial has no direct effect on the amount of light fired by the flash. The interplay between the flash exposure compensation and the normal exposure compensation gives you a lot of control to reach your desired balance of artificial and natural light.

Image 116: Considering Ambient Light When Using Flash:
With many successful flash exposures, you don't even realize at first glance that flash
was used. In this photo, the cat's eyes betray the use of a flash. Fuji's automatic TTL flash
system is one of best in the world and consistently delivers results that users of other
brands can only dream of. Since there's always room for improvement, though, be sure
to make regular use of the compensation functions for both flash and ambient light.
Exposure parameters: XF35mmF1.4 R, ISO 400, f/2.2, 1/125 second, EF-20.

### TIPS FOR EXPOSING WITH FLASH

- When you attempt to meter a CUSTOM WHITE
  BALANCE (see "Manual White Balance" in section
  2.7) with a flash that is attached and ready to fire, the
  flash will go off, thereby affecting the camera's white
  balance measure. Since different flash units exhibit
  different color temperatures (and since photographers
  often modify a neutral flash with color filters), this
  feature can be very useful.

- You can strike the right balance of flash light and
  ambient light by using flash exposure compensation
  to adjust the flash (go to SHOOTING MENU 5 in the

X-Pro1 and/or adjust the flash unit output directly on the device) and by using the exposure compensation dial to regulate the ambient light.

• If you want to depict the background sharply when using long exposure times, you should use a tripod despite using a flash. Sometimes, however, you may intentionally want a blurry background. In this case, the flash will help to ensure that the subject in your exposure is still in focus and stands out against what's behind it.

**Image 117: Foreground and Background:** I intentionally took this night exposure by hand with a long exposure window of 1/15 second to capture some of the movement that was critical to this scene on the street. The illuminated toys and the other ambient light contrast with the person in the foreground, who is illuminated with a modest flash (and is subsequently in better focus). The flash was also synchronized to the second curtain here, and to prevent the scene from looking too cool, I chose a white balance that was on the warmer side. Exposure parameters: XF18mmF2 R, ISO 3200, f/2, 1/15 second, EF-20.

- As I mentioned above, the X-Pro1's official flash sync speed is 1/180 second, but in reality you can often get away with 1/250 second. Sometimes that's not enough, though—for example, if you are shooting a portrait in broad daylight and want to use a wide-open aperture to establish a shallow depth of field that will isolate your subject from the background. Before you reach for the last resort of ISO 100 (which probably wouldn't take care of this problem and would end up reducing the dynamic range), you should attach a neutral gray filter (ND gray filter) to the lens to reduce the incident light by the equivalent of a few aperture stops.

- When shooting moving objects with long exposure times, synchronize the flash to the *second* curtain. You can select the appropriate shutter speed for your purpose by using the **S** or **M** exposure modes.

- The X-Pro1 is a marvel at high ISO settings. This makes using the flash unnecessary in many cases and allows you to rely on the ambient light, which may end up producing a better look in your final image. Don't flash your subjects to death—less is more. It's true that in the studio you need to compose the light for the entire scene, but the small flash units EF-20 and EF-X20 are first and foremost intended to be artificial brighteners, not the only sources of light for a scene.

- With the aid of a pin-compatible Canon TTL extension cord (see section 1.3) you can expose remotely when using the X-Pro1 with FUJIFILM system flash units. In other words, you can use the flash in TTL mode even when it is removed from the camera. Important: You can also then use flash units from Canon, but not in TTL mode—you'll need to control them manually.

- The EF-X20 comes equipped with a slave mode that allows it to be optically triggered by another flash. This slave mode doesn't operate based on TTL control; you will need to configure it manually by defining the desired flash output directly on the flash unit. There are seven different levels of output ranging from maximum (1/1) to 1/64 of the full power. The EF-X20 also reacts to a preflash from the master flash unit intended to reduce red-eye effects. If your shot will feature a preflash, adjust the slide switch on the bottom of the EF-X20 that is serving as the slave to *P-Mode*; if no such preflash will occur, adjust it to *N-mode*. To return the flash back to its normal TTL operation controlled by the camera, set the switch back to *X*.

**Image 118: The EF-X20 in Slave Mode:** The small EF-X20 system flash can be controlled wirelessly by another flash unit. When using it in this manner, you will need to set its output manually. In this illustration the EF-X20 was triggered by a flash from a FUJIFILM X100, which in turn captured the response.

- When using a wide-angle lens, remember to flick on your flash unit's wide-angle diffuser to make sure that your flash uniformly and completely illumines your entire scene.

• Lens hoods are a good thing, but when using the EF-20 or EF-X20—especially for closeup and macro shots—they can lead to unwanted shadows. It's best to remove the hood for these particular situations or make use of a remote flash.

## IMPORTANT

Exposures taken in poorly lit circumstances with the auto ISO function active (e.g., at dusk) often end up being more than adequately illuminated or even overexposed. Adding extra light from a flash won't improve the image at all. In these cases, make sure to regulate the ambient light with the exposure compensation dial, so that your flash can produce the effect you desire.

Also keep in mind that the TTL flash system works well with the dynamic range options DR200% and DR400%. But be careful: the DR function's requirement for a higher ISO setting can lead to shorter exposure times and/or larger f-numbers. Neither of these are desirable for flash photography, especially because the official limit for the shortest flash sync speed for the X-Pro I is 1/180 second.

# 2.10 USING THIRD-PARTY LENSES

One highlight of the X-Pro1 is undoubtedly the small flange-back distance of the X-Mount lens connector at only 17.7mm. This means you can attach practically any third-party lens from other camera systems—with the appropriate adapters—to the X-Pro1. The Chinese manufacturer Kipon has already announced X-Mount-compatible adapters for 42 third-party systems, and the high-quality German manufacturer Novoflex has also dutifully added X-Mount adapters for some 13 established third-party systems.

Does this make the X-Pro1 a veritable Leica killer? Is this the camera that Leica has failed to bring to the market for years?

FUJIFILM has no objection to this view and is happy to stand in the shadow of the iconic brand from Solms. It's also fitting that Fuji developed its own adapter specifically for Leica's M-system. When connected to the X-Pro1, this adapter unlocks various exclusive corrective features for vignetting, color shifts, and lens distortion.

This doesn't make the many comparisons with Leica any more sensible, however. The X-Pro1 is not a rangefinder camera. It's a pure-bred autofocus camera (Leica's M-series only features manual focusing) and as such—despite its hybrid viewfinder—is only marginally equipped to work in combination with manual focus lenses: the only tool that the X-Pro1 features to assist with manual focusing is a magnified digital viewfinder. Your search for focus peaking and other comparable tools to help with manual focusing in the X-Pro1 will be in vain.

In other regards as well, the X-Pro1 is poorly equipped for working with third-party lenses, owing to its firmware (version 1.11). When a lens is attached to

the X-Pro1 via an adapter, the auto ISO operates with a minimum shutter speed of 1/30 second independently of the actual focal length and what is defined in the adapter menu. This is too fast for many wide-angle lenses and too slow for most normal and telephoto lenses.

The X-Pro1 sets the minimum flash sync speed at 1/15 second when a third-party lens is attached, which is largely useless for lenses with longer focal lengths. To add to this, the camera has an adapter menu where you can input the focal length of the lens currently attached. In other words, the X-Pro1 "knows" exactly what the current focal length is, but doesn't do anything with this information.

Image 119: FUJIFILM M-Mount Adapter:
Fuji's own adapter for lenses that feature Leica's M connector includes X-Mount signal contacts as well as a function button on the adapter ring that brings up the adapter menu on the monitor or in the viewfinder. Furthermore, this adapter unlocks extra camera functions that allow you to correct several optical errors such as vignetting, distortions, or color shifts at the border of an image.

Still, the display frame for the OVF uses the selected focal length setting in the adapter menu (SHOOTING MENU 3 > MOUNT ADAPTER SETTINGS), as long as it's between 18 and 60 millimeters. Focal lengths less than 18mm are indicated in the optical viewfinder with yellow arrows in the corners; focal lengths of greater

than 60mm, with a red frame calibrated to 60mm. Within the acceptable range of focal lengths for the OVF— 18mm to 60mm—two frame indicators will appear in the viewfinder: one white, one blue. The white frame is corrected for parallax for objects at infinity and the blue frame, for objects at about two yards.

**IMPORTANT**

Third-party lenses attached to the X-Pro 1 over a specific adapter can only be focused manually. The only exposure modes that are available are the aperture-priority **A** and manual exposure **M** modes. Other functions such as auto ISO, TTL flash, and DR extension, however, are still available.

## CONNECTING AND RECOGNIZING THIRD-PARTY LENSES

After you have mechanically attached a third-party lens to your camera via an adapter, you should first make sure that SHOOTING MENU 3 > SHOOT WITHOUT LENS > ON is selected—otherwise your X-Pro1 won't take any pictures.

Next go to SHOOTING MENU 3 > MOUNT ADAPTER SETTINGS. Here you will have six lens settings to choose from: four focal length presets (21mm, 24mm, 28mm, and 35mm) as well as LENS 5 and LENS 6—two focal lengths that you can set manually.

If you happen to be using an M-adapter from FUJIFILM, you will also have a number of correction settings available, which I'll cover below.

## FOCUSING WITH THIRD-PARTY LENSES

The only way to focus precisely when using a third-party lens is to use the magnified display of the electronic viewfinder (EVF) or the LCD monitor. Your camera will need to be in manual focus (MF) mode, so turn the focus mode selector on the front of the camera to M. As usual, you can magnify the digital displays by pressing the command dial.

To focus as exactly as possible, you'll want to open the aperture as wide as possible. The reduced depth of field will help you to find the correct focus point. After you've found it, you can then reset the aperture to your desired setting. The focus point should not move, but the depth of field should become larger. You can observe this effect in the EVF. The viewfinder's distance and depth of field indicators will be nonfunctional.

To refine your focus at any time you can always reactivate the magnified digital display. Well, *almost* at any time: the magnified display will not be available while the camera is transferring data from the buffer memory to the memory card. As soon as that finishes, you can activate it again. Let's hope that Fuji takes care of this weird quirk in future firmware updates. In the meantime you can make do with a bit of patience and a super-fast memory card.

## EXPOSING CORRECTLY WITH THIRD-PARTY LENSES

When a third-party lens is attached, the X-Pro1 works exclusively in the aperture-priority (**A**) or the manual (**M**) exposure modes. However, neither of these modes functions exactly as they do with Fuji's own XF lenses: while X-Mount lenses don't set the aperture until the shutter button is pressed halfway in **A** and **M** modes, third-party lenses reduce the aperture immediately after setting a larger f-number. This not only causes the depth

Image 120: **Voigtländer Heliar F1.8/75mm with M Adapter:**
Numerous adapters make it possible to attach nearly any new or old third-party lens to your X-Pro1. Especially popular are lenses that feature Leica's M connection, which for a while now have been available from more brands than Leica itself, including Carl Zeiss and Voigtländer. This image was shot with a high-aperture 75mm Heliar and a Kipon M adapter—a lightweight telephoto lens for portraits with character. Exposure parameters: Voigtländer Heliar F1.8/75mm, ISO 200, ca. f/2, 1/45 second.

of field to increase in the EVF display; it also causes the live view image to get darker, since less light is able to enter the lens and reach the sensor.

The camera attempts to counteract this loss of light and enhances the display in the viewfinder. This works, but only up to a point.

We've already discovered several times that the live histogram doesn't relay any useful information in **M** mode. With a very dark subject, however, the live histogram also can't deliver any useful information in the other exposure modes (**P**, **A**, and **S**). Using

a third-party lens with a narrow aperture is similar to creating "a very dark subject," because we've reduced the amount of light that reaches the sensor and darkened the effective viewfinder display. This causes dusk to become night quickly in the live image, which in turn renders the live histogram useless because it relies on the live image for its data.

Keep these relationships in mind when you want to expose precisely with third-party lenses in combination in aperture priority mode, **A**, with the help of the histogram. A simple solution for this problem is to use a very large aperture when setting the exposure for your shot. Then you can use the histogram and the exposure compensation dial to optimize your exposure settings. Finally, you can stop the aperture down once you're satisfied—this will change the aperture and the shutter speed, but won't change the overall exposure of your image.

**TIP**

You can get the best exposure preview of your image in poor lighting conditions in the EVF or on the LCD monitor by pressing the shutter button halfway. The camera then enhances the live image display as much as possible.

### SPECIAL FEATURES OF THE FUJIFILM M ADAPTER

FUJIFILM's own M adapter functions in principle in the same way as other third-party adapters. But it offers a few additional functions that are contained in the camera's firmware and unlocked only when you attach Fuji's adapter to the camera.

Since Fuji's M adapter features X-Mount signal contacts, it's not compatible with some M lenses for reasons of space. You can find a list of compatible lenses at
🌐 www.fujifilm.com/products/digital_cameras/
    accessories/lens/mount/fujifilm_m_mount_adapter/
    compatibility_chart/

FUJIFILM also includes a small template that you can use to determine if your M lens will fit mechanically or not.

When you use the Fuji M adapter with your X-Pro1, the adapter menu for each of the six lenses expands to include three additional settings:

• DISTORTION CORRECTION corrects pincushion or barrel distortions caused by the lens. There are three correction levels available for each of these distortion types.

• COLOR SHADING CORRECTION counteracts color shifts near the edges of an image, which occur most often with wide-angle lenses. Each of the four image corners can be independently corrected.

• PERIPHERAL ILLUMINATION CORRECTION reduces (or increases) vignetting. There are five levels available to decrease or amplify vignetting effects.

You can set correction values separately for each of the six focal lengths available in the adapter menu (SHOOTING MENU 3 > MOUNT ADAPTER SETTINGS). You'll need to handle all of these corrections manually—they aren't automatically applied. Also, you have to set the correction settings for each lens individually, which will require you to take test shots and compare the results.

    The corrections you apply in the adapter menu are made during the RAW conversion. In other words, the JPEGs will be corrected according to your inputs.

Furthermore, the external RAW converters Silkypix, RAW File Converter EX, Adobe Lightroom, and Adobe Camera RAW can recognize the correction settings in the RAW file's metadata. For technical reasons, however, they are only able to apply the distortion and the vignetting corrections when developing the RAW file. The correction for the color shading unfortunately gets left by the wayside, which means you'll need to refer back to the camera's JPEGs.

# 2.11 SOURCES AND LINKS

I hope this book has answered your questions, solved a few concrete problems, and provided a slew of useful information. Since even a wide-ranging book can't cover every possible topic, however, I'd like to share some useful links for online sources and discussion forums where you can gather more information about the X-Pro1 system.

## FORUMS
- www.fujix-forum.com
- www.fujixseries.com
- www.seriouscompacts.com/f98

## DETAILED REVIEW
- www.dpreview.com/reviews/fujifilm-x-pro1

## OFFICIAL SOURCES
- fujifilm-x.com/x-pro1/en
- www.fujifilm.com/products/digital_cameras/x/fujifilm_x_pro1

## VIDEOS FROM THE FUJI GUYS
- www.youtube.com/user/fujiguys

## ACCESSING EXIF DATA AND MAKER NOTES

The X-Pro1 saves a wealth of information in your RAW and JPEG files about your exposure settings as EXIF information (Exchangeable Image File Format). To access these metadata as well as a lot of information specific to individual vendors (i.e., Maker Notes), such as the camera serial number, date of manufacture, dynamic range extension, film simulation, etc., and to read this information to your computer, it's advisable to use an image viewing or editing program that relies on the utility ExifTool.

In Windows, for example, the program ExifTool GUI enables this, and on MacOS, GraphicConverter.

```
                  Make:  FUJIFILM
    Camera Model Name:   X-Pro1
           Orientation:  Horizontal (normal)
          X Resolution:  72
          Y Resolution:  72
       Resolution Unit:  inches
              Software:  Digital Camera X-Pro1 Ver1.10
           Modify Date:  2012:06:08 11:01:00
  Y Cb Cr Positioning:   Co-sited
             Copyright:
                  ---- ExifIFD ----
         Exposure Time:  1/120
             F Number:   2.0
     Exposure Program:   Program AE
                   ISO:  800
      Sensitivity Type:  Standard Output Sensitivity
         Exif Version:   0230
   Date/Time Original:   2012:06:08 11:01:00
          Create Date:   2012:06:08 11:01:00
Components Configuration: Y, Cb, Cr, -
Compressed Bits Per Pixel: 3.2
   Shutter Speed Value:  1/122
        Aperture Value:  2.0
      Brightness Value:  1.13
 Exposure Compensation:  0
    Max Aperture Value:  2.0
          Metering Mode: Multi-segment
          Light Source:  Unknown
                 Flash:  Off, Did not fire
          Focal Length:  18.0 mm
      Flashpix Version:  0100
           Color Space:  sRGB
      Exif Image Width:  4896
     Exif Image Height:  3264
 Focal Plane X Resolution: 2092
 Focal Plane Y Resolution: 2092
Focal Plane Resolution Unit: cm
        Sensing Method:  One-chip color area
           File Source:  Digital Camera
            Scene Type:  Directly photographed
       Custom Rendered:  Normal
         Exposure Mode:  Auto
         White Balance:  Auto
Focal Length In 35mm Format: 27 mm
    Scene Capture Type:  Standard
             Sharpness:  Normal
Subject Distance Range:   Unknown
             Lens Info:  18mm f/2
            Lens Make:   FUJIFILM
           Lens Model:   XF18mmF2 R
    Lens Serial Number:  21A00660
                 ---- FujiFilm ----
               Version:  0130
 Internal Serial Number: FPX 21128392    593130323434 2012:02:10 FD903011198E
               Quality:  FINE
             Sharpness:  Normal
         White Balance:  Auto
            Saturation:  Normal
White Balance Fine Tune:  Red +0, Blue +0
       Noise Reduction:  n/a
High ISO Noise Reduction: Normal
       Fuji Flash Mode:  Off
   Flash Exposure Comp:  0
                 Macro:  Off
            Focus Mode:  Auto
           Focus Pixel:  4151 1632
             Slow Sync:  Off
          Picture Mode:  Program AE
       Auto Bracketing:  Off
       Sequence Number:  0
          Blur Warning:  None
         Focus Warning:  Good
      Exposure Warning:  Good
         Dynamic Range:  Standard
             Film Mode:  F0/Standard (PROVIA)
 Dynamic Range Setting:  Auto (100-400%)
       Min Focal Length: 18
       Max Focal Length: 0
Max Aperture At Min Focal: 2
Max Aperture At Max Focal: 0
     Auto Dynamic Range: 400%
         Faces Detected: 0
```

## Image 121: EXIF Data with Maker Notes:

This screen grab of the MacOS program GraphicConverter shows a snippet of the EXIF data for an image taken with the X-Pro1. You can see that in addition to a vast amount of information about the exposure parameters, there are also general details such as the camera's serial number, its date of manufacture, and the serial number for the lens used to take the shot.

# 2.12  Firmware Version 2.00

Just in time for Photokina 2012, FUJIFILM released a new firmware version 2.00. And here are the new features and improvements:

- Improved AF (autofocus) speed and accuracy in very dark or bright light.

- A more accurate Distance Scale.

- Manual focusing using the focus ring and the "Focus by Wire"-System feels more natural than before.

- The X-Pro1 now uses the maximum aperture of the attached Fujifilm lens showing a rather shallow depth of field to provide a "safe basis" for your focusing and DOF decisions.

- Now, the Electronic Viewfinder allows for 3x magnification besides the 10x magnification to help with manual focusing. To activate magnification in MF-mode, press the command dial; to switch between 3x and 10x, turn the command dial to the right (10x) or left (3x).

- The Auto ISO function can now be extended all the way to AUTO (6400).

- The improved Multi Metering mode of the camera is now supposed to analyze exposure "even more intelligently." For example, the black iPad case in the upper left corner of image 61 is now rendered significantly darker than the piece of paper in the upper right corner. Firmware 2.00 improvements to the metering process will also allow for more natural rendering of difficult lighting situations, especially in night and low light photography. Exposure results seem to be "more conservative" overall (exposing

slightly to the left) which results in a less frequent use of the DR200% and DR400% options when the camera operates in Automatic DR.

• The problem that I described earlier – memory cards that were not ejected properly on a Mac or iPad causing long start-up times of the camera – is now fixed.

The new Firmware-Version 2.00 is now working with a new naming scheme for the update process. As before, the name of the firmware file that updates your camera body is FPUPDATE.DAT. The update files for the three (at the time of this writing) lenses have different names: XFUP0001.DAT (18 mm), XFUP0002.DAT (35 mm) and XFUP0003.DAT (60 mm).

Therefore, you can copy all the update files you need on one SD card and update your system (camera and lenses) in one run without risking naming conflicts.

However, please note that you have to first update the camera body to version 2.00 and then your lenses (in any order you like)!

# INDEX

## A

AdobeRGB  217
AE/AF LOCK MODE  122
AE-L/AF-L button  5, 121
AE-Lock  121
AE/zoom-out button  5
AF-assist lamp  4
AF/delete button  5
AF ILLUMINATOR  125
AF-Lock  124
ambient light  246
aperture priority  81
aperture ring  6
APS-C sensor  141
ASTIA  184
autofocus modes  110
    AF Continuous (AF-C)  110
    AF Single (AF-S)  110
automatic exposure bracketing  102
automatic ISO  150
AUTO POWER OFF  21
average Metering  93

## B

batteries and chargers  20
battery chamber  6
Bayer array  27
BC-W126  23
black-and-white conversion  190

## C

cable channel cover  6
closeups (macro mode)  130
COLOR SPACE  217
    Adobe RGB  217
    sRGB  217
command dial  5
CONTINUOUS shooting  223
contrast detection autofocus (CDAF)  109
CORRECTED AF FRAME  119
custom profiles  207

## D

depth of field  127
diopter  24
diopter lens  24
DISP/BACK button  5, 63
DRIVE button  222
DRIVE/zoom-in button  5
dynamic range (DR)  158
    DR function (100%, 200%, 400%)  163
    DYNAMIC RANGE BKT  172
    extending the dynamic range  158
    high dynamic range (HDR)  159

# E

energy conservation mode  21

ETTR: expose to the right  212

EVF (electronic viewfinder)  61

exposure and metering  78

exposure compensation  95

exposure compensation dial  4

exposure control  79

    Aperture priority (A)  79

    Manual exposure (M)  79

    Program automatic (P)  79

    Shutter priority (S)  79

exposure value (EV)  158

eye sensor  5

# F

film simulation  182

    ASTIA  184

    MONOCHROME  190

    MONOCHROME + Ye/R/G FILTER  190

    PRO NEG. HI  184

    PRO NEG. STD  184

    PROVIA  182

    SEPIA  191

    VELVIA  184

film simulation bracketing  193

firmware  12

firmware update  13

FLASH MODE  239

    automatic flash (AUTO)  239

    forced flash (FORCED FLASH)  239

    slow sync (SLOW SYNCHRO)  239

    suppressed flash (SUPPRESSED FLASH)  239

    synchronization to the second shutter curtain (2ND CURTAIN SYNC.)  239

flash photography  238

    flash exposure correction  245

    flash sync speed  244

flash sync terminal  5

flash units  43

    EF-20  43

    EF-42  43

    EF-X20  43

Fn button  4

focus-by-wire  127

focus distance indicator  128

focusing  109

focusing on fast-moving objects  132

focus mode selector  4

focus ring  6

frame counter  16

FUJIFILM M-Mount-adapter  252

FUJINON XF18mmF2 R  35

FUJINON XF35mmF1.4 R  36

FUJINON XF60mmF2.4 R Macro  38

# H

handgrip  6

HDMI port  7

HDR exposures  104

high dynamic range (HDR)  104

HIGHLIGHT TONE  196

histogram  98

    live histogram  98

hot shoe  4

hybrid viewfinder  4

    EVF  61

    OVF  61

# I

image playback 72

indicator lamp 5

internal RAW conversion 213

internal RAW converter 56

ISO 138

    ISO setting and image quality 141

ISO bracketing 155

# J

JPEG 53

# L

LCD monitor 5, 61

    LCD BRIGHTNESS 71

LED indicator lamp 7

lens release button 4

lens signal contacts 4

lithiumion battery 20

# M

macro mode 130

magnifying buttons 75

manual focus (MF) 110, 126

manual mode 87

MENU/OK button 5, 8

metering 91

    average metering 91

    multi metering 91

    spot metering 91

M-Mount adapter 252

MOTION PANORAMA 223

movies 234

multi metering 93

MULTIPLE EXPOSURE mode 236

# N

noise 142

noise reduction 204

NP-W126 20

# O

ON/OFF switch 4

OVF/EVF viewfinder selector 4

OVF (optical viewfinder) 61

# P

panorama 223

    tips for using the panorama mode 230

phase detection autofocus (PDAF) 109

playback button 5, 72

playback menu 8

POWER SAVE MODE 21

program automatic 80, 89

PRO NEG. HI 184

PRO NEG. STD 184

PROVIA 182

# Q

Quick Menu (Q) button 5,10

QUICK START MODE 21

# R

RAW 53

RAW+JPEG mode 57

red-eye correction 243

Rocket-air Blower 30

# S

SD memory card  17

self-timer  237

SENSOR CLEANING  28

Sensor Swabs  32

setting image size  59

setup menu  8

SHADOW TONE  198

sharpness  202

shooting menu  8

shutter priority  84

shutter speed dial  4

speaker  5

spot metering  94

sRGB  217

# T

third-party lenses  251

tripod mount  6

TTL flash  43

# U

USB/HDMI connector cover  6

USB port  7

# V

VELVIA  184

viewfinder  24

viewfinder selector  52

VIEW MODE  63

VIEW MODE button  5

Voigtländer Heliar F1.8/75 mm  255

# W

white balance

    automatic white balance  177

    manual white balance  179

    setting the white balance  175

# X

XF18mmF2 R  35

XF35mmF1.4 R  36

XF60mmF2.4 R Macro  38

X-Mount  34

X-Trans-sensor  4, 26, 27

# Get in the Picture!

**c't Digital Photography gives you exclusive access to the techniques of the pros.**

Keep on top of the latest trends and get your own regular dose of inside knowledge from our specialist authors. Every issue includes tips and tricks from experienced pro photographers as well as independent hardware and software tests. There are also regular high-end image processing and image management workshops to help you create your own perfect portfolio.

Each issue includes a free DVD with full and c't special version software, practical photo tools, eBooks, and comprehensive video tutorials.

Don't miss out – place your order now!

**Get your copy:**
**ct-digiphoto.com**